SEVEN
KEYS
TO
MODERN
ART

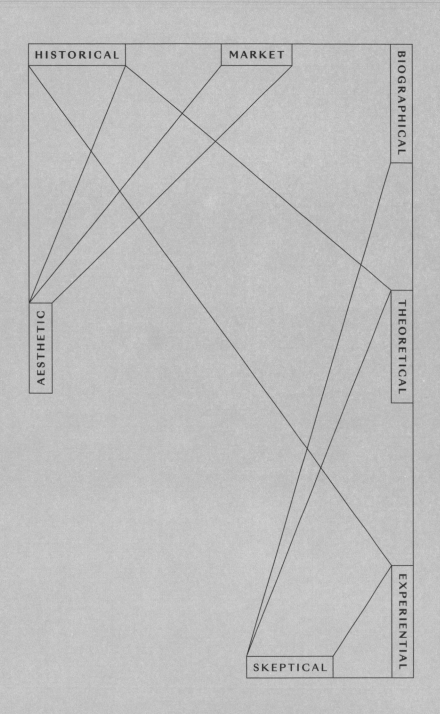

SIMON MORLEY

SEVEN
KEYS
TO
MODERN
ART

40 illustrations

Simon Morley is Assistant Professor in the
College of Arts, Dankook University, Republic
of Korea. He has lectured at such museums as
Tate, the National Gallery, Hayward Gallery,
Serpentine Gallery, Whitechapel Gallery and
Camden Arts Centre, and has contributed
to numerous publications including *Third
Text*, *World Art*, the *TLS*, *Burlington Magazine*,
ArtMonthly, *The Art Newspaper*, *Contemporary
Art* and the *Independent on Sunday*.

Seven Keys to Modern Art
© 2019 Thames & Hudson Ltd, London
Text © 2019 Simon Morley

First published in the 2019 in the United States
by Thames & Hudson Inc., 500 Fifth Avenue,
New York, New York 10110

www.thamesandhudsonusa.com

Library of Congress Control
Number 2018945301

ISBN 978-0-500-02162-0

Printed and bound in Hong Kong by RR Donnelley

CONTENTS

7 Preface

8 Introduction

20 **Henri Matisse** (1869–1954)

32 **Pablo Picasso** (1881–1973)

44 **Kazimir Malevich** (1878–1935)

56 **Marcel Duchamp** (1887–1968)

68 **René Magritte** (1898–1967)

78 **Edward Hopper** (1882–1967)

88 **Frida Kahlo** (1907–1954)

98 **Francis Bacon** (1909–1992)

110 **Mark Rothko** (1903–1970)

120 **Andy Warhol** (1928–1987)

132 **Yayoi Kusama** (b. 1929)

144 **Joseph Beuys** (1921–1986)

156 **Robert Smithson** (1938–1973)

168 **Anselm Kiefer** (b. 1945)

180 **Barbara Kruger** (b. 1945)

192 **Xu Bing** (b. 1955)

204 **Bill Viola** (b. 1951)

216 **Louise Bourgeois** (1911–2010)

226 **Lee Ufan** (b. 1936)

238 **Doris Salcedo** (b. 1958)

249 Notes

252 Picture Credits

253 Index

PREFACE

Seven Keys to Modern Art is intended for anyone interested in modern and contemporary art. This means it is a resource for all who visit art galleries and museums and who want to dig a little deeper. It could also be useful for specialists – students of art history and fine art or even the professional artist, for example. I have discovered that it is enlightening to approach one's own practice according to the Seven Keys presented here, because it can help achieve some sceptical distance, without closing down creative options.

The development of this book really began when I was working in the 1990s and early 2000s as a freelance lecturer, guide, and course and workshop leader at various museums and galleries in London. Over a period of about fifteen years I talked about art, old and new, to almost anyone who wanted to listen – to those aged from seven to well over seventy. Most of the time this happened in front of the real thing, rather than with slides or, later, digital images. I learned a huge amount from the various people who listened to me talk, asked questions and discussed what they thought and felt.

During this period, I was also making my own art, while writing reviews and essays for the art and general press. In 1995 I began teaching art history at university level at the Sotheby's Institute of Art, London, which gave me insight into the market. A few years later I switched to teaching studio art at art schools in the UK, and, since 2010, in the Republic of Korea. Living in South Korea has helped broaden my perspective on art. In fact, the idea of the complementary status of the Seven Keys I propose here is certainly indebted to a kind of thinking that isn't familiar in the West, and this different perspective has also informed my interest in how perception is culturally conditioned, and how art both works with, and against, habits of thought.

These days, I no longer give many talks, and instead, spend my time making art, teaching, and writing about art in journals, catalogues and books. But I've never forgotten the sense I had back in the days I was a museum lecturer of the public's insatiable appetite for art, their desire to engage with what they saw in spite of the often enormous hurdles to appreciation set up by so many modern artists.

I'd like to thank the staff of the education departments at the various museums and galleries where I used to work as a freelancer, in particular former employees at Tate: Richard Humphreys, who gave me my first break; Sylvia Lahav; Miquette Roberts; and Marko Daniel, formerly head of public programmes at Tate Britain and Tate Modern, who invited me to run the Rothko Course that was the initial stimulus for this book.

Since 2010 I have lived and worked mostly in the Republic of Korea. My MA and PhD Fine Art students at Dankook University, with whom I road-tested the book's structure, gave useful feedback. I'm most grateful to all the people who have listened to me and participated in my workshops over the years. I learned a lot from them.

At my publishers, Thames & Hudson, special thanks go to Roger Thorp, who first showed an interest in the book when he worked at Tate Publishing. He believed in the project sufficiently to ensure it came to fruition at his new home. Also, thanks to Amber Husain, Associate Editor, for many useful suggestions early on, and the book's editor Rosalind Neely for assistance in greatly improving the text.

Finally, I'm indebted to my partner, Chang Eungbok, for her encouragement and support and much-needed intercultural dialogue.

INTRODUCTION

ANOTHER GUIDE TO MODERN ART

Books such as this aim to help decipher the bizarre and sometimes intimidating phenomenon called 'modern art', which is characterized by various strategies that seem to take us further and further beyond the old familiar boundaries – beyond the artists' own, and certainly *our*, comfort zones. Modern and contemporary artists put a premium on self-expression and innovation. They court outrage for its own sake, and make things that seem to be so obtusely intellectual that often only a small elite can understand them.

Guides to such art point to visual and theoretical dimensions that are not immediately obvious, reconstructing the original intentions of artists and the contexts within which works are made, while hoping to indicate how they are important and relevant today. It is certainly no easy task to keep in mind the connections between the physical presence of a work, the expressed intentions of an artist, the evolving opinions of art historians and critics, and the continuously changing cultural perspectives that determine how all these factors are understood. *Seven Keys to Modern Art* joins all the other books in trying to be a useful guide. But it doesn't follow the familiar model.

The word 'key' in the book's title suggests a metaphor relating to locks, implying the book will unlock the meanings of the works that are its focus. But this isn't a book that reduces the works It discusses to information that has been safely decoded. On the contrary, *Seven Keys* aims to maintain flexibility of thought in relation to its subject, to be a guide that doesn't so much show us how to look *at* the works as helps us to look *with* them.

Rather than proceeding on the basis of the familiar art movements or '-isms', *Seven Keys* focuses on just twenty individual works of art. Together, they span the period from 1911 to the early 2000s, and represent a wide variety of media, styles, subjects and intentions – being the creations of men and women from different periods, various places and diverse backgrounds.

The selection process has obviously been highly subjective – but certainly not just the result of my own personal preferences. Nor have the works been included because they are necessarily by the most 'important' artists or are acknowledged masterpieces. Rather, they are here because together they represent the rich diversity of

modern and contemporary art, and serve as useful springboards to each other, to other works by the same artists or to the wider world of art in general. As a result, certain themes recur throughout the book – leitmotifs linking what at first may seem to be very different works.

Discussing individual works of art isn't so unusual, but what *is* unusual is that each of the works is discussed according to the same Seven Keys. These are the conventional modes of existence of each work, from the point of view of interpretation. Before each of these keys there is a short introductory overview outlining why a specific work is important, then the Seven Keys are presented in an order that seems appropriate for the work under discussion. Afterwards, there are two more categories, Further Viewing and Further Reading, to help additional exploration.

THE SEVEN KEYS:

1. THE HISTORICAL KEY
In this mode, the work of art is understood to be involved in an ongoing, developmental dialogue with subjects and styles inherited from earlier periods. The new often has more in common with the old than is at first recognized, and so the best way to understand the former is to compare and contrast it with the latter. Therefore, in this key the artwork is seen in a context that views it as a sign or symptom of the broader socio-cultural conditions and stylistic norms that prevailed at the time it was made, rather than as an artefact with intrinsic aesthetic or expressive qualities. Art is judged to be important because it has symbolic value and must therefore be considered in relation to changes and continuities through time, organized in terms of recurring codes and stylistic properties.

2. THE BIOGRAPHICAL KEY
Paying attention to the life of the artist is considered in this mode to be the best way to understand his or her work. The latter is understood as an expression of the former. There are two versions of this approach. The hard version, often called expression by 'contagion', argues that the character of an artist is experienced by a viewer directly via an encounter with their work. The soft version suggests

that the uniqueness of any work of art is intimately related to the specific personality and local circumstances that give rise to it, and that it depends for its power on the emotional and intellectual life of the maker, through which we are given access to more general social and psychological issues.

3. THE AESTHETIC KEY

In this mode, a work of art is approached primarily as a visual artefact, consisting of specific plastic or formal properties to which we respond emotionally and intellectually. The focus here is on our emotional responses to line, colour, form, texture, and so on. This mode recognizes that, in responding to a work of art, we use the same cognitive and affective processes as when appraising ordinary things and circumstances, but within the aesthetic state of mind, the object of perception – the work of art – is removed from the realm of practical knowledge and goals. As a consequence, the aesthetic experience will also involve a degree of detachment, and a reflexive attitude. Everything we experience has the potential to become art, because everything can have an aesthetic dimension. But what a culture defines as art will be determined by social consensus, and how a work is judged ultimately comes down to a combination of factors that include the biological, personal and cultural.

4. THE EXPERIENTIAL KEY

The main concern here is how a work can communicate across time, place and culture, touching on basic affective and psychological realities. There are two aspects to this key. One is subjective and phenomenological, focusing on how a viewer directly responds to the stimulus of the work as a multisensory experience. The second analyses these responses by drawing on research into the psychology of perception and the neurobiological foundations of perception, imagination and creativity. Social conditioning greatly affects the ways in which we respond to art, determining the meanings we attribute to the experience, and the brain functions in tandem with the body and the surrounding environment to generate the specific experiences that are derived from the encounter with an artwork.

5. THE THEORETICAL KEY

This mode encourages a language-oriented and intellectual relationship to art rather than an aesthetic, affective or expressive one. It emphasizes the potential of art to make us think, instead of treating it as a way of accessing the artist's psyche, engaging our sensibility, or exploring our sensory and emotional faculties. There are two broad possibilities. In the first, the manifest theoretical positions adopted by artists and critics and voiced at the time of making the work are addressed. The work of art is understood to be involved in exploring abstract ideas or immaterial subjects, such as existence, causality and truth. This approach links art with examining first principles and ultimate grounds, and an artwork is understood to exist within the context of deep and timeless existential questions about the meaning of life.

In the second approach, the work of art is judged to require comprehensive review and analysis in relation to unexamined assumptions about value and meaning. In particular, attention is paid to the institutional frameworks in which the work functions, and the ways in which meaning is socially constructed and politically implicated, and how the work includes, in often unconscious ways, traces of the prejudices of the society within which it was produced.

6. THE SCEPTICAL KEY

The consensus view can't be accepted without question, and this mode emphasizes that the cultural credentials of a work should not be taken for granted. Value judgments are largely the opinions of elites. Although the work is in a museum, praised by the experts, and sought after for its economic value, this does not place it beyond constructive criticism. Furthermore, decisions about the value of the artwork in our own era are inevitably myopic, because only the passage of time brings the necessary distance from which real judgments can be made. History is full of examples of fashion influencing judgments. It is therefore valuable to maintain a sceptical attitude. This key encourages the reader to play the 'devil's advocate', to seek different opinions, and to adopt constructively critical viewpoints.

7. THE MARKET KEY

Art is deeply embedded in a complex web of power relations, involving different kinds of exchange. The status of the work of art as a commodity within the capitalist economy, and as a symbolic and political token deployed by the state system, are the focus of attention in this mode. The work functions within an economic system that it helps to sustain, but, paradoxically, can also actively critique and subvert.

These Seven Keys converge on the same object – a single work of art – but they choose to see different things. On occasion, they are also clearly incompatible, in that the point of view promoted in one is ignored, contradicted or even denigrated in another. Inevitably, some of the keys will be more enlightening than others in relation to the specific character of the work they discuss, and this is reflected in the different running orders in which the keys are presented. But this order is fairly arbitrary, and the keys could be arranged in other ways.

The Historical Key provides much-needed ballast, offering a deep cultural context that places a work among similar artefacts, and in relation to a symbolic world view. But it fails to concern itself with the often intensely personal and transformative experience of art in the here and now. The Aesthetic Key allows for a meditation on what we see, but can seem to suggest that a work exists only in a detached realm, an illusion that the Biographical Key challenges by adding an all-too-human dimension, and the Market Key by relating the work of art to economic issues.

I could, of course, have included more keys. A Psychological Key was considered, because Sigmund Freud, Carl Jung and their followers have had an enormous influence on how art is interpreted. Instead, this approach has been incorporated into the broader categories of the Theoretical Key and the Experiential Key. A Political Key might have been useful, as would a Feminist Key, but much of the thrust of these approaches can be found in the Theoretical Key and the Sceptical Key. A Technical Key could also have been added, so as to discuss the materials and skills involved in the making of a work. But aspects of this practical dimension find their way into the Aesthetic Key and the Experiential Key.

The Seven Keys also aim to reflect the impact of perhaps the two most exciting recent contributions to the understanding of art. World art studies involve treating the field as truly global. They reveal the extent to which the art of diverse cultures and periods share characteristics, but also fundamentally differ in important ways as a consequence of specific geographical, social and religious factors. Neuroaesthetics, meanwhile, is informed by insights into the brain made possible by advances in the various neuro- and biological sciences. We can now draw on what we know about human evolution and its impact on cognition, and about the relationship between neural resources and the wider social and environmental context of art, thereby achieving a better understanding of how exposure to art deeply affects the way we think and feel.

Together, studies in world cultures and neuroaesthetics can serve to draw attention to the complex relationship between three interconnected levels of experience in understanding art: an individual's growth and adaptation; local cultural norms that are the result of collective responses to the forces of change; and species-wide universals grounded in the constants of human experience and dictated by biology. These givens of nature combine with the nurture of individual and contingent influences, solidify into cultural beliefs and forms, and are then subject to continuous modification under pressures from within and without.

If there is an original approach in the model proposed in this book it lies not in the subject and contents of the Seven Keys, but in the presentation of each of these familiar keys as being neither coupled together with the others nor as maintaining its intrinsically independent status. Each key has its own autonomy, while also working cooperatively with the others. Each should make you feel, in relation to the work of art it addresses, that it is the best, the most discriminating and the most rational approach, while at the same time also permitting you to see it as part of the interconnected network.

Each key is self-sufficient, but also dependent on the others. Giving too much independence to one key would mean little chance of coordination and communication, while allowing the keys too much interdependence would lead to a loss of global flexibility. Preference is given to the equivalent or complementary relation as opposed to the binary, contrary or oppositional. This places the

discussion of the works in a kind of in-between state, where it is possible to counter the two opposing tendencies within thought processes – the one trying to couple together different cognitive components, while the other seeks the maintenance of their intrinsic independent behaviour or status.

The keys are part of a web of processes in which opposites penetrate, are relational, and in a state of dynamic becoming. An ancient symbol for such complementarity is the Taoist yin/yang sign of traditional Chinese culture. This is a way of thinking that counters the idea that it must be a choice between oneness, sameness, uniformity or synthesis on the one hand, and multiplicity or plurality on the other.

A potential criticism of the approach proposed in *Seven Keys* is that because no hierarchy is offered – because we do not feel there is a synthesis or that an authorial preference has been given to one approach – a remote, static, neutral, uninvolved and rather arid relationship to the work of art is encouraged. But, as I have tried to make clear, what *Seven Keys* hopes to do is precisely the opposite. It considers each key as in a flexible and dynamic interrelationship with the others, because then it is possible to avoid the limitations imposed by a way of looking – or reading – that aims to produce a tidy fusion on the one hand, or a segregation into distinct parts on the other.

Using the keys together should allow for what might be called an infusion of different meanings, based on each work's complex multisensory and cognitive reality. The word key should therefore also bring to mind the meaning it has in the world of music, where an instrument is said to be 'in a key' – that is, the pitches are 'natural' to it – or that a composition is in a 'key', meaning it is in a group of pitches or a scale. *Seven Keys* should therefore perhaps suggest the way the word is used in *Songs in the Key of Life*, the Stevie Wonder album from 1976.

THE REAL THING

Nowadays, we can easily feel overwhelmed by the sheer scale and accessibility of the images the digital world makes available. At the time of writing (though figures change constantly), an average of 52,000,000 photos are uploaded to Instagram every day, and googling Mark Rothko presents 933,000 results in 0.55 seconds. Furthermore, we increasingly live both with and *within* the hyperreality generated by digital media, and to a truly unprecedented extent are now capable of shaking off the limitations imposed by material reality and bodily existence. The seductiveness of this dematerialized and disembodied state is enormous, and also potentially extremely dangerous, especially in a world facing ecological disaster.

In this context, a special reason for considering and cherishing the physical presence of a work of art and of valuing an encounter with one 'in the flesh' is that it can serve to draw us away from the dubious solace of virtual reality and back towards awareness of our sentient and embodied selves, moving and thinking in real time and space. Artworks can help to keep us in touch with dimensions of thought and experience that are increasingly forgotten, suppressed, belittled or ignored in a culture of conflicting obsessions. On the one hand, there exists a preoccupation with practical reasoning and algorithms, with the outsourcing of decision-making to increasingly 'intelligent' machines and with the pure virtuality of the Internet. On the other, there are human anxieties of coping with real-world ecological catastrophe, social unrest and violence, while also indulging in endless bouts of narcissistic emotional excess.

A work of art, unless it is expressly made for the digital realm, is a specific object whose primary habitat is the three-dimensional world. This means it is something to which we respond from within the framework supplied by our cultural context with our mind *and* body. So, it is worth pausing for a moment to reflect on how much we *don't* see – its texture, size, true colour, and so on – when we look at a photograph of an artwork in a book or on a computer screen.

By becoming a photographic reproduction in a book, a work of art has also been torn from its origins. It can now be infinitely duplicable in all kinds of contexts for which it was never intended. The two-dimensional whiteness of a book page is a space primarily

set aside for words, and for the kind of intellectual thinking words invite. By being so visually diminished and sited within a book or on a screen imitating a book, an artwork has been displaced into a context in which a certain kind of thinking will be tacitly prioritized – the 'reading' or intellectual mode. The intended habitat of a work of art, by contrast, is often the expansive and three-dimensional architecture of a walled room, and an encounter with it in such a space is far less constrained by intellectualizing attitudes (or should be – museum wall labels do a good job of transforming this space into a simulacrum of a book page).

But the possibility that we have already seen, or will ever see, all the works illustrated in *Seven Keys* is slim. Some are in Europe, others in the United States or in East Asia, although all except the Smithson (which is sited in a landscape) and the Salcedo (which exists only as a photograph) are in public collections. A purist would demand that we rely only on the experience we have of the actual work. But this is unrealistic, and even the direct encounter is influenced by what we bring with us in terms of prior knowledge and contexts – for instance, our memories, which include memories reinforced by photographic images of artworks, as well as our encounters with real ones – and also our own opinions that prejudice us in one way or another before we ever get to see the work 'in the flesh'.

And just what is 'in the flesh'? In *Seven Keys* one of the works no longer exists, and was always meant to be ephemeral, so it can now only be seen as a documentary photograph (see p. 238 [Salcedo]). Another is so remote that I confess I haven't seen it, and so am familiar with it only as a photograph – in this case, one taken at the time the work was made (see p. 156 [Smithson]). Other examples include a video that is exactly the same in two locations (see p. 204 [Viola]), a replica of a work now lost (see p. 56 [Duchamp]), a reconstruction of a work made specifically for a New York Gallery and now lost (see p. 132 [Kusama]), and one work that, except for the change in dimensions between the gallery-located work and the image in this book, presents the viewer with only negligible differences in visual characteristics, and therefore meaning (see p. 180 [Kruger]).

ART AS EXPERIENCE

The main premise of *Seven Keys* is that no great work of art has been made in order to be the pretext for rational explanation, documentation or study as sociological data. Instead, *Seven Keys* hopes to keep in view something that can often be obscured, not only as art becomes a marginal or insignificant part of people's lives but also when its study gets institutionalized and professionalized: *what we most value in our encounters with works of art is their potential as transformational experiences.*

Seven Keys assumes that any important work of art is not primarily determined by a structure of thought or of expression, and that the experience of art is fundamentally incommunicable, and cannot be accurately summarized as a clear idea or a named emotion. A work of art is better described as a structure of existence – *a structure of being itself.* Even a so-called Old Master painting safely housed in a muscum, whcrc it is transformed into 'sacred' patrimony and buried under a mountain of scholarly exegesis, remains an unstable and changeable entity existing in an interactive, experiential field with no end – one to which we can bring only shifting cognitive perspectives.

All great works of art are more like amorphous organisms that exist within an ecological system than like solid and fixed objects. They have the capacity to continuously expand towards us from their original location in a specific time and place on many levels – the physical, mental, emotional, spiritual, intellectual, practical, social, educational, institutional and financial – while simultaneously merging with other works of art. An encounter is much more than simply a way of enjoying leisure time or a pretext for amassing historical and theoretical data. It could be a matter of survival.

HENRI MATISSE

The Red Studio, 1911

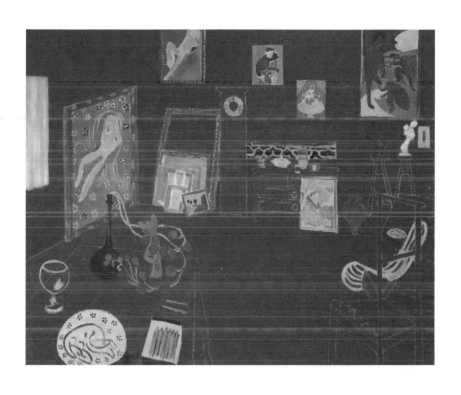

Oil on canvas, 181 × 219.1 cm (71¼ × 86¼ in.)
Museum of Modern Art, New York

In 2004, the last time such a survey was undertaken, *The Red Studio* was voted the fifth most influential work of modern art in a poll of experts. The bold linear simplification and the intensity of flat, all-over colour draw the painting into the world of decorative art, a category usually deemed inferior to fine art, though Henri Matisse (1869–1954) embraced it as something positive. Indeed, for him, the most important goal of the artist was not so much to make an image or tell a story, but rather to turn painting into a vehicle for the expression of emotion through emphasizing its visual properties. *The Red Studio* paves the way towards abstraction, although Matisse himself would never abandon making recognizable references to the visible world.

THE MARKET KEY

Since 1949, *The Red Studio* has resided in the Museum of Modern Art, New York (MoMA). It was first purchased in 1926 directly from Matisse by the British aristocrat socialite David Tennant, who was a personal friend of the artist. Tennant hung it in the bar of the fashionable nightclub he founded, the Gargoyle Club, on the top two floors of a townhouse in the louche Soho district of central London. Matisse was a member, and regularly visited in the early years.

In 1941, Tennant asked the Redfern Gallery to sell the painting, but no buyer could be found in war-torn Britain. Years later, the British abstract painter Patrick Heron, who was himself much influenced by Matisse, recalled encountering it in the basement, and bemoaned the fact that there had been no one enlightened enough in Britain to see how important it was. But Britain's loss was America's gain. *The Red Studio* crossed the Atlantic, risking the attention of the German U-boats, after it was bought by Georges Keller, an art dealer working at the Bignou Gallery, New York. The Museum of Modern Art, New York, finally purchased it in 1949 via that gallery.

The bar where *The Red Studio* hung at the Gargoyle Club must have been a smoky but convivial and very informal place, in sharp contrast to the austere temple of pristine whiteness, air conditioning and high security that is the Museum of Modern Art, where it ended up. This journey tells us much about how radical art has entered

the mainstream and is regarded as worth collecting. Nowadays, important works by Matisse rarely come up for sale, because they already feature in museum collections. However, in November 2007, a painting depicting one of Matisse's favourite models, *L'Odalisque, harmonie bleue* (1937), fetched $33.6 million at Christie's, New York, easily breaking the previous auction record of $21.7 million.

THE HISTORICAL KEY

In 1905, Louis Vauxcelles, a French art critic, dubbed Matisse *'Donatello parmi les fauves'* (Donatello among the wild beasts), as his paintings, as well as those by artists in the same exhibition, were in such intense colours and displayed such bold brushwork that they made even Impressionism and Post-Impressionism seem tame by comparison. But the group, which also included André Derain and Maurice de Vlaminck, embraced the insult and became known as the Fauvists. Matisse was now elevated to the position of de facto leader of the Parisian avant-garde.

Inspiration for *The Red Studio* came from the work of such Post-Impressionists as Paul Gauguin and Vincent van Gogh, who recognized the expressive potential of line and colour. At the same time, *The Red Studio* looks back in time, and beyond Europe, to non-Western techniques and styles. The flat field of colour and limited spatial illusionism evoke Byzantine icon painting or medieval stained glass, although this painting was in fact inspired by Matisse's encounter with Islamic art in an exhibition at Munich in 1910 and a subsequent visit to Seville.

The convention of showing paintings within paintings was a well-established one, although it was usually in the context of private collections or public exhibitions. There was also nothing new in artists choosing to make their own workplace the subject of their art. However, Matisse's studio is surprisingly devoid of the typical paraphernalia of easels, palettes and pots of paint. This work could almost be a depiction of an ordinary room. But we can see an open box of pastels in the centre foreground, and the many paintings provide a clue to the nature of the space. Indeed, there is sufficient detail to identify them as recent works by Matisse. The ceramic in the left foreground is also by him.

Several of Matisse's works painted in the years immediately before and after this one evoke Arcadia, the ancient Greek province that is a symbol of humanity living in bucolic harmony with nature, and one of these hangs on the wall to the right – *Luxe II* (1907–8; Statens Museum for Kunst, Copenhagen). But in *The Red Studio* itself Matisse has done away with conventional symbolism, and simply paints his own place of work, which, through the intensity of the saturated red and arabesque linearity, becomes not so much a studio as an exuberant expanse of luxurious colour. Indeed, Matisse has envisaged his own studio as a new kind of sacred space – one dedicated to the possibilities of pure painting as an expressive medium.

THE AESTHETIC KEY

The fact that this is a picture of Matisse's studio is far less important than the way in which he uses the mundane subject as the pretext for creating a powerfully visual experience. For Matisse, painting was above all a language of colour. In 1947 he wrote: 'I use colour as a means of expressing my emotion and not as a transcription of nature. I use the simplest colours. I don't transform them myself, it is the relationships which take charge of them. It is only a matter of enhancing the differences, of revealing them.'[1]

The normal organization of a painting into figure and ground, or solid objects and empty space, has been compromised by the wall-like effect of the red, which is flatly and evenly painted. Illusionistic, perspectival painting especially depends on visual organization into figure and ground, but once a surface is treated as two-dimensional, an artist can draw attention to the interplay between the 'positive' forms and the 'negative' or empty spaces. The red colour unites the whole contents of the painting – the table, chair, floor and walls – emphasizing the two-dimensionality of the whole surface. The pictorial convention of gathering detail at the centre of the visual field and focusing the eye on a specific area of the composition has been replaced by the dispersal of attention across the work's whole surface. Furthermore, while in Western paintings based on Renaissance principles there is usually more visual detail on objects depicted at the front of the composition, thereby mimicking the

viewing experience in real life, here, by contrast, the same treatment is given to the foreground, middle ground and background.

Matisse complicates the viewer's readings of pictorial space, trading on the irrepressible inclination to see a third dimension in a flat surface. The table in the foreground is drawn in such a way as to produce the spatial illusion of depth in accordance with the rules of Renaissance fixed-point perspective, but the chair on the right, i is rendered in 'reverse perspective', whereby lines converge towards the viewer, rather than towards some point at infinity. This was a system often used in Christian icons, Persian miniatures and East Asian art. But Matisse undermines the credibility of the virtual space he suggests, and it seems only tentatively presented.

An artist usually uses line to organize space into coherent, understandable parts, but here colour seems to be dissolving the solidity of the linear structure. In fact, Matisse did not create the white lines in *The Red Studio* by adding paint, but rather by leaving exposed the ground of the gesso – the primer used to seal the canvas – as if he wanted to cut holes in the picture's illusion while also maintaining vestiges of it. Looking at *The Red Studio* can be a disconcerting experience because the work does not conform to the normal rules of viewing a picture. What is solid, and what isn't? What distances and spaces are being described? The dominant sensations are of purity and simplicity, as if Matisse has shaken off much of what he has learned in order to begin again with more primal means.

THE EXPERIENTIAL KEY

The mind can deliver a sense of detachment from what is observed, which helps to supply certainty, but it can also produce the feeling that we are existing in the middle of things. It is the latter sensation that Matisse's art seems to encourage. We are made aware of a less differentiated kind of vision, which especially brings to attention the ground, or the negative space, that normally goes unnoticed within the perceptual field in everyday situations and also in more conventional paintings. When looking at a scene, we unconsciously define and structure it in terms of objects of focused attention set off against a separate ground that is construed as boundless, shapeless,

homogeneous. This ground is of secondary importance to the objects of attention, and, as a result, is usually ignored. Such organization of space into figure and ground is what psychologists term a visual gestalt, a structured whole.

Matisse creates a surface plane in which positive forms and negative space are confused, thereby undermining our tendency to produce a gestalt based on separation. Rather, he suggests a structure that incorporates awareness of an undifferentiated field. In this sense, *The Red Studio* is about wholeness – about bringing everything together, and Matisse increases this effect by decentring visual perception, which in normal optical conditions is divided into a small area of focused, detailed information, and a much greater area of unfocused and unconscious perception. Matisse instead gives the impression that we are perceiving the whole visual field with equal attention.

This is a fairly big painting, so when we stand in front of it, the red fills our field of vision. Indeed, the feeling of envelopment, or of the invitation to enter into the painting, is even evident on the level of the image content – Matisse has placed a box of pastels towards the front that seems to encourage us to lean in, pick it up and start drawing. Even though Matisse maintains vestiges of a linear, grid-like superstructure, he uses colour to confuse us about our sense of location, of where things are in relation to where we are. Indeed, the painting's linear structure seems barely strong enough to contain the pulsing red mass.

Physiologically, colour is produced by our retina rather than by things – in other words, it is created by our minds as a response to light frequencies. As the visual dimension of light, colour is intrinsically shifting, generating a kind of pulsing, undulating space that requires the constant, and usually unconscious, checking and verification of the relationship between things.

Being both material and sensual, colour plays directly on our emotions. Indeed, colour helps breaks down the boundaries that separate us from each other and the world. Red is an especially strong visual stimulus. It seems to advance towards us into space, thereby implying something that is potentially threatening or enveloping. Green, meanwhile – which we see in the house plants – has an altogether more docile effect, and is the complementary colour to red.

When these two colours are seen near to each other, they seem to enhance their own chromatic properties. But if red advances in space, then green sits somewhere a little behind. The small areas of blue, by contrast, lie further back in the picture. In other words, rather than using the geometric trick of perspective, Matisse has exploited the potential of colour to generate space in a directly optical fashion, creating space in our eyes and in our interaction with the painting.

Matisse claimed he had no idea where the red in his painting came from – the walls of his studio certainly weren't red. Apparently, the painting was originally predominantly blue grey, which would correspond more naturalistically with the white walls of an actual studio – this stage can still be seen around the top of the clock and beneath thinner paint towards the left-hand side of the work. An empirical explanation is that the red is the result of the phenomenon known as simultaneous contrast. If you look out on a green garden and then look back into the room you are in, you will see everything in the room tinged with the complementary to green, which is red. This would make Matisse's chromatic transformation of his studio not so much a flight of the imagination as a sensitive and seemingly unconscious representation of his psycho-visual experience.

THE THEORETICAL KEY

Matisse is often dismissed as a purely retinal artist – one who was only interested in aesthetic pleasure – and did not concern himself with abstract theory. But perhaps because his work abandoned so many of the conventions that firmly established painting as the more highly regarded fine art, he felt it was important to provide a theoretical justification for his radical new aesthetic.

The core of Matisse's theory was the idea that the plastic language of painting can be compared to music. Music is not mimetic – it does not imitate sounds in the world – and, similarly, painting should not imitate the visible forms of the world but rather exploit the 'visual music' of shape, form, line, colour and texture, and the compositional principles of harmony, balance, emphasis, rhythm, complexity, etc. Through its own intrinsic abilities to resonate directly with our emotions, painting was thereby cast as a powerfully expressive medium.

'Composition is the art of arranging in a decorative manner the diverse elements at the painter's command to express his feelings,' Matisse wrote in 'Notes of a Painter' (1908).[2] 'In a picture every part will be visible and will play its appointed role, whether it be principal or secondary.' Because colour was traditionally considered an inferior aspect of the painter's craft, Matisse was keen to explain the central role he apportioned to it in the new art: 'The chief function of colour should be to serve expression as well as possible,' he declared. 'I put down my tones without a preconceived plan.... The expressive aspect of colours imposes itself on me in a purely instinctive way.'[3]

This formalist conception of art supposes that it functions timelessly, and within its own autonomous world, sequestered away from other symbolic social domains, such as the world of religion. It depends on an essentialist standpoint – on faith in the purity of the image as a vehicle leading to absolute and universal truth. In terms of artistic practice, this means that each artwork must realize its own essential nature by purging itself of everything that was not specific to it, and by explicitly revealing its materials and codes.

THE BIOGRAPHICAL KEY

Henri Matisse was born in 1869 in Le Cateau-Cambrésis, northern France. He initially trained as a lawyer before moving, in 1891, to study art in Paris. There he was taught by the Symbolist painter Gustave Moreau, who had a great influence on his work. In 1904, Matisse's first one-man exhibition took place at the gallery of the dealer Ambroise Vollard. The following year came the *succès de scandale* of the Salon d'Automne exhibition in Paris, when Matisse was dubbed a *fauve*. After that he travelled widely in Italy, Germany, southern Spain and North Africa. His subsequent paintings especially reflect the impact of his encounters with Islamic art.

In the spring of 1909, a series of commissions from the Russian collector Sergei Shchukin and a new contract with the prestigious Galerie Bernheim-Jeune in Paris led Matisse to decide to move his studio to a location that could offer greater peace and quiet, one where he could dedicate himself entirely to painting. The studio in this painting is in the garden of this new home, the *maison bourgeoise*

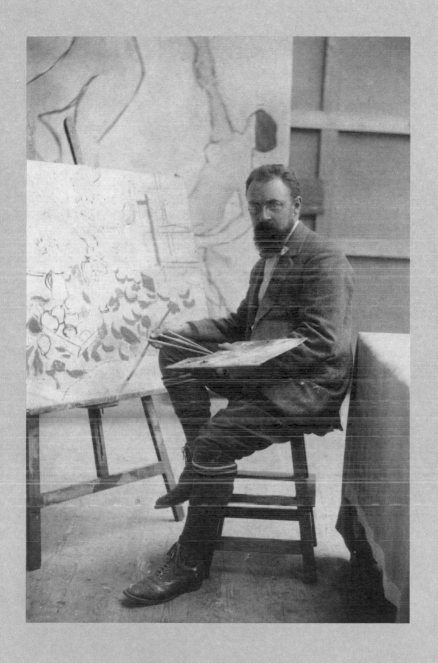

Henri Matisse in his studio at Issy-les-Moulineaux, 1909 or 1912. Photographer unknown

not far from Paris, located at 92, avenue du Général de Gaulle in Issy-les-Moulineaux. Matisse lived there with his wife and three children between 1909 and 1917, making over sixty paintings, including several masterpieces, such as *Dance* and *Music* (both 1910; State Hermitage Museum, St Petersburg), which were commissioned by Shchukin.

THE SCEPTICAL KEY

Today, Matisse's oeuvre has achieved canonical status, but it remains problematic. In *The Red Studio,* colour fills the canvas, and everything is reduced to crisp and clear contours. But this field of colour is blandly uniform and lacks nuance when compared with the works of renowned colourists such as Titian, Eugène Delacroix or Claude Monet. The effect is predominantly decorative in nature, and, although Matisse happily embraced the idea of the decorative, the result is that often his work doesn't rise above the ornamental and fails to supply any meaningful experience beyond the simply pleasurable – a condition that risks excluding it from the highest rank of art.

In 1905, Matisse may have seemed like a 'wild beast' to some people. When his works were first shown in the United States during the 1913 'International Exhibition of Modern Art' (the 'Armory Show') in New York City, the conservative art students from the Art Institute of Chicago burned him in effigy. But already by that time in Europe Matisse's work was not considered radical enough by the avant-garde. While he was peacefully painting his visions of sensual fulfilment and aesthetic autonomy, Europe was lurching towards the madness of the First World War. The red of *The Red Studio* should have been the red of spilt blood or socialist revolution, but instead Matisse was happy to pander to the desires of the bourgeois collector, claiming that formalism – the self-sufficiency of the self-reflective world of the artist and the nurturing of a refined sensibility – were art's highest purpose, and that his work was to be like an armchair for a tired businessman or man of letters. The idea that *The Red Studio*'s very lack of usefulness, and celebration of the exuberantly decorative, supply the basis for its continued cultural value are increasingly questionable. Almost no contemporary artist would consider it valuable to pursue this kind of vision of painting. Too much has been left out.

FURTHER VIEWING

Barnes Foundation, Philadelphia
Rosary Chapel, Vence
Musée Matisse, Nice
Musée National d'Art Moderne, Centre
 Georges Pompidou, Paris
Museum of Modern Art, New York
State Hermitage Museum, St Petersburg

FURTHER READING

Dorthe Aagesen and Rebecca Rabinow
 (eds), *Matisse: In Search of True
 Painting*, exh. cat., Metropolitan
 Museum of Art, New York, 2012–13
Stephanie D'Alessandro and John
 Elderfield (eds), *Matisse: Radical
 Invention, 1913–1917*, exh. cat., Art
 Institute of Chicago and Museum
 of Modern Art, New York, 2010
John Elderfield, *Henri Matisse:
 A Retrospective*, exh. cat., Museum
 of Modern Art, New York, 1992–93

Jean-Louis Ferrier, *The Fauves: The Reign
 of Colour*, Pierre Terrail, 1995.
Jack D. Flam, *Matisse on Art,* University
 of California Press, 1995
Dan Franck, *Bohemian Paris: Picasso,
 Modigliani, Matisse, and the Birth of
 Modern Art*, trans. Cynthia Liebow,
 Grove Press, 2003
Ellen McBreen and Helen Burnham,
 Matisse in the Studio, exh. cat.,
 Museum of Fine Arts, Boston, and
 the Royal Academy of Arts, London,
 in partnership with the Musée
 Matisse, Nice, 2017
Hilary Spurling, *Matisse the Master.
 A Life of Henri Matisse: The
 Conquest of Colour, 1909–1954*,
 Knopf, 2005
Sarah Whitfield, *Fauvism,* Thames
 & Hudson, 1991

PABLO PICASSO

Bottle of Vieux Marc, Glass,
a Guitar and Newspaper, 1913

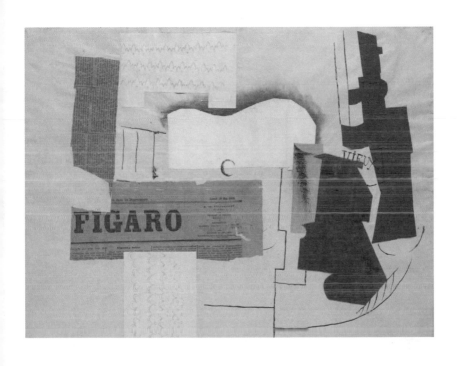

Printed papers and ink on paper, 46.7 × 62.5 cm (18¼ × 24½ in.)
Tate, London

33

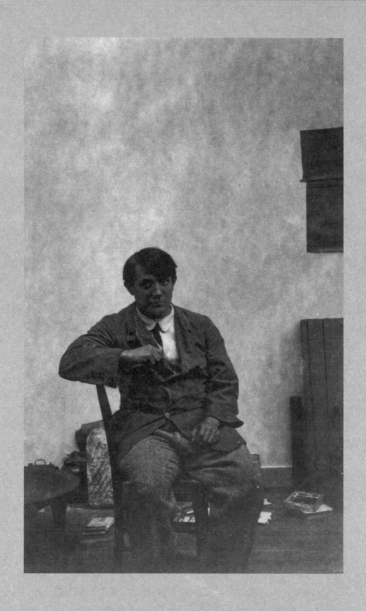

Pablo Picasso in his studio, *c.* 1914. Photographer unknown

Pablo Picasso's (1881–1973) paintings have repeatedlty commanded record-breaking prices at auction. But *Bottle of Vieux Marc, Glass, Guitar and Newspaper* is a small, very fragile work, one of Picasso's first *papiers collés*, or collages (from the French *coller* [to glue]). When looking at it, we are more than usually likely to be aware of the materials out of which it is made. Cubist works like this launch an assault not only on the integrity of the image itself, but also on conventional notions of the artist's skill. Fragments of everyday modern life literally adhere to the work's surface. It seems to pose a threat to the idea of art as the embodiment of timeless values.

THE BIOGRAPHICAL KEY

Pablo Picasso was born in Malaga, Spain, the son of an artist, under whom he trained before studying at the art academy in Barcelona. In 1904, Picasso settled in Paris, where he lived for most of the rest of his life.

Picasso's private life is often a useful guide to the meaning of his work, and he himself believed his art was akin to a diary. But, during the period when he made *Bottle of Vieux Marc, Glass, Guitar and Newspaper*, there are few obvious links between his art and the events in his life. Nevertheless, it is still worth considering the specific context for this work's creation, because only then is it possible to fully appreciate Picasso's intentions and motivation. For example, in May 1913 Picasso's father died, and so his son returned to Barcelona for the funeral. He was devastated by the death of the man he seems to have both loved and hated. His father was a painter, but not very successful, and there is an apocryphal story that he was so overcome by the genius of his barely adolescent son that he handed Pablo his palette, paints and brushes, never painted again, and set himself the task of grooming his son for greatness.

Bottle of Vieux Marc, Glass, Guitar and Newspaper was almost certainly made rapidly, and then immediately consigned to a plan-chest or portfolio, where it was more or less forgotten. As a result, its exact date is not known, and it was initially dated to 1912 or 1913. But the consensus today is that it was probably made some time

during 1913 either in Céret in the French Pyrenees, where Picasso spent the summer of 1912 and the spring of 1913, or in his studio on boulevard Raspail in Montparnasse, Paris, where, between 1912 and 1913, he made a large number of such paper collages.

THE AESTHETIC KEY

The different papers comprising this collage have their own special textures as well as colours, and because they are glued on top of the blue paper that serves as the background support, this also introduces an element of tactile low relief. The blue paper has cockled slightly where the glue has contracted the paper, so that the surface isn't flat, and casts small shadows, adding to the sense of vulnerability and imperfection.

Bottle of Vieux Marc, Glass, Guitar and Newspaper juxtaposes horizontal, vertical and curved lines, producing the impression that the work is built out of interlocking parts. Through the use of cut-out pieces of paper, Picasso ensures that a flat and two-dimensional plane is perceived, and the work is a balanced arrangement of shapes. At first, there seem to be no perspectival lines producing the illusion of three dimensions. However, in three areas Picasso used charcoal to suggest shadow – above the guitar in the upper middle, around the guitar's sound hole, and on a wine glass to the right of the composition. This sets up a moderately illusionary spatial dimension, one that serves to produce a heightened visual tension through its ambiguous and contradictory status. The newspaper in this collage is both a representation of one resting on a table *and* a fragment of real newspaper, *Le Figaro*. It is therefore not just an image of what it represents, but also a part of the thing itself.

Bottle of Vieux Marc, Glass, Guitar and Newspaper is a dialogue or play between the perception of flatness and the vague vestiges of the familiar codes of representation, and between abstract shapes, or shapes that don't seem to represent anything, and those that do. But, by focusing so intensely on form alone – on trivial objects taken from his usual environment – and by suppressing any narrative content, this collage suggests that art need not depend on the world of objects and can be object-less or abstract – and that sufficient

aesthetic pleasure and critical meaningfulness lie in shapes and colours arranged on a flat surface.

THE HISTORICAL KEY

Although in terms of the history of art the subject of *Bottle of Vieux Marc, Glass, Guitar and Newspaper* is a very familiar one – it is a 'still life', a picture of an arrangement of the objects indicated in the title – what it does to this familiar genre is unprecedented. The revolutionary nature of this and similar works made by Picasso and Georges Braque lies not in the subject matter but in the way that the artists boldly deconstruct form and flout the norms of medium and technique. They had an enormous influence on the subsequent evolution of modern art.

The collage technique showed artists the possibilities inherent in directly exploiting the raw, non-artistic materials of modern life, thereby implying that a new kind of realism had been born (see [Malevich] p. 52). It also severed the connection between modern art and traditional notions of craft and technical skill. Furthermore, collage introduced the idea, fully developed Marcel Duchamp (p. 56) of the 'readymade' – that is, the possibility of using something already in existence rather than created by the artist to make art – thereby transforming the artist's role from fabricator to nominator, someone who makes a selection and then presents it as a work.

Bottle of Vieux Marc, Glass, Guitar and Newspaper was created during a crucial period in the development of Picasso's oeuvre, and it marks the transition from what is now called Analytical to Synthetic Cubism, or from works that are abstracted representations of observed things seen from multiple viewpoints and often reduced to almost abstract signs, to works that are primarily inventions, with the additions of real materials. At the time, critics discussed the potentially mystical meanings behind the fragmented fields of Cubism, and also related it to the new science of the fourth dimension, which was a much-debated topic. This period saw the invention of the automobile, the aeroplane, the telephone, the wireless radio, the X-ray and electricity for the home. Einstein's theory of relativity was also revealed to the world, transforming scientific knowledge.

All these innovations seemed to serve as contexts for the revolution that was Cubism.

Works like this were also interpreted as the visual equivalents of an anarchist bomb. Society was under threat from new, radical and dangerous political movements, such as communism, anarchism, socialism and nationalism. This wider context implies that in the field of visual art Cubism represented the same forces that drove the revolutionary social and political transformations taking place in European society as a whole.

THE EXPERIENTIAL KEY

Picasso overturns the conventional notions of pictorial space, throwing us into an uncomfortable space of uncertainty. The familiar and innocuous subject matter has been chosen by Picasso precisely because it doesn't deflect our attention from his primary goal, which is to construct and deconstruct the language of picturing itself – the very act of representing. This picture is a kind of puzzle, and we must decipher its parts. As Picasso declared: 'Anything new, anything worth doing, can't be recognized.'[4]

The overall sensation we are likely to have is of an arrangement of shapes and lines on a surface that have some relationship to recognizable objects in the world, but one that has become extremely abstracted. Accessing the usually obvious dimension to a picture – its contents – is now fundamentally problematic. When is a shape a representation of a thing, and when it is just a shape? Picasso deliberately confuses readings of the spatial organization. What is a figure and what is ground? By forcing us to try to make sense of what we see, we are obliged to take on a more engaged role. For example, we must try to work out the meaning of the curious dark green-brown shape on the right, created by sticking a piece of paper to the blue paper ground. Is it a shadow cast by the liqueur bottle or some object?

Bottle of Vieux Marc, Glass, Guitar and Newspaper makes the connection between the linked activities of thinking and seeing in relation to art much more manifest. We perceive the shapes, and then we make sense of them by matching what we now see to what we have already seen – we *re*-cognize the rectangle with printed

letters on it as a fragment of newspaper, and the hand-lettering to the right as belonging to the label on a bottle. In a sense, then, this collage makes us re-enact the usually unconscious processes through which we scan the visual field and organize it into a coherent gestalt. Picasso's work therefore demonstrates that we see according to habits, both learned and biological, and that one role of art is to wrest us free of such habits.

THE THEORETICAL KEY

This work turns a picture into a script to be read. Looking at *Bottle of Vieux Marc, Glass, Guitar and Newspaper* isn't so much an optical experience as a reading of a message. It involves the activity of decoding the visual. Picasso deploys discrete visual signifying units, which are analogous to words or phonemes in a written or spoken language, because the various components of the work's sign system draw their meaning from their position within a series of juxtapositions and oppositions. Picasso's treatment of the wine glass, for instance, explores the codes conventionally used for depicting such an implement, shifting within the same object from a rendering as a flat, linear outline to one using modelling. He uses the same piece of newspaper twice – once to represent a newspaper, and once, by folding it over, to function as part of a guitar. In other words, he uses the same material to signify, or represent, two different things.

Cubism can be understood as a visual form of semiotic theory – the study of signs. In the early twentieth century the founder of modern structural linguistics Ferdinand de Saussure proposed that any verbal sign is composed of two parts: the *signifier,* or the spoken or written word that is used as the vessel; and the *signified*, or the meaning itself. Saussure emphasized that the two are not organically or inevitably linked, and that most signs depend on the establishment of a convention through which, for example, the word 'bottle' is used in English as a *signifier* for the glass object used to hold liquid – a *signified*. The dual nature of the verbal sign can also to some extent apply to visual signs, in that, for example, the image of a bottle rendered in fixed-point perspective is not the same as the bottle itself. In other words, images are representations or coded

systems through which the world is described. Furthermore, Picasso reveals the extent to which any visual sign is fluid and tends to be ambiguous, unlike verbal signs.

During the same period that Saussure was developing his theory, the philosopher C. S. Peirce was also exploring semiotics, but he sought to address the more complex nature of non-linguistic signs, and proposed that there are three kinds of sign: *symbol, index* and *icon.* The first has no actual resemblance to its referent and works through making a learned connection between it and the referent. This sign is like the words of a language discussed by Saussure. The indexical sign, meanwhile, is not linguistic, and works by having a direct existential link with its referent, as when a handprint indicates the presence of the person who made it. Icons, of which Peirce considered there to be three kinds – *image, metaphor* and *diagram* – work through having some kind of similarity to their referent.

In *Bottle of Vieux Marc, Glass, Guitar and Newspaper* Picasso unconsciously exploits the three types of iconic sign. He uses cut-up newspaper to function directly as an *image* of itself, while the guitar, bottle, glass and table are also signalled through simplified images. He also uses *metaphor*, where something is used to stand in for, or has a parallelism with, the referent – for example, when he draws three short parallel lines, creating an analogy with the frets of a guitar. But these lines only really read as part of a guitar because Picasso especially exploits the *diagrammatic* sign, in which information is represented structurally, according to a visualization in which internal relations represent their relations to something by visual analogy. Whereas in Western art this kind of still-life subject had customarily been made through the *image* sign, this collage *diagrams* what it represents.

THE SCEPTICAL KEY

Picasso's abandonment of the norms of representation render *Bottle of Vieux Marc, Glass, Guitar and Newspaper* little more than a momentarily entertaining visual puzzle devoid of any expressive value. He used the materials that surrounded him, and this can suggest that, at least in principle, anybody could have made the collage,

so it challenges the idea that a work of art should show evidence of training and technical skill. Furthermore, while *Bottle of Vieux Marc, Glass, Guitar and Newspaper* poses tractable problems for the viewer, those it presents for the conservator are likely to be insurmountable. The cheap materials used will not endure, and they already present serious problems for the conservation department of the museum tasked with the unenviable responsibility of preserving the work.

When art becomes so banal – so throwaway – it effectively collapses the difference between art and life, and risks divesting the former of its cultural value, or its ability to address the latter. We should therefore weigh up what has been gained against what is lost and conclude that, while Picasso's collage technique was certainly novel and provocative, it ultimately signified a dead end. Indeed, it is clear that Picasso was well aware of this fact because he soon abandoned this practice.

THE MARKET KEY

In 1907, the Paris gallery owner Daniel-Henry Kahnweiler signed contracts with Picasso and Braque to buy their works as they painted them. This agreement meant that Picasso was freed from the struggle to sell works and please patrons. With few exceptions, during this crucial period the two artists exhibited only at Kahnweiler's gallery. In 1913, however, Picasso also participated in the important 'Armory Show' in New York, as well as exhibiting at the Thannhauser Moderne Galerie in Munich. These were both events that signalled the beginnings of Picasso's international fame.

But at the time that Picasso made *Bottle of Vieux Marc, Glass, Guitar and Newspaper* he was a struggling artist, using whatever was at hand that cost him nothing. By the time he sold the work during the Second World War to the film producer Pierre Gaut, who purchased it directly from his studio, Picasso was wealthy and world famous. In 2015, an unknown buyer paid a record-breaking $179 million for *Women of Algiers* (1955) at Christie's, New York.

In the late 1950s, the Tate Gallery, London, was looking for a collage by Picasso from the key years from 1911 to 1915. It is customary in the UK for a national institution like Tate, which acquires

works of art using taxpayers' money, to request and to receive a 10 per-cent reduction on the asking price. In this case, however, Gaut agreed to 7 per cent. The money was paid in Swiss francs (120,960, or about £9,900, at the time; today about £192,000). In 1961, the work entered the Tate Gallery's collection, and, as it had never been exhibited in a gallery, it was called simply *Glass, Bottle and Guitar*. In a catalogue from 1981 it becomes *Guitar, Newspaper, Wine-glass and Bottle*. But the title given on the gallery's website, on the wall label of the gallery and on the postcards sold in the museum shop indicate that the definitive title is now *Bottle of Vieux Marc, Glass, Guitar and Newspaper,* and that the date is 1913.

FURTHER VIEWING

Metropolitan Museum of Art, New York
Musée National d'Art Moderne, Centre
 Georges Pompidou, Paris
Musée National Pablo Picasso, Vallauris
Musée Picasso, Antibes
Musée Picasso, Paris
Museo Picasso Malaga
Museo Reina Sofía, Madrid
Museum Ludwig, Cologne
Museum of Modern Art, New York
Museu Picasso, Barcelona
State Hermitage Museum, St Petersburg
Tate, London

The Mystery of Picasso (1956),
 a documentary directed by
 Henri-Georges Clouzot
Surviving Picasso (1996), a film directed
 by James Ivory

Neil Cox, *Cubism*, Phaidon, 2000
Pierre Daix, *Picasso: Life and Art*,
 Icon Editions, 1994
Michael C. FitzGerald, *Making
 Modernism: Picasso and the Creation
 of the Market for Twentieth-Century
 Art*, University of California Press,
 1996
Rosalind E. Krauss, *The Picasso Papers*,
 MIT Press, 1999
Roland Penrose, *Picasso: His Life
 and Work*, 3rd ed., University
 of California Press, 1981
Christine Poggi, *In Defiance of Painting:
 Cubism, Futurism, and the Invention
 of Collage*, Yale University Press,
 1992
John Richardson and Marilyn McCully,
 A Life of Picasso, 3 vols, Jonathan
 Cape, 1991–2007

FURTHER READING

John Berger, *The Success and Failure
 of Picasso*, Pantheon Books, 1989
Pierre Cabanne, *Cubism*, Editions
 Pierre Terrail, 2001

KAZIMIR MALEVICH

Black Square, 1915

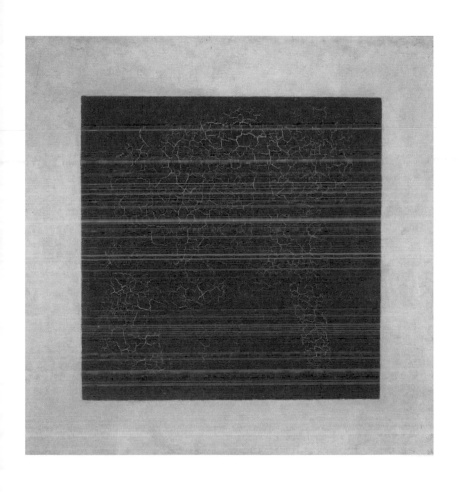

Oil on linen, 79.5 x 79.5 cm (31¼ × 31¼ in.)
State Tretyakov Gallery, Moscow

Black Square is the most extreme statement made by Kazimir Malevich (1878–1935) towards what he called the new 'objectless' art. It is a deliberately intimidating work, negating much of what we expect from an encounter with a painting. There is no image, but, whereas in most abstract works we would at least be able to contemplate the artful play of shape and colour, here we see only a simple black square painted on a white square ground. The work lacks compositional complexity and is like a perceptual blind spot. The fact that two years after the 'Last Exhibition of Futurist Painting 0.10' in 1915 in Petrograd (St Petersburg) at which it was shown Russia plunged into revolution and civil war lends weight to the idea that *Black Square* is prophetic – a sign of the death of all outdated symbols and the 'icon' for a new society.

THE THEORETICAL KEY

Black Square is seriously underdetermined, that is, it contains less than the amount of evidence needed for certainty regarding its meaning. The painting's unprecedented simplicity spawns a plethora of complex, competing and incompatible interpretations, which pour in to fill the void left behind by the lack of figurative imagery and formal complexity. The work's meaning therefore seems to lie outside the frame established by the material object – the painting itself – and resides instead within the wider social context, and among the many meanings originating with the artist, the critics, the art historians and the viewers.

Black Square stages a quiet drama between the invisible and the visible, darkness and light, obscurity and clarity. The blackness functions as a deletion or a concealment of what is normally visible in painting, and this forces upon the viewer a heightened awareness of what lies beyond the visible, or beyond comprehension. *Black Square* conveys a powerful sense that something is missing, has been concealed, erased, or cannot or will not find shape. The blankness of the black square is like a psychic void, akin to a state of depression or trauma, or perhaps, conversely, of ecstatic liberation. Indeed, whether this obscure domain is something benevolent or malevolent depends on the belief system through which such an experience is assessed.

In secular terms, what Malevich aimed to present was the visual equivalent to the idea of the 'zero', or a 'no-thing' – a 'non-object'. It is therefore about the *reductio ad absurdum* of painting as a system. He reduces the painting medium to an essence, at which point painting as a genre implodes. *Black Square*, in this sense, functions as an idea, and it is of no real importance which one of the four extant *Black Squares* made by Malevich one looks at. What matters is the mentally constructed principal – the conception existing in the mind as a result of intellectual understanding and awareness.

As far as Malevich was concerned, the meaning of *Black Square* was clear. His friend, the artist Varvara Stepanova, noted in his diary in 1919: 'If we look at the square without mystical faith, as if it were a real earthy fact, then what is it?' To emphasize its affinities with sacred art, for the exhibition of the painting in Petrograd in 1915, it was hung high up across the corner of the gallery, surrounded by other more visually complex works by Malevich. This location consciously evoked the position of a religious icon in a Russian home, implying that the painting was meant to have sacred implications, or, at least, that within the new vision of art it was to be given a value similar to that attributed to a Russian Orthodox icon. As Malevich wrote in an autobiographical note, two years before his death: 'My acquaintance with icon painting convinced me that the point is not the study of anatomy and perspective, nor in depicting the truth of nature, but in sensing art and artistic reality through the emotions. In other words, I saw that reality or subject matter is something to be transformed into an ideal form away from the depths of aesthetics.'[5]

THE HISTORICAL KEY

Malevich belongs to a generation of European artists that includes Wassily Kandinsky and Piet Mondrian, who considered it essential to abandon representational imagery derived from the perceivable world in order to create a more purely spiritual, inward-looking art. But *Black Square* seemingly marks the point of no return.

Both Matisse (through his liberation of colour) and Picasso (through jettisoning so much of the paraphernalia of representation) had already challenged, but never rejected, the idea that art needed to

stay loyal to some kind of external visible reality. Malevich took the next step. Especially important in this regard was Cubist collage, like the one by Picasso discussed earlier (p. 32, which introduced the idea of lying flat shapes of extraneous material on to a surface. The overt two-dimensionality of these cut-outs had the effect of countering illusionism, while also introducing spatial dynamics that were not based on imitating the three-dimensional world. Malevich adopted the collage effect in oil paint, simplified its compositional devices, freed colour from its role as the surface of objects and jettisoned cues to external sources.

Malevich declared that his painting was free of attachment to the objects of the visible world. Of *Black Square*, he wrote: 'The white margins are not margins framing a black square, but merely the sensation of desert, the sensation of non-existence, in which the square form is the first objectless element of sensation. It is not the end of Art, as people, think, but the beginning of actual existence.'[6] What he meant was that his radically reductive work should be understood as both an end and a beginning. It was the annihilation of all previous ideas concerning the meanings and goals of art, and also the first signal that a new art, which Malevich dubbed Suprematism, had been born. This, he further announced, was the only art that could truly speak for the present and the future. These Suprematist works consist of flatly coloured circles, rectangles and other geometric shapes, usually placed diagonally, suspended within the flat, white, rectangular space of a canvas. This minimal compositional system was meant to be read as a self-contained world of purity and timeless value.

The idea of making such a simple visual statement seems to have already been explored by Malevich in 1913, when a black square appeared as part of his scenery design for a Futurist opera called *Victory over the Sun*. Between 1923 and 1924, Malevich made a second *Black Square*, which was a different size from the original, while he created a third, in 1929, probably for an exhibition at the State Tretyakov Gallery because the paint surface of this one was already badly cracked. A fourth, also smaller, example, painted in the late 1920s or early 1930s, was carried at Malevich's funeral in Leningrad in 1935, and his friends and disciples buried his ashes in a grave marked with a black square.

THE AESTHETIC KEY

No reproduction can do justice to the full aesthetic impact of *Black Square that* is delivered directly through its austere, uncompromising presence. The square format and black colour force viewers to consider what is optically present, rather than any symbolic or expressive meaning, and what they see is unprecedentedly simple and minimal. By rejecting representation and reducing form and colour to such a pared-down state, Malevich expunges his personality. We no longer need to consider the artist as an individual, and instead,what is important is how the work encapsulates in especially clear visual form the principal task of the Modernist painter: the return of art back to its essential nature, the properties of the medium. In this way, *Black Square* is a statement about flatness, about what a painting really is.

But in fact, the so-called black square is neither exactly square nor entirely black – none of the square's sides runs parallel to the right-angled frame, nor is the seemingly black hue really black, as it is made from mixing various colours. But the slightly skewed nature of the square actually serves to bring a welcome imperfectness to what otherwise would be a rather sterile exercise in austere reductiveness. Furthermore, very soon after it was painted, the surface of *Black Square* started to crack, and today its original pristine condition can only be gleaned from the better state of subsequent versions, which have survived in a more robust state because Malevich wisely applied a varnish.

One earlier painting has long been evident below the fissured latticework of the surface coat – a Suprematist composition of geometric forms set at slight diagonals – but, in 2015, experts using X-ray analysis discovered another even earlier painting underneath in Malevich's Cubo-Futurist style.

THE EXPERIENTIAL KEY

It is problematic to a seek aesthetic or sensual grounds for appraising the value of *Black Square* as a great work of art, or to interpret it in relation to specific historical contexts. What the first viewers

experienced, and what we still experience – if we are unfamiliar with the subsequent history of art – is akin to hearing a language that cannot be understood, or like finding ourselves in a strange, unfamiliar and perhaps inhospitable place. Malevich aimed to create a space free from meaning, a psychic void into which we lose ourselves – what he called a 'desert'. He intended to alienate and wanted to prise us from our habitual role as mere spectator, and to force us into the more uncomfortable, but potentially emancipating, role as an engaged participant. For, because *Black Square* lacks the usual cues or prompts, we are obliged to seek our own connections, our own meanings.

But it is the concept rather than the work that counts, a truth attested by the different versions of *Black Square* that Malevich painted. The concept made it a symbol of utopian idealism. Indeed, the currently deteriorated condition of this example, the first *Black Square,* seems to speak poignantly of the inevitable inability of any *material* object to endure through time – in contrast to an idea, which, as long as there are those to discuss and promote it, will remain uncorrupted.

But the cracked surface that now disfigures this *Black Square* cannot and should not be ignored in favour of an abstract, dematerialized concept. The deterioration has become part of what we experience. The chance effects caused by the instability of the medium contribute additional feelings and associations, suggesting vulnerability, abjectness and decay – emotions that Malevich himself certainly did not intend, but that now are salient components of any response to this work. In this sense, *Black Square*'s experiential status has radically shifted. The painting is no longer a 'zero-point', and an encounter with it reminds us that experience also has a history. It evolves, not only for each individual but also for culture in general.

THE BIOGRAPHICAL KEY

Malevich's life overlaps with some of the most dramatic events of the early twentieth century, and this work embodies these world-historical changes. Malevich's parents were Poles who fled Poland in a period of unrest and moved to Kiev in the Ukraine, which at

Kazimir Malevich, *c*. 1925. Photographer unknown

that time was part of the Russian Empire; their son would always sign his works Kazimierz Malewicz – the Polish version of his name. In 1904, Malevich moved to Moscow, and although he only ever travelled once outside Russia (later, in the 1920s) he quickly assimilated the most radical tendencies in Western European art. Henri Matisse's *Red Room* (1908; State Hermitage Museum, St Petersburg) was in the collection of Sergei Shchukin, the Russian collector who had commissioned it, and he was in the habit of throwing the doors of his palatial residence in Moscow open to visitors. In this way, Malevich was able to see the Matisse, in addition to many other works by the Parisian avant-garde, without having to leave Moscow. For example, Shchukin also owned a number of Picasso's paintings from both the Blue Period and Rose Period, which explored monotonal colour, and several Cubist works.

Malevich was a mystic who believed the artist's principal purpose was to find visual form for the transcendental and eternal. 'I *search* for *God*, I *search* within *myself* for *myself...I search for my face,*' he declared.[7] But when the Bolshevik Revolution occurred in 1917, Malevich enthusiastically welcomed the new atheistic regime, and embraced the role of teacher. For a time, his radical ideas met with official encouragement, but by 1928 the tide had turned. The Bolsheviks mandated a style of art based on idealized realism, designed to function as propaganda. Malevich's influence rapidly waned, and in isolation, as well as in personal danger of arrest, he adjusted his style to one that, while far from Soviet Socialist Realism, was more obviously figurative and narrative, and a dramatic move away from the radicalism of his earlier work.

Malevich died in 1935, at the height of the Stalinist purges, and was mourned by a few loyal followers. During the Second World War the exact location of his grave was forgotten. Later, in 1988, a commemorative sign – a white cube with a black square on it – was placed where he was believed to be buried. However, in 2012, the actual location of the grave was rediscovered in a Moscow suburb, but the plot had been turned into a housing development.

THE SCEPTICAL KEY

Since Malevich's time the shock potential of a monochrome painting has been significantly moderated. The idea is now a familiar artistic option, and, since 1915, many similar black-squared 'zeros' have been born. Minimal works like *Black Square* have become a bland stylistic option, as well as cultural property and potentially valuable investments. *Black Square* claims to be both an end and a beginning, but it looks today like a tired rhetorical gesture. Any claim that it represents some kind of 'ultimate' or 'absolute' is obviously false, and the self-proclaimed revolutionary status of the gesture, is entirely fictional.

Furthermore, despite Malevich's claim to have pushed painting to its logical end, the activity of painting in all its richness still continues. Indeed, painting is still valued by many important artists as a medium of expression. Malevich's quest for the elusive transcendent – the 'supreme' – actually led to a dead end, one that diminished the scope of painting to such an extent that for a time it risked becoming merely an arbitrary object or a concept. But if a painting can mean anything, then it also means nothing.

The decrepit state of *Black Square* is a telling metaphor for the failure of the utopianism of not only early twentieth-century art, but also many of its social, political and religious doctrines. Indeed, the heady rhetoric of purity that Malevich aggressively used in support of his work is uncomfortably close to those reckless and often deadly attempts to be free from contamination, of which the twentieth century is tragically full.

Research also revealed that three barely visible words on the lower-left edge of the white border, which were previously thought to be Malevich's signature, actually say in Russian, 'Negroes battling in a cave'. It is possible that this scribbled and overpainted title alludes to the kinds of jokes made by artists about the relationship between an image and a title (a parodic work by a French artist with this title actually existed); perhaps Malevich appended the title after the painting had begun to crack, because the underlying shapes can be interpreted as shadowy figures. This amusing and lighthearted play with the idea of a black square as a representational image suggests that, at least for a time, Malevich had another opinion concerning

the meaning of his painting – a desire to deconstruct the metaphysical aspirations with which he is more usually associated, which also indicates that he may have had doubts about the value of what he had made.

THE MARKET KEY

In 2008, Malevich's *Suprematist Composition* (1916) set the world record for a Russian work of art sold at auction. It fetched just over $60 million at Sotheby's New York, thereby massively surpassing the previous record for a Malevich of $17 million, set in 2000.

There are four *Black Squares*, but one was lost for several decades, and from the time of Malevich's death until the early 1990s only three were known. The fourth came to light again by chance in Samarkand in 1993, and thereupon entered the collection of Inkombank. This was the *Black Square* carried at Malevich's funeral. By 1998, Inkombank was bankrupt, and in 2002 an auction was held to sell off its assets. On hearing of the auction, the Ministry of Culture of the Russian Federation deemed Malevich's work to be a 'state cultural monument' and demanded its withdrawal from the auction. Subsequently, a US$1 million purchase price was donated by Vladimir Potanin, a major benefactor of the arts and the head of the Interros holding company. In this way, the fourth *Black Square* entered the collection of the State Hermitage Museum in St Petersburg.

FURTHER VIEWING

Other Black Square examples:
State Hermitage Museum, St Petersburg
State Russian Museum, St Petersburg

Museum of Modern Art, New York
State Tretyakov Gallery, Moscow
Stedelijk Museum, Amsterdam

FURTHER READING

John E. Bowlt, *Russian Art of the
Avant-garde: Theory and Criticism
1902–1934*, rev. ed., Thames &
Hudson, 2017
Rainer Crone and David Moos, *Kazimir
Malevich: The Climax of Disclosure*,
Reaktion Books, 1991
Charlotte Douglas, *Kazimir Malevich*,
Thames & Hudson, 1994
Britta Tanja Dumpelman (ed.),
*Kazimir Malevich: The World
as Objectlessness*, Kunstmuseum
Basel/Hatje Cantz, 2014

Pamela Kachurin, *Making Modernism
Soviet: The Russian Avant-garde
in the Early Soviet Era, 1918–1928*,
Northwestern University Press,
2013
Kasimir Malevich, *The Non-Objective
World: The Manifesto of
Suprematism*, Dover Publications,
2003
Aleksandra Shatskikh, *Black Square:
Malevich and the Origin of
Suprematism*, trans. Marian
Schwartz, Yale University Press,
2012
Paul Wood (ed.), *The Great Utopia:
The Russian and Soviet Avant-garde,
1915–1932*, exh. cat., Solomon
R. Guggenheim Museum,
New York, 1992

MARCEL DUCHAMP

Fountain, 1917

1950 replica of 1917 original
Porcelain, 30.5 × 38.1 × 45.7 cm (12 × 15 × 18 in.)
Philadelphia Museum of Art

In the same 2004 poll of experts that voted Matisse's *The Red Studio* (see p. 20) the fifth most influential piece of modern art, Marcel Duchamp's *Fountain* was given first place. But it has also been described as the most destructive artwork of the twentieth century. *Fountain*'s most notorious aspect is the fact that Duchamp (1887–1968) didn't actually make it. This is an example of what he called the 'readymade' – an object *selected* to be a work of art rather than made by the artist. *Fountain* invites a reconsideration of aesthetics, forcing us to embrace an enigmatic and challenging mix of the emotional and the intellectual, the unique and the mass-produced, and the culturally specific and the universal. *Fountain*'s capacity to unsettle has certainly diminished since 1917, but it has far from disappeared.

THE HISTORICAL KEY

The context for the 'invention' of the readymade is the Dada movement, which emerged in neutral Zurich and New York City during the First World War as an anti-art protest against the violence and devastation of the conflict, but beyond that, against a status quo that could legitimize such a tragedy through nationalism and religion. Dada was anarchic and often nihilistic, and deliberately provocative.

The more specific context is that in 1917 Duchamp purchased a men's urinal from the showroom of J. L. Mott Iron Works in New York City. He then signed it 'R. Mutt 1917' and anonymously submitted it as a sculpture to an exhibition to be staged by the Society of Independent Artists, a progressive organization that Duchamp himself helped found. The board of directors rejected it, even though the exhibition was meant to be open to any artist who paid the entry fee. In the same year, Duchamp had *Fountain* photographed for a New York-based Dada periodical, *The Blind Man*, and the photograph appeared alongside essays defending the work. The anonymous editorial declared: 'Whether Mr Mutt with his own hands made the fountain or not has no importance. He CHOSE it. He took an ordinary article of life, placed it so that its useful significance disappeared under the new title and point of view – created a new thought for that object.'

Duchamp's seemingly petty and perverse action must be seen within the context of the New York art world – a milieu that in the early twentieth century was very far from being the global avant-garde art centre it later became, but where there were already a growing number of American artists aligning themselves with the most radical developments coming out of Paris, particularly Cubism and Futurism. Duchamp, a Frenchman well versed in these tendencies, who had himself made Cubist paintings, moved to America in 1915, and was committed to encouraging the nascent art scene. His action was intended to force the Americans to look beyond Parisian art.

Duchamp's importance as an artist extends well beyond the innovation of the readymade. He also made slightly altered or assisted readymades, in which he added to, or combined, found objects, as well as paintings on glass, texts, films, animations, and what today would be called installations. It wasn't until the 1960s, after replicas of his lost readymades had been made, that *Fountain* rose to prominence, and a new generation of artists adopted the premise that anything in theory – or *as* theory – could be art, and embraced Duchamp's mixture of irreverence, jokiness, intellectual obscurity and cool indifference. From the late 1920s to the 1940s Duchamp had made very little work, preferring to play chess, and his real legacy lies in the cultivation of an attitude – one that is now often simply called 'Duchampian'.

THE BIOGRAPHICAL KEY

There are almost as many 'Marcel Duchamps' as there are writers on him. He has been discussed as a profound philosopher, a mystical alchemist, tantric initiate and occult master, but also as a self-publicist, a failed artist and a deeply neurotic person.

Duchamp was born in Normandy, France, in 1887. Of the seven children in the family, four became artists: two older brothers, Jacques Villon and Raymond Duchamp-Villon; a younger sister, Suzanne Duchamp-Crotti; and Marcel Duchamp himself. In 1904, Marcel followed his brothers by moving to Paris to study art, and in his formative years they remained in close contact. But in 1915 Duchamp moved to New York. He would travel back and forth between Europe and the United States for much of the rest of his life.

A key moment in Duchamp's personal and professional life came in 1912, when the twenty-four-year-old submitted a Cubist-inspired work entitled *Nude Descending a Staircase, No. 2* to the progressive Salon des Indépendants in Paris, and was forced by the board, through the intermediary of his brothers, to withdraw the painting a few days before the show opened, because of concerns that it was not suitable for exhibition. This betrayal was, by Duchamp's own admission, a major turning point, and the 1917 *Fountain* episode was clearly in part motivated by his desire to replay the event from a position of power.

THE AESTHETIC KEY

When interviewed in 1964, Duchamp said he had chosen a urinal because he thought it had the least chance of being liked. As time has passed, however, the criteria for liking an artwork have shifted greatly – and largely thanks to Duchamp himself. Taste has expanded to incorporate *Fountain*, although such judgments now involve the intellectual faculties more than the emotional or aesthetic in the familiar sense.

But *Fountain* still fulfils several important criteria within a more conventional aesthetic framework. For an object to become an aesthetic experience it must be perceived as purpose-less. In the case of *Fountain*, we must forget, or at least supplement, the knowledge that we are looking at a urinal – an embarrassing object, even an indecent one, that is associated with bodily waste and belongs to a world of primal necessity very far removed from art. Therefore, in order to treat *Fountain* as an aesthetic object, it is first necessary to stop urinating in it, literally and metaphorically. The object must be removed from its original function and relocated in a new context – the world of art – through aesthetic distancing.

In fact, this transposition to a new status is greatly speeded up by the way Duchamp chose to display his object – sideways, that is, not as it would be hung if used in a men's toilet. This simple shift in orientation, a matter of rotating the object by forty-five degrees, immediately distances it from its lowly origins, and we can then be free to admire its proportions, and the smooth whiteness of the porcelain. In this purely visual sense, *Fountain* is pleasing to the eye.

Portrait of Marcel Duchamp, 1920–21. Photograph by Man Ray

From early on, for example, it was compared with recognizable, sculpted imagery – for instance, a seated Buddha. In other words, the object has been turned into a work of art through reasons of representational and symbolic content. But aesthetic distancing is also accomplished in two other ways: through the addition of a signature (albeit fictional), which is usually associated with a work of art; and also through the choice of a title.

What Duchamp has done is to insert his object into the familiar aesthetic framework with the intention of exposing its limits. For example, the original *Fountain* was lost or destroyed soon after it made its infamous debut, so what we are looking at here is a photograph of a replica from 1950. Normally, this would seem to matter, but, in this case, it is of little significance because the work's found, utilitarian status, and association with the functional, mass-produced objects of industrial society, is one of its inherent and provocative characteristics. In principle, any signed urinal of a similar kind is sufficient.

THE EXPERIENTIAL KEY

Fountain fundamentally questions what it means for us to experience something as a work of art. Quite apart from anything else, it reminds us that this experience is always historically contingent. In 1917, everyone (including Duchamp himself) reacted against *Fountain*, judging it was not art. Today, the experience of *Fountain* is divided between those who continue to find it unworthy as art, and those who do. For the latter, the ability to welcome *Fountain* into the pantheon will be based on different criteria from those that conditioned artists and the public of an earlier period. For the initiated, the expansion of the idea of art begun by Duchamp has not occurred mostly on the level of affective or expressive faculties, but rather on levels related to associative ideas, concepts and issues of social purpose – the realm of mental, cognitive and intellectual activity. Duchamp has trained some of us to recognize that our mental faculties are now more important than those conventionally involved in making judgments about art.

Prior to the readymade, art functioned more or less as an amalgam of sensibility and sense, affect and thought. After the readymade,

art could hypothetically, and increasingly in practice, continue to exist in terms only of the last – of pure idea. *Fountain* therefore marks the moment when the experience of art shifts from the affective to the intellectual, making the former difficult to assimilate to the latter. Affect does, however, play a role in the appreciation of *Fountain*. But any emotion we feel will arise in relation not only to the intrinsic aesthetic qualities of the work but also to the social commitment to the *idea* of contemporary art, its value in society as something inherently different from the recognizable art of the past. This does not mean that we must leave behind our emotional responses. Rather, it suggests that by merging and blending them in new ways with other dimensions of consciousness, we will expand the reach of art in general.

THE THEORETICAL KEY

Duchamp was looking for ways to reject the most fundamental assumptions about art. A key notion explored during these years, one that would become central to his concept of art and the artist, was what he termed the 'beauty of indifference'. Rather than seeing art as a means of self-expression or as a way of creating a beautiful artefact, Duchamp promoted the idea that a work of art must have an existence that is completely separate not only from the life of the maker, who henceforth approaches his or her practice with the air of the detached and ironic observer, but also from the production of anything resembling an aesthetically pleasing and handmade object.

Duchamp wanted to draw art into the realm of speculative and philosophical ideas. For him, art had to be an occasion for novel and potentially subversive thinking in, and through, visual forms. He showed artists that in our society the abstract category of art, which is animated by the activities of artists, collectors, institutions and the public, has the power to ennoble anything. As an additional consequence of the readymade status of *Fountain*, Duchamp also made possible the controversial possibility that anyone can be an artist, and that no skills, at least none of the familiar sort, are necessary.

Duchamp's readymade is part of the wider assault launched by Dadaism on the vestiges of the fine-art system, which, despite the challenges posed by the modernism of Manet and the Impressionists,

the Post-Impressionists, and then artists such as Matisse, Picasso and Malevich, still left some basic principles unchallenged. One such idea was that art must be a vehicle for self-expression and that it depends on universal aesthetic values made manifest through the skilful or original manipulation of specific media sanctioned by convention. Duchamp succeeded in challenging these apparently unassailable ideas by showing that *anything* could be art, and that *anyone* could be an artist. *Fountain* thus signals the beginning of what has come to be accepted practice in the contemporary art world, where an openness or 'anything goes' approach has replaced the old fine-art system that was still in place in 1917, and that lingered on into the 1960s.

THE SCEPTICAL KEY

Duchamp knew his limitations as a draughtsman – he couldn't draw hands and had no colour sense – and wisely realized he would always fail in the competition with his older brothers, more technically skilled artists. He therefore took art in a different direction, moving towards an approach that was, in his words, 'anti-retinal' – that is, was not primarily about seeing and the senses. But in the process, Duchamp fatally lured many other artists into what turned out to be a barren dead end. He encouraged an attitude to art that condemned artists to produce shocking or controversial work that is inherently doomed to obsolescence, because it will be superseded by the next radical provocative artwork. To maintain the 'shock of the new' requires that an artist engage in perpetual challenges to the latent assumptions hidden within their current era.[8]

Duchamp endorsed the momentum of Modernism but denied its trajectory. There was no impetus to discover, just to ask endless dilettantish questions. While *Fountain* was a borderline case for the art world in 1917, it certainly isn't today. After Duchamp, any chosen object, however outrageous, could be classifiable as art simply because of the readymade's prior existence as a recognized artistic strategy. A gallery or museum will present it as good or bad art, not as a fundamental challenge to the category of art itself.

We must also recall that we are studying a replica – a fact that undermines one of the cardinal qualities of the readymade –

that it is a banal, mass-produced item chosen by an artist at a particular moment and time. What we see here is a museological artefact safely embedded within a social discourse. Furthermore, if art is now anything that the institutions of the art world choose to define as such, then its status is simply dependent on who wields power and influence within the important institutions. In this sense, the 'Academy of the Readymade' is far worse than any Beaux-Arts academy containing paintings of anodyne Venuses, because, having abandoned aesthetics, the avant-garde can offer nothing more to replace it than the intimidating and alienating evidence of who is exercising the power to confer the name of art upon the infinite world of things and events.

THE MARKET KEY

Many of the original readymades, like *Fountain,* were lost, and they first became known through miniature replicas, which Duchamp created for his *From or by Marcel Duchamp or Rrose Sélavy (Box in a Valise)* (1935–41; Philadelphia Museum of Art). As Duchamp became more famous, a growing number of requests were made from gallerists and museums for his work, and Duchamp eventually authorized full-size replicas of *Fountain* and other readymades.

For the exhibition 'Challenge and Defy' at the Sidney Janis Gallery, New York, in 1950, he authorized Janis to purchase a secondhand urinal in Paris, to which Duchamp then added a copy of the original inscription (see p. 58). In 1998, it entered the collection of the Philadelphia Museum of Art, which already possessed an unrivalled collection of Duchamp's works through the 1950 donation of Walter C. Arensberg, a friend of Duchamp who had also resigned from the board of the Society of Independent Artists on account of the *Fountain* scandal of 1917.

Another set of replicas of all the major readymades was fabricated in 1964 by Galleria Schwarz, Milan. This *Fountain* replica was made from glazed earthenware painted to resemble the original porcelain. This involved close work with Duchamp, as well as with the Stieglitz photograph. The work exists in an edition of eight. Four further examples were also made at that time, one each for Duchamp and Arturo Schwarz, and two for museum exhibition.

Duchamp signed each of these replicas on the back of the left flange, 'Marcel Duchamp 1964'.

One of the Schwarz *Fountain* replicas sold at Sotheby's New York in 1999 for $1,762,500, a record for a work by Duchamp at auction. However, three years later another from the series sold for a hammer price of $1,185,000 at Phillips de Pury & Luxembourg in New York.

It is still the case that judgments in the art market concerning art depend primarily on visual rather than intellectual comprehension for understanding their importance. Most collectors of classic European modernism fail to comprehend, or flatly reject, the contextual basis for Duchamp's readymades – the fact that a urinal in a men's toilet is a urinal, while one signed and placed in a gallery is art. Collectors of specifically contemporary art, by contrast, are more likely to recognize the philosophical and aesthetic implications of the readymade and its ilk.

FURTHER VIEWING

Other Fountain replicas:
D. Daskalopoulos Collection,
 Halandri, Greece
Sidney and Lois Eskenazi Museum
 of Art, Indiana University
Gallerie Nazionale d'Arte Moderna
 e Contemporanea, Rome
Israel Museum, Jerusalem
Dakis Joannou Collection
Moderna Museet, Stockholm
Musée Maillol, Dina Vierny
 Foundation, Paris
Musée National d'Art Moderne,
 Centre Georges Pompidou, Paris
National Gallery of Canada, Ottawa
National Museum of Modern Art, Kyoto
San Francisco Museum of Modern Art
Tate Modern, London

Musée National d'Art Moderne,
 Centre Georges Pompidou, Paris
Philadelphia Museum of Art
Tate Modern, London

FURTHER READING

Dawn Ades, Neil Cox and David
 Hopkins, *Marcel Duchamp*,
 Thames & Hudson, 1999
*Marcel Duchamp: Interviews und
 Statements*, Hatje Cantz, 1991
Thierry de Duve, *Pictorial Nominalism:
 On Marcel Duchamp's Passage
 from Painting to the Readymade*,
 University of Minnesota Press, 1991
Thierry de Duve, *Kant After Duchamp*,
 MIT Press, 1996
Thomas Girst, *The Duchamp Dictionary*,
 Thames & Hudson, 2014
Dafydd Jones (ed.), *Dada Culture:
 Critical Texts on the Avant-garde*,
 Rodopi, 2006
Rudolf E. Kuenzil and Francis
 M. Naumann (eds), *Marcel
 Duchamp. Artist of the Century*,
 MIT Press, 1996
Gavin Parkinson, *The Duchamp
 Book*, Tate Publishing, 2008
K. G. Pontus Hultén (ed.), *Marcel
 Duchamp: Work and Life/
 Ephemerides on and About
 Marcel Duchamp and Rrose
 Sélavy 1887–1968*, MIT Press, 1993
Michel Sanouillet and Elmer Peterson
 (eds), *The Writings of Marcel
 Duchamp*, Da Capo Press, 1989
Arturo Schwarz (ed.), *The Complete
 Works of Marcel Duchamp*,
 2 vols, Thames & Hudson, 1997
Calvin Tomkins, *Duchamp:
 A Biography*, Henry Holt, 1996
'100 Years Ago, a Urinal Changed
 the Course of Art', Katherine
 Brooks, *Huffington Post*, 17 May
 2017, http://www.huffingtonpost.
 co.uk/entry/marcel-duchamp-
 fountain-urinal-100th-anniversary_
 us_58e54e4fe4b0917d3476ce14
 (visited 22 March 2018)

RENÉ MAGRITTE

The Empty Mask, 1928

Oil on canvas, 73.3 × 92.3 cm (28¾ × 36¼ in.)
Kunstsammlung Nordrhein-Westfalen, Düsseldorf

In *The Empty Mask*, René Magritte (1898–1967) has painted on a bizarre object four texts in French, which, clockwise from the top left, say 'sky', 'human body (or forest)', 'facade of a house' and 'curtain'. Magritte deployed a version of simplistic realism that had become commonplace in the world of commercial art, while undermining its conventions from within. In this sense, he turned his back on the kinds of radical formal and conceptual experiments of the modernist artists discussed so far. His paintings relate to a European tradition that conveys a powerful sense of the strange and unsettling by giving visual form to emotions and desires that disrupt the smooth surface of the perceived world.

THE THEORETICAL KEY

Painting for Magritte was a profoundly conceptual and philosophical tool, a fact that his deceptively easy-to-read visual style is intended to both disguise and facilitate. Painting was a means to visualize philosophical concerns, to generate irreconcilable perceptual and intellectual contradictions. He aimed to expose the arbitrary nature of representation by making unexpected links between images, text and meaning, and talked of the 'treachery' of images, believing that, by revealing the gaps in language, another less conventional and authoritarian language could be encouraged.

In seeking to understand the dynamics of consciousness, it is necessary to explore the psychoanalytic theory of Sigmund Freud, who was especially important for Magritte and the Surrealists. Freud revealed that often the manifest content of conscious experience conceals the latent content of unconscious, unfulfilled desires, and that dreams make this mechanism particularly clear. He emphasized that even waking life is continuously disturbed by the eruption of uncontrolled and often debilitating stimuli coming from what he called the 'libido' – the animal instinct to survive, the sexual and aggressive drives – which we all struggle to repress, sublimate and conceal, but which are revealed in slips of the tongue, to give one example. In fact, Freud theorised, the organized and 'civilized' realm of the signs that describe the world are always vulnerable to disruption because the unconscious can never be

fully controlled and transformed into more socially acceptable behaviour or thoughts.

Magritte explores the buried, unconscious linguistic element within the visual – the fact that an image functions as a sign for a thing it represents. He forces the viewer to ask questions about who controls the circulation of signs, and what purpose these signs serve in relationship to the exercise of power. He shows that the connection between a word and the image of that word is wholly arbitrary. As Magritte noted in an essay from 1929, 'an object is not so possessed of its name that one cannot find for it another which suits it better'.[9] He also suggested that the visible conceals much that is invisible, and his painting presents the viewer with an irreconcilable contradiction that renders both visual and verbal language dysfunctional.

Magritte uses familiar images to subvert habits of seeing through making unusual juxtapositions and distortions. He releases the forces of the unconscious into the stable representational world created by the conscious mind. Freud discussed what he called the 'uncanny' – the feeling of something peculiarly unsettling that seems to have supernatural origins and that Freud considered was actually caused by unconscious memories from childhood returning to haunt the present. Freud used the German word *unheimlich*, which is more literally translated as 'un-homelike', so the uncanny can be described as the strangely unfamiliar, or what was once familiar but is no longer. The uncanny can be linked to objects, people and mirrors, and can be the minimal difference that causes the world to lose its familiar solidity. It signals the emergence of something that has been repressed, and is the way truth catches up with us. In Freudian theory, these 'truths' involve castration anxiety, Oedipal rivalry, the sense of omnipotence experienced by infants, and other experiences and thoughts that, as adults, we are obliged to try to forget.

THE HISTORICAL KEY

Late nineteenth-century Symbolism also favoured the indeterminate and ambiguous over the easily defined, and, in this context, Magritte's painting can be discussed as a continuation of the 'suggestive art', as the Symbolist Odilon Redon termed his own practice in 1909.[10]

More broadly, Magritte's work can be located within Western traditions of iconoclasm – when images are criticized as idols and systematically defaced or destroyed in response to the dictates of some higher truth. Historically, this was usually motivated by religious belief, because the monotheistic religions teach that the true God is transcendent and invisible, and so cannot and must not be represented. In the case of the secular and sceptical Magritte, however, as with other modern artists, the motive for iconoclasm derived rather from deep-seated doubts concerning the power of language to represent reality. This, in its turn, reflected a growing cultural awareness that reality is a social construct produced through the codes of language – that the map (language) is very far from being the territory (the world itself).

Another work entitled *The Empty Mask*, also dating from 1928 and now in the collection of the National Museum Wales, shows a similar free-standing frame-like structure, but rather than written texts it displays images of – clockwise from top left – blue sky, a curtain, a facade of a house, a fire, a forest and a sheet of paper cut-outs...but no human body.

THE BIOGRAPHICAL KEY

René Magritte was born in 1898 in Lessines, Belgium. In 1912, when he was fourteen years old, his mother committed suicide by drowning herself in a river near their home, an event that obviously had a profound effect on the boy. On leaving art school in 1918, Magritte worked in commercial advertising, making posters and designing advertisements to support himself while at the same time working on his painting. By the mid-1920s, he had found his signature style, which drew heavily on the commercial art with which he was familiar, while also assimilating aspects of Modernist avant-garde art.

In 1927 Magritte showed the first of what are now considered his characteristic works at the Galerie Le Centaure, Brussels, but the exhibition was poorly received, and as a result, he decided to leave Belgium with his wife in order to try his luck in Paris. There, he quickly made contact with the Surrealists. This painting was therefore made during an exciting period of creativity and originality for Magritte,

René Magritte *c.* 1924–25. Photographer unknown

when he was at his peak as an artist. Indeed, his most powerful and thought-provoking paintings, all produced in an unsettlingly bland and conventionally lucid style, date from between 1926 and 1930, when he was in his late twenties and early thirties.

An aura of death seems particularly to pervade much of Magritte's work from the second half of the 1920s. Like many other paintings by Magritte, *The Empty Mask* seems to allude to the trauma caused by the tragic death of his mother. One can sense it not only through the suggestion of an absence, but also through the way the work exposes the failure of language to communicate effectively about the kinds of extreme experiences that really matter.

THE AESTHETIC KEY

Magritte's concern for the aesthetic is limited, but it nevertheless remains an important dimension of his work. He used the banalized and commercialized conventions of a familiar representational style based on fixed-point perspective, which derived from the Renaissance, and in which the illusion of three-dimensional space is created using geometric projection, with all lines perpendicular in relation to the picture plane converging at the central vanishing point on the horizon line. In *The Empty Mask*, Magritte uses this method to depict a shallow space in which there is what looks like the reverse of an eccentrically shaped canvas, or some kind of architectural structure, which is standing on a wooden floor in front of a wall. From the evidence provided by related works by Magritte, it seems this form probably derives from the shape of a window frame, or a deformed version of the frame used for a children's school primer.

Within the code of banal representation that Magritte adopts, he makes several considered aesthetic decisions. He has carefully selected the visual style of his script, for example, which is written in a dutiful schoolboy-like cursive, or what the philosopher Michel Foucault calls 'a script from the convent'.[11]

The use of gloomy and dull colours in *The Empty Mask*, as well as the general sense of sensory blankness, suggest the artist intended to convey the specific emotional mood of inertia and sadness. The axial symmetry of the highly balanced composition and the

way in which the bizarre object carrying the texts is contrasted with the dark background also give the painting an imposing and rather ominous presence. The words refer to things that are not actually depicted, alluding therefore to absences. A shadow seems to hang over the image, and the work's title adds to the general feeling of melancholy.

But Magritte does not draw attention to these stylistic effects. The painting technique is subdued and visually uninteresting – and is meant to be. He aims to undermine banal representational conventions from within. His interest lies not so much in making formal innovations as in depicting something that is emotionally and intellectually unsettling precisely because it appears within a conventional aesthetic code – just as dream imagery seems uncanny because it reorganizes the familiar contents of waking life. The artist produces a seemingly objective world constructed through optical realism in order to encourage the viewer to consider the disturbing content

THE EXPERIENTIAL KEY

The figurative style and the script in which the words are written in *The Empty Mask* are impeccably clear, so the challenge for us lies not so much in any obstacle it poses through formal innovation, nor in what has been depicted, but in the tantalizingly uncertain meanings the painting sets in motion, like ripples from a stone dropped in water. Magritte embraces vague states of mind and poetic moods, conjuring chimeras, and the mysterious and equivocal world revealed within the visible can be read as symptoms of unsettling psychological forces, of repressed or uncomfortable feelings and sensations.

The Empty Mask is like a dream image – things that are perfectly ordinary and familiar in normal life are here made to seem extraordinary. Magritte explores displacements, juxtapositions and apparent non sequiturs – the 'mystery of the ordinary', as an important exhibition of his work was entitled.[12] The work's title functions not so much as a helpful guide to the work's meaning as a way of generating yet another level of enigma. Magritte takes what we consider familiar, rendering it unfamiliar. Why are these texts written on this curious structure? Are they supposed to be captions for missing images?

If so, then the words seem to have completely replaced the images to which they refer. In the case of *The Empty Mask,* what perhaps lies hidden and makes the painting so unsettling is the uncomfortable combination of the banal and unruly desires suggested by the narrative associations brought into play by the words.

THE SCEPTICAL KEY

In *The Empty Mask*, Magritte uses written language, thereby making the visual something primarily to be *read* rather than to be seen. In this sense, despite its enigmatic content, the painting is eminently traditional. It turns away from the most challenging aspects of Modernism – for all their strangeness, Magritte's paintings are actually a retreat from the revolutionary potential first unleashed by the Post-Impressionists, and then embraced by much of the twentieth-century avant-garde, which emboldened artists to rid their work of lingering dependence on traditional pictorial models and subordination to literary, narrative conventions.

Magritte's belief in Freudian psychoanalysis led him to assume that the surface of the visible hides a more important, invisible truth. It was to this invisible world that he turned his attention, thereby abandoning the visible to the mass media. From this perspective, Magritte's work fails to subvert codes of representation on the level of form itself, and is limited to the superficial of narrative or discourse.

In fact, it can be argued that Magritte made important work for no more than a decade. Subsequently, his paintings became little more than pastiches of his own works, as he refined his initially thought-provoking and disturbing imagery into a clichéd world that is instantly recognizable as the Magritte 'brand'.

THE MARKET KEY

As of 2017, *The Empty Mask* has been shown twenty-seven times since it was first exhibited in Brussels between 1931 and 1932. In 1967 it was exhibited in 'Word as Image' at the Sidney Janis Gallery, New York, and sold to a private collector. Six years later, this collector resold

it to the Kunstsammlung Nordrhein-Westfalen in Düsseldorf, where it now forms part of the collection. The current record for a work by Magritte is the £14.4 million paid for *La Corde sensible* (1960) at Christie's, London in 2017. The last time this work was auctioned, in New York in 1986, it sold for just $363,000. Another Magritte – *Le Domaine d'Arnheim* (1938) – featured at the same auction in 2017, fetching a more modest £10.2 million. Back in 1988 it had achieved the then second-highest price for a Magritte when it sold in New York for $825,000. In 2013, this work was reportedly bought by the Russian collector Dmitry Rybolovlev for $127.5 million, which was far above the record paid at auction for a Magritte. In 2017, Rybolovlev made history by paying $450.3 million at a New York auction for Leonardo da Vinci's *Salvator Mundi* – the current world record paid for *any* painting.

FURTHER VIEWING

Musée René Magritte, Brussels
Museum of Modern Art, New York
Tate Modern, London

FURTHER READING

Todd Alden, *The Essential René Magritte*, Harry N Abrams, 1999
Patricia Allmer, *René Magritte: Beyond Painting*, Manchester University Press, 2009
Anna Balakian, *Surrealism: The Road to the Absolute*, University of Chicago Press, 1986
Stephanie Barron et al., *Magritte and Contemporary Art: The Treachery of Images*, exh. cat., Los Angeles County Museum of Art, 2006–7
Linda Bolton, *Surrealism: A World of Dreams*, Belitha Press, 2003
Hal Foster, *Compulsive Beauty*, MIT Press, 1993
Michel Foucault, *This is Not a Pipe*, trans. and ed. James Harkness, University of California Press, 1982
Siegfried Gohr, *Magritte: Attempting*

the Impossible. D.A.P./Distributed Art Publishers, 2009
Rosalind E. Krauss, *The Optical Unconscious*, MIT Press, 1994
René Magritte and Harry Torczyner, *Magritte: Ideas and Images*, trans. Richard Miller, Harry N. Abrams, 1977
René Magritte, Anne Umland, Stephanie D'Alessandro, *Magritte: The Mystery of the Ordinary, 1926–1938*, exh. cat., Museum of Modern Art, New York, Menil Collection, Houston, and Art Institute of Chicago, 2013–14
Didier Ottinger (ed.), *Magritte: The Treachery of Images*, exh. cat., Centre Georges Pompidou, Musée National d'Art Moderne, Paris, and Shirn Kunsthalle Frankfurt, 2017
Robert Rosenblum, *Modern Painting and the Northern Romantic Tradition: Friedrich to Rothko*, Thames & Hudson, 1978
Ellen Handler Spitz, *Museums of the Mind: Magritte's Labyrinth and Other Essays in the Arts*, Yale University Press, 1994
David Sylvester, *Magritte*, exh. cat., Thames & Hudson, 1992

EDWARD HOPPER

New York Movie, 1939

Oil on canvas, 81.9 × 101.9 cm (32¼ × 40 in.)
Museum of Modern Art, New York

While modern art seemed to be heading inexorably towards a conception of painting as purified and existing in a self-sufficient world, or a notion of art that expresses the unconscious realm of dreams, Edward Hopper (1882–1967) took a different approach. He remained allied to conventions of naturalistic realism that assume the painter's task is to produce works whose illusionary worlds more or less mimicked and obeyed the same rules as normal vision. But this obstinate adherence to a concept of a painting as a *picture* – a stage set or a window – at a time when the most innovative artists were challenging such norms and overthrowing them now seems far less retrogressive than it once did.

THE HISTORICAL KEY

During the 1930s, many American artists were struggling to identify what was a truly *American* subject matter and style. Two camps emerged. One was dedicated to bringing to fruition the experimental character of European abstract art and Surrealism, while the other pursued varieties of realism that turned away from stylistic innovation in order to allow for more obviously socially relevant content. Hopper belongs to the latter camp, and to choose a movie theatre as the theme for a painting must have seemed perfectly natural to him.

As the plentiful sketches made by Hopper attest, this work is actually an amalgam of several real movie theatres in New York – the Palace, Globe, Republic and Strand, but mostly the Palace, on West 46th Street, which still exists. The usherette is wearing the stylish jumpsuit worn by the real usherettes at the Palace, but she is in fact Hopper's wife, Jo, who, in reality, was sketched under a wall light in the hallway of their home.

The sliver of 'silver screen' depicted by Hopper, which is of mountain peaks, is thought to have come from the 1937 film *Lost Horizon*, directed by Frank Capra. The movie was about Shangri-La, a fictional utopian community high up in the Himalayas. During the 1930s, while America reeled under the blows inflicted by the Great Depression, the public had their own Shangri-La – Hollywood. Americans went to the movies very regularly. In 1929, at the start of the Depression, with a population of 122 million, Americans visited the cinema 95 million

times every week. Many movie theatres were as large as cathedrals, and nicknamed 'picture palaces' because of their extravagant design. Hopper's is no exception. The rich satiny reds of the seats and the curtains, and the ornate plasterwork on the central pilaster, are intended to give the impression that this is an opulent emporium of dreams. Movie theatres hosted three shows a day, and in a single day upwards of twenty thousand cinemagoers could come and go, so an usherette had to be good with people, and working in the big theatres was a desirable job.

From an art-historical perspective, *New York Movie* can be related to the theme of pictures within pictures – such as is common in depictions of an artist's studio (see Matisse, p. 20). In this case, however, there is a moving picture within a static one. The painting has a distant echo of the interiors featuring women lost in thought by painters of the Dutch Golden Age, such a Johannes Vermeer or Pieter de Hooch. The usherette in the painting is also the transatlantic cousin of Édouard Manet's barmaid in *A Bar at the Folies-Bergère* (1882; Courtauld Gallery, London). Manet's barmaid evokes indifference and vacancy, but this usherette may also be showing her solitude and loneliness, a theme to which Hopper returned again and again. As he noted of his work in general, 'Unconsciously, probably, I was painting the loneliness of a large city.'[13]

THE AESTHETIC KEY

Hopper always made many preparatory drawings for his paintings, and essentially *New York Movie* can be described as a filled-in drawing. He used oil painting in an understated way, without an overt display of bravura brushwork. Colour is also subdued, and almost always mixed with white. Often his paintings have a bland quality.

But we shouldn't overlook the innovations Hopper introduced into the aesthetics of picture making – above all, on the level of formal simplification and compositional structure. In relation to the latter, *New York Movie* is strikingly unorthodox. Hopper's compositions were influenced by camera technology, and while many Impressionist paintings suggest the influence of photography, where cropping is typical, Hopper's seem more like Hollywood movie stills. *New York*

Movie uses light and dark to generate a powerful sense of contrast, which was typical of the black-and-white films of the era.

Structurally, the painting gives the impression of two worlds, bisected more or less down the middle of the canvas. The perspective lines draw us towards the vanishing point of the cinema screen, but the strong light source on the right and the solitary figure of the usherette pull us towards that side of the canvas. The usherette is indeed the main source of visual interest, but she has been shunted to the far right, while the screen, which we would normally expect to be able to see, has been displaced to the top-left margin.

THE EXPERIENTIAL KEY

Hopper worked with a traditional notion of what it meant to experience a painting. While much avant-garde modern art was designed to encourage a process that engages us actively as participants in the making of meaning, Hopper adhered to an older idea, one in which we remain firmly spectators, outside the world created by the artist. As is often the case in Hopper's paintings, a compositional device in the foreground of *New York Movie* – the backs of the seats, two of which are curiously higher than the others – seems both to block entry and simultaneously to invite occupancy. The centre is uncomfortably blank. Indeed, the way Hopper has organized the image, pushing all the action to the sides to create a void in the middle, comprised of the pilaster and a dull brown wall, makes this a painting as much about absence as presence.

While the converging perspectival lines draw us towards the interior of the painting, we are not invited all the way in, just far enough to become a member of the audience, duplicating the role we are already playing by looking at Hopper's painting. We can imagine watching the movie – which is tantalizingly cropped from view – by sitting in one of the vacant chairs, thereby becoming a member of the audience. Or we can remain outside, on the threshold of the painting, and watch the two worlds Hopper creates inside – one of the audience members watching the film and one of the usherette lost in her dreams. Both are unfolding simultaneously, as if frozen in time.

But while this is a silent and static image, we also sense a powerful temporal dimension within the picture. Something has happened just before this moment, and something will happen after it. But, in the meantime, we are made to inhabit a timeless now – as if we are suspended within the daydream of the usherette. And yet the painting also invites us to speculate about its unfolding narrative. This sensation is enhanced by the fact that the film being projected is made of individual static frames that, when run together, give the illusion of movement. While we may be outside the static space of the representation, we are definitely inside the flow of time the painting evokes. In truth, this cinema must have been a noisy place, and part of the magic Hopper brings to the painting is to create a luminous pool of stillness and silence to a place that was in reality full of sound.

Is the usherette a woman marooned within the modern city, bereft of spiritual consolation, but lulled into passivity by the distraction of the silver screen? Or is she poised between two worlds – the films, which offer an easy, temporary and trivializing escape from the boredom, confusion, stress and insecurity of reality – and another, more mysterious and arcane place, the one suggested by the light and the staircase? For, as in so many works of art, these symbols suggest the yearning for transcendence.

The usherette seems caught between two possible futures two possible modes of existence – and it is unclear which of them she will choose. But perhaps Hopper is ultimately saying that the lot of the modern soul is to be suspended like this in limbo, awaiting the Day of Judgment that never comes.

THE THEORETICAL KEY

Hopper wasn't interested in philosophizing. He rejected the speculative nature of abstract art, seeing his task as an artist as being more down-to-earth, and as involving him in the attempt to recover the fragments of the everyday from the oblivion of the unnoticed. But Hopper's work is nevertheless deeply philosophical in an existential sense.

Like many of his works, *New York Movie* seems to be a visualization of what the sociologist Emile Durkheim called '*anomie*', the breakdown of social bonds between the individual and the community

Edward Hopper, undated. Photographer unknown

that occurs within modern, urbanized, technological society, and then results in a loss of meaning in life. This new form of social and psychological dislocation and spiritual void suggested that the breakdown of traditional social bonds and grind of daily life in the city had led to a possibly dangerous psychological state marked by a sense of emptiness, and a potential tendency towards social deviance. A cinema is a place where people go to forget the level of anomie they experience in their daily lives. It is a dream palace.

In Hopper's painting, the nesting of one depiction (a film) within another (a painting) inevitably brings to mind not only the notion of painting as illusion, but also that of reality as a whole as something illusory. Films are deeply immersive, and the darkened space in which they are watched is like a cave where one can lose oneself. False realities are layered one on top of the other – the false reality of the film, the audience, the usherette, the theatre and modern urban society as whole. *New York Movie* has been likened to Plato's Cave, and it can be discussed as a meditation on how we willingly embrace shadows, apparitions and figments.

THE BIOGRAPHICAL KEY

Edward Hopper was born in 1882 in Nyack, New York, the son of a dry-goods merchant. He lived most of his life in New York City, where he died in 1967. As a young man, Hopper studied for a time in Paris, where he was influenced by the Impressionists, but he chose American life as his subject, and, by 1925, had found his characteristic realist style. Hopper's wife, Jo, who also trained as a painter, was the model for most of his paintings of women, including this one. After 1934, they spent nearly half their time in an isolated house on Cape Cod. But it is urban and suburban life that preoccupied Hopper until the end of his life.

Like most Americans, the Hoppers were avid cinemagoers, so this painting is based on personal experience. It suggests that, where Hopper's work is concerned, the connection between what is depicted and what happens in everyday life is perhaps closer than is the case with any other artist in this book. 'Great art is the outward expression of an inner life in the artist,' Hopper declared, 'and this inner

life will result in his personal vision of the world.'[14] For Hopper, this 'personal vision' typically involved one or two solitary figures, set within empty or anonymous spaces, or depictions of buildings and streets that are imbued with the uncanny aura of human presence. But he was very reluctant to analyse the sources of this 'vision', saying that this activity was something best left to the critics.

THE SCEPTICAL KEY

Hopper painted 'easel paintings' – works of modest dimensions that don't lose much when shrunk in size for photographic reproduction. Indeed, *New York Movie* doesn't improve a great deal when seen 'in the flesh', when compared with seeing it at a distance or in a photograph. Hopper may well have been aware that most people were likely to see his paintings in reproduction, and often in black and white, and so may have taken this into account when making them. His painting is therefore in stark contrast to a typical Modernist work, which puts a premium on formal, object-like properties, and that often seems to have been made in deliberate defiance of the capacities of photographic reproduction technology. On these levels, an encounter with the real *New York Movie* is therefore likely to be disappointing.

Hopper was no virtuoso. The surfaces of this painting are remarkably uniform, as if he were so intent on reproducing the image he had already planned in sketches that he had little concern for translating it into coloured paint. Hopper was committed to the retrograde idea that a painting tells a story. His works are narrative paintings in the most hackneyed sense, and they rarely rise above quality illustrations.

THE MARKET KEY

New York Movie was given anonymously to the Museum of Modern Art, New York, in 1941. Hopper had first shown at MoMA as early as 1929, at what then was a relatively new museum, and he had a retrospective there in 1933. 'Edward Hopper's career should be of encouragement to young American artists at present struggling in obscurity, as he did for so long,' noted the press release to the exhibition.

As a result of a specific model that until recently dominated ideas about modern art, one in which Expressionism gives way to Cubism, then to abstract art, Surrealism, and seemingly inexorably, to Pop and Conceptual art, Hopper is still today seriously under-represented in some accounts of twentieth-century art, and in museum collections beyond the United States. For example, Tate, London, does not own a work by Hopper. This situation will not change easily, because important works rarely come up for auction, and they are very expensive.

In 2013, a not especially impressive work by Hopper, *East Wind Over Weehawken* (1934), realized $40,485,000 at auction at Christie's, New York, making it the most expensive Hopper ever sold. This sum far exceeded the estimate for the work of between $22 million to $28 million and easily beat the record $26.9 million paid for *Hotel Window* (1955) in New York in 2006.

FURTHER VIEWING

J. Paul Getty Museum, Los Angeles
Metropolitan Museum of Art, New York
Museum of Modern Art, New York
National Gallery of Art, Washington DC
Whitney Museum of American Art, New York
Yale University Art Gallery, New Haven

Edward Hopper House, Nyack, New York. Although Hopper never lived in the house after 1910, it remained the family home. Since 1971, the Edward Hopper House has been a not-for-profit art centre hosting exhibitions of contemporary art, as well as early work by Hopper.

Shirley: Visions of Reality (2013), a film directed by Gustav Deutsch

FURTHER READING

Esther Adler and Kathy Curry, *American Modern: Hopper to O'Keeffe*, exh. cat., Museum of Modern Art, New York, 2013–14

Lloyd Goodrich, *Edward Hopper*, Harry N. Abrams, 1978
Gail Levin, *Edward Hopper*, Crown, 1984
Gail Levin, *Edward Hopper: An Intimate Biography*, Rizzoli, 2007
Gail Levin, *Hopper's Places*, University of California Press, 1998
Deborah Lyons and Brian O'Doherty, *Edward Hopper: A Journal of His Work*, W. W. Norton, 1997
Patricia McDonnell, *On the Edge of Your Seat: Popular Theater and Film in Early Twentieth-Century American Art*, Yale University Press, 2002
Gerry Souter, *Edward Hopper: Light and Dark*, Parkstone Press International, 2012
Carol Troyen, Judith A. Barter et al. (eds), *Edward Hopper*, exh. cat., Museum of Fine Arts, Boston, National Gallery of Art, Washington DC, Art Institute of Chicago, 2007–8
Sheena Wagstaff (ed.), *Edward Hopper*, Tate Publishing, 2004
Walter Wells, *Silent Theater: The Art of Edward Hopper*, Phaidon, 2012
Ortrud Westheider and Michael Philipp (eds), *Modern Life: Edward Hopper and His Time*, Hirmer Publishers, 2009

FRIDA KAHLO

Self-Portrait with Cropped Hair, 1940

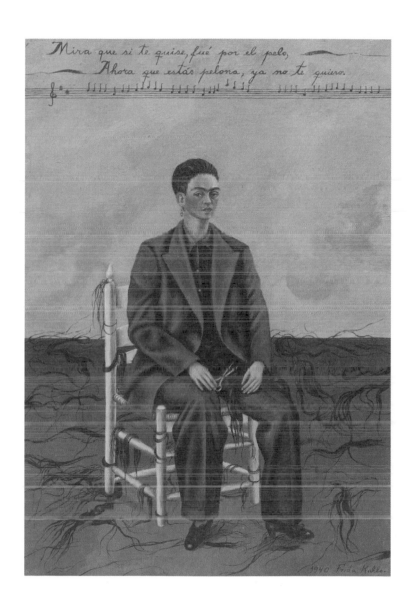

Oil on canvas, 40 × 27.9 cm (15¾ × 11 in.)
Museum of Modern Art, New York

Today, there is a profitable business in what one critic has termed 'Kahlobilia'.[15] But the promotion of the Frida Kahlo (1907–1954) 'brand' risks failing to do justice to the artist's work itself. Kahlo's paintings are usually hung in museums in the same room as the Surrealists, and, in style and content, her work can clearly be related to a kind of art that uses a deceptively simple figurative style in order to create provocative juxtapositions of everyday objects evoking the uncanny world of dreams and the unconscious. But it is also important to take into account the specific Mexican context for her work.

THE BIOGRAPHICAL KEY

Frida Kahlo was born in Mexico City in 1907 to a German father and a mother of indigenous and Spanish descent. When she was six she contracted polio, which left her disabled in her right foot, and earned her the nickname 'peg-leg Frida'. In *Self-Portrait with Cropped Hair*, Kahlo's right leg is awkwardly posed. To minimize the evidence of her deformity, she often wore trousers – a photograph taken by her father of the family in 1928 shows her dressed very convincingly as a man, looking rather like she does in this painting. Later, also in part to conceal her deformed leg, Kahlo took to wearing the long Tehuana skirts of the women from the south of Mexico, which became one of her trademarks. But Kahlo's troubles were far from over. In 1925, a bus in which she was riding collided with a tram and she suffered severe injuries that confined her to bed for many months. As a consequence, she would be obliged to undergo thirty-two medical operations over her lifetime.

In 1929, Kahlo married the famous Mexican painter Diego Rivera and became pregnant a year later. However, the injuries sustained in the accident made it impossible for her to give birth, and Kahlo was forced to have an abortion. Kahlo and Rivera divorced in 1939, and it was soon afterwards that she painted *Self-Portrait with Cropped Hair*. Later, Kahlo lamented, 'I suffered two grave accidents in my life, one in which a streetcar knocked me down.... The other is Diego.'[16] But despite Rivera's many faults – he was a great womanizer – their divorce did not last long, and they were remarried at the end of 1940.

This is a profoundly intimate work, and it is necessary to put aesthetics, politics and art theory aside in order to fully engage with the circumstances of Kahlo's life from which it originates. Indeed, the biographical core of all her work was freely acknowledged and encouraged by Kahlo herself. 'I do not know if my paintings are Surrealist or not,' she said, 'but I do know that they are the most frank expression of myself.'[17]

The immediate context for *Self-Portrait with Cropped Hair* is a very troubled period in Kahlo's personal life, and here the symbolism seems more explicit. Like Rivera, Kahlo used Mexican iconography, such as Tehuana clothing, and historical artefacts like Aztec sculpture, as symbols of cultural identity and unity. She often sought to cope with her personal life by including it in her highly confessional paintings, which were couched in oblique symbolism. But here, the fanciful dreamlike imagery and the nationalistic and ideological symbolism found in her other self-portraits are gone. This painting contrasts radically with several other self-portraits in which she depicts herself in the colourful Tehuana costume. It conveys an overwhelming impression of psychological emptiness, personal dejection and loss, mixed with a steely, almost ironic defiance. The man's suit she is wearing is certainly Rivera's (he was a portly man). Kahlo yearned to possess the authority of men, but within the context of her marriage to Rivera and the society of the time, any access to the public sphere was mostly only possible through her role as the beautiful partner of a famous man. She was obliged to occupy a passive role as a represented object.

THE HISTORICAL KEY

André Breton, leader of the Surrealists, saw Kahlo's work on a visit to Mexico in 1938. He subsequently wrote a catalogue essay for the one-person show he organized for Kahlo at the Julien Levy Gallery in New York, a space with a reputation for showing the Surrealists. In the essay, Breton declared that Kahlo's work was like 'a ribbon around a bomb', and that it had 'blossomed...into pure surreality'.[18]

But to limit a reading of Kahlo's painting to a European Surrealist context risks missing other more local and unique points of reference.

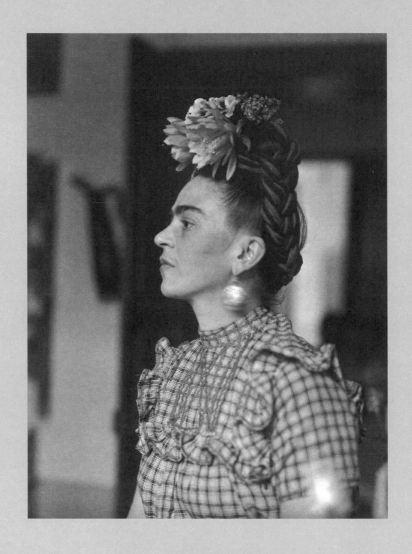

Frida Kahlo, undated. Photograph by Sylvia Salmi

Kahlo was a member of the urban Mexican intellectual elite who embraced left-wing politics and nationalism, a concern she shared with Rivera. During this period of civil strife in their homeland, Kahlo was a lifelong member of the Communist Party and a political activist. Her paintings are hybrids that use imagery rooted in Mexican history – especially folk art, religious painting and older artefacts from Aztec and Mayan culture. *Self-Portrait with Cropped Hair*, for example, clearly owes a debt to Mexican folk art, especially votives – images produced by the Roman Catholic faithful in order to give thanks for a miracle or a favour received from God. The small size of the painting also brings such artefacts to mind. Indeed, this painting could be described as a bittersweet votive, painted to mark Kahlo's recent divorce from Rivera.

THE EXPERIENTIAL KEY

Self-Portrait with Cropped Hair suggests that what we are looking at is not so much an image of external reality as an inner, psychological state. Kahlo said that, unlike the Surrealists, she never painted dreams: 'I paint my reality.'[19] Her work is a visual equivalent for a state of mind. By adopting the look and pose of a man, Kahlo confuses our ability to interpret the painting, and, without knowledge of the personal circumstances that gave rise to it, we will inevitably be left wondering why the person depicted is cross-dressing, and what relationship the lyrics at the top of the work have to her predicament. The expression is rather disdainful, and Kahlo has painted herself so that she appears to be avoiding eye contact. The look on the face gives little away.

Normally, Kahlo's self-portraits evoke her femininity, but here she appears to be trying to negate it. She cast herself as a man – the only overtly womanly attribute on display is her earrings. The artist depicts herself seated in an empty, characterless space on a simple wooden chair, with a recently shorn head of hair. The suit is too large for her, which adds to the feeling that she is undersized or shrunken, an impression reinforced by the way she is isolated within the empty space of the bare room.

She is still holding a pair of scissors, and all around her, almost like a living creature, lies the evidence of her once impressive tresses. This gives the painting a decidedly uncanny air, as if there is something sinister about her hair. The lines from a Mexican song above her are painted as if they are written on the wall or perhaps inscribed on the surface of the canvas in defiance of the usual rules of figurative painting. The text translates as, 'Look, if I loved you it was because of your hair. Now that you are without hair, I don't love you anymore.'[20]

THE AESTHETIC KEY

While Kahlo's paintings are often about excruciating pain, anger, torment and inner struggle, they were made using a style and technique that conveys a very strong sense of premeditation, control and inner detachment. But it is precisely this paradox that adds considerably to their haunting power. However, the explicitly 'amateur' or folk-art style of *Self-Portrait with Cropped Hair* can deter from assessing it primarily in the kind of formal or aesthetic terms reserved for Matisse (see p. 20), or abstract artists such as Malevich (see p. 44).

And yet this work has a pronounced aesthetic character of its own. *Self-Portrait with Cropped Hair* has a powerful religious aura – the work is almost like an icon, or a votive painting, which is usually made by artisans or amateur artists, or by the person who is giving thanks. Its pronounced bilateral symmetry conveys a strong sense of balance and unity. The crease on the figure's right trouser leg follows the central vertical axis of the canvas, and this underlying structure is picked up by the button line of the deep-red shirt, which then leads to her coldly staring right eye. Set at an angle, the yellow chair, which is also the brightest part of the painting, brings a slight asymmetry to an otherwise extremely static composition.

The use of muted colour throughout the whole work serves to increase the feeling of sadness Kahlo describes through her powerful symbolism. Visual rhythms set up by the freshly cut hair create countermovement, animating the dark reddish-brown region in the lower part of the work. At the top of the painting, the black lyrics and musical notation also create a dynamic counterpoint.

THE THEORETICAL KEY

The focus on Kahlo's personal life in relation to her work has led to oversimplifications that pervade both the scholarly and popular literature. Certainly, Kahlo was concerned to use art to communicate the events of a life characterized by physical disability, pain, marginalization, and gender and political oppression. But, on greater reflection, it is evident that her work is far more nuanced than is often portrayed. A closer reading of *Self-Portrait with Cropped Hair* shows that it is highly ambiguous. It displays the ambivalence of a woman who sought power through association with powerful men but at the same time dreamed of independence from these demeaning alliances. Within the space of her imagination, Kahlo actively played with the fluidity of gender.

Self-Portrait with Cropped Hair is a fundamentally equivocal image, mixing what seems to be the desire for self-mutilation and self-liberation. The painting is open to all sorts of interpretation. For example, the hair has several meanings. Long hair can be a symbol of femininity. By cutting it off and also donning male clothes, Kahlo seems to show an act of defiance about her subordinate female position. But, more broadly, long hair is a symbol of power, and so cutting it off means loss of potency. Then again, short hair and the suit give Kahlo the possibility of mimicking men, thereby adopting the status and power associated with manhood. She strives through this visual transformation to take on man's power. It is worth noting that Kahlo took an interest in the fluidity of gender, by always refusing to remove her facial hair and, as a young woman, by cross-dressing frequently.

At the same time, this painting also dramatizes Kahlo's distress that she is no longer desired by her husband (Rivera, who especially admired her long hair, had recently had an affair with her younger sister). In this context, the scissors, which are held at crotch height, are especially provocative, and difficult to interpret. On the one hand, they can be read as the male sex organ, implying the female's lack of the phallus. On the other, they can signal the appropriation of the phallus. Then again, the position and the shape of the open blades suggests the female sex organ, which is now cast as a *vagina dentata* (literally, a 'toothed vagina'), thereby symbolizing the power of women, either imagined or real, to injure or emasculate men.

The psychologist Carl Jung referred to what he termed the *anima* and *animus* – the intertwining of feminine and masculine characteristics within every human psyche. He argued that in order for what he called true 'individuation' – that is, the process of healthy psychological development – to occur, it was necessary for males to come to terms with their *anima* and females with their *animus*. In this context, Kahlo's painting can be viewed as a manifestation of this masculine dimension of herself, now partly projected on to her former husband.

Sigmund Freud's concept of the double is also a useful reference point. Freud described how a child creates multiple projections of themselves before settling on one that becomes the ego-self. These older versions, or doubles, reappear in adulthood when someone re-encounters what Freud termed the 'narcissism of the child' within them, thereby causing a return to an earlier, more primitive state of being. When this happens, Freud described it as producing the experience of the 'uncanny'. In this reading, the double depicted by Kahlo is a split-off masculine persona, a representation of an aspect of her own self that had to be denied in order to preserve the acceptable self-image as a woman.

THE MARKET KEY

Self-Portrait with Cropped Hair entered the collection of the Museum of Modern Art, New York, as a gift from Edgar Kaufmann, Jr, an architect, lecturer and author, who was also director of the Industrial Design Department at MoMA. Kahlo knew his father, who also purchased examples of her work. During her lifetime, her paintings were well received – she was the first twentieth-century Mexican artist to have a work acquired by the Louvre. However, after her death, her reputation faded, and by the 1960s, she was almost forgotten.

Her first museum retrospective in the United States, held in 1978 at the Museum of Contemporary Art, Chicago, was an immediate success, and by the mid-1980s, Kahlo's work was firmly in the ascendant. In 1983, Hayden Herrera's book *Frida: A Biography of Frida Kahlo* introduced the artist and her work to a wider audience, and a film called *Frida* starring Salma Hayek appeared to critical acclaim in 2002.

In 2015, Christie's, New York sold a painting by Kahlo dating from 1939 for $8 million, a record for a price paid at auction for her work. Sotheby's has privately sold some of her paintings for more than $15 million each. The pop star Madonna is a major collector of her work. One reason that Kahlo's paintings now fetch such high prices on the international market is that, for several decades, Mexico barred their export in an attempt to conserve the country's cultural heritage.

THE SCEPTICAL KEY

The rediscovery of Kahlo's work in the 1970s coincided with a period when feminist scholars were searching for women artists, and scholars of non-Western art were seeking indigenous artists to discuss and promote. As a result, Kahlo's paintings either lie hidden beneath explorations of her life in lurid detail or feature as illustrations for a feminist analysis of her work. The context of radical agitation, and the role of Kahlo's art as an aspect of political struggle in Mexico are frequently ignored.

From a certain feminist perspective, Kahlo's paintings could be seen to present clichéd notions of struggle that risk conflating women's suffering with aspects of their constitution, while in the context of world art they often do little more than supply exotic and easily digestible representations of Mexico.

FURTHER VIEWING

Museo de Arte Moderno, Mexico City
Museo Dolores Olmedo, Mexico City
Museo Frida Kahlo, Mexico City
Museum of Modern Art, New York

Frida (2002), a film directed
by Julie Taymor

FURTHER READING

Christina Burrus, *Frida Kahlo: 'I Paint My Own Reality'*, Thames & Hudson, 2008

MacKinley Helm, *Mexican Painters: Rivera, Orozco, Siqueiros and Other Artists of the Social Realist School*, Dover, 1989
Hayden Herrera, *Frida: A Biography of Frida Kahlo*, Harper & Row, 1983
Hayden Herrera, *Frida Kahlo: The Paintings*, Harper Perennial, 2002
Frida Kahlo, *The Diary of Frida Kahlo: An Intimate Self-Portrait*, Harry N. Abrams, 2005
Helga Prignitz-Poda, *Frida Kahlo: The Painter and Her Work*, Schirmer/Mosel, 2004
Catherine Reef, *Frida & Diego: Art, Love, Life*, Clarion Books, 2014

FRANCIS BACON

Head VI, 1949

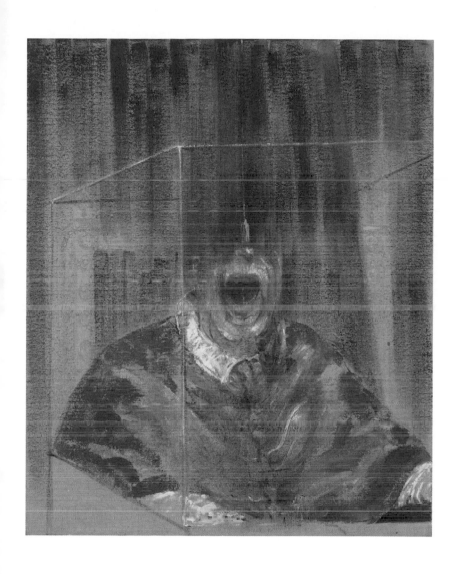

Oil on canvas, 93.2 × 76.5 cm (36¾ × 30 in.)
Arts Council Collection, Southbank Centre, London

Francis Bacon (1909–1992) remained committed to painting the human figure at a time when many of the most ambitious artists were moving into expressive abstraction. He believed that it was no longer possible to depict the human presence according to conventional notions of beauty, because they had been ruined by the tragic course of modern history. However, the spontaneous execution and unsavoury subject matter of *Head VI* should not distract us from paying careful consideration to the deeper sense of order the work evokes.

THE HISTORICAL KEY

Head VI was the last in a series of male heads completed by Bacon between 1948 and 1949 that are linked by the stylistic traits of a central figure, a dark background, scumbled vertical lines and a transparent scaffold or boxlike structure. While the earlier figures in the series are recognizably modern people, some of them wearing shirts and ties, this one differs in the striking introduction of lush purple robes and the suggestion of an ornate throne. These elements are in fact derived from Bacon's study of Diego Velázquez's *Portrait of Pope Innocent X* (c. 1650; Galleria Doria Pamphilj, Rome). *Head VI* thus became the first of Bacon's celebrated series of 'Popes' based on Velázquez's masterpiece.

The convention of citing the work of another artist was common before the modern period, but rare when Bacon chose to refer to a masterpiece by an artist from three hundred years earlier. He may have got the idea from Vincent van Gogh, who radically transformed pictures by Eugène Delacroix, Jean-François Millet and the Japanese artist Hiroshige. Around the same time as Bacon, Pablo Picasso (see p. 32) also reinterpreted the masterpieces of earlier artists, including Velázquez (but never his *Pope Innocent X*).

Bacon did not base *Head VI* on a direct encounter with Velázquez's original in Rome, which he never actually saw, saying he preferred to use reproductions in books. Working from photographs was a common practice for Bacon, and the imagery for his paintings was often inspired by his archive of photographs culled from a bewildering variety of sources. Another source for this painting, for example,

is a film still from Sergei Eisenstein's *Battleship Potemkin* (1925), featuring a close-up of a screaming nurse shot by soldiers on the Odessa steps. By using these different sources, radically altered but still remaining recognizable in the new work, Bacon was able not only to make a link between historical and modern times, but also to change completely the meaning of the originals.

In *Head VI*, Bacon has created a deeply disturbing image that is very far from the mood conveyed by Velázquez's original. The period during which Bacon came to critical notice has been dubbed the Age of Anxiety, and, in many ways, Bacon is one of its most emblematic artists. Indeed, it is natural to use his works as illustrations of humankind after the horrors of the Second World War and the more recent Cold War. In Bacon's hands, the confident authority and self-assurance of the Velázquez are transformed into an iconic image of existential agony, one more befitting of an age reeling from the recent revelations of the Nazi death camps and the detonation of atomic bombs at Hiroshima and Nagasaki. As the American writer George Steiner wrote: 'The spheres of Auschwitz-Birkenau and of the Beethoven recital, of the torture-cellar and the great library, were contiguous in space and time. Men could come home from their day's butchery and falsehood to weep over Rilke or play Schubert.'[21]

Bacon had no time for abstract art. He hated the Mark Rothko room in the Tate Gallery, London (see p. 110), because to him it failed to confront the necessity of linking the instinctual act of making with a record of the visible world. For Bacon, there was little trace of the tragic in Rothko – there was nothing much to see or feel beyond the decorative colours in the American's art; he felt that it could only express the arbitrary play of unfocused emotions.

THE BIOGRAPHICAL KEY

Francis Bacon was born in 1909 in Ireland to Protestant English parents. He never attended art school. While living in Paris between 1927 and 1929 and working as an interior and furniture designer, he saw an exhibition of Picasso's paintings that inspired him to become an artist. He moved to London and began painting while also continuing to work as an interior designer. It was only

Francis Bacon in his studio, *c.* 1960. Photograph by Paul Popper

at the end of the Second World War that he began to gain any significant critical attention.

Bacon lived in what has been described as the 'gilded gutter',[22] drinking and gambling heavily, and engaging in doomed and sometimes violent homosexual relationships. Because his paintings often have a direct relationship to the events and people in his life, biographical information can help to shed light on the significance of his work. Indeed, as Bacon said in an interview: 'I feel ever so strongly that an artist must be nourished by his passions and his despairs.'[23]

All his life, Bacon suffered from chronic asthma, which often left him short of breath; like many other paintings by Bacon, *Head VI* conveys a very strong sense of uncomfortable confinement and the fear of suffocation. But the painting may particularly reflect the artist's difficult relationship with his father, a horse trainer with a military background who could not tolerate his son's sexuality. When his son's preference became obvious, he disowned him.

In 1927, Bacon moved to Berlin, which was at the time a homosexual's paradise. *Head VI* casts the Pope as a kind of awful drag queen. Bacon was one of the first artists to reveal his sexual preference in his work, and at a time when homosexuality was still a punishable crime. The word 'Pope' derives from the Italian word 'papa', meaning 'father', suggesting a reference to Bacon's own father. The love of art, the 'camp' and Bacon's feelings towards his father all fuse to produce a powerfully evocative image. At the same time, however, the choice of a historical model also serves to distance the subject from any biographical context, contributing to the detached and impersonal dimension of the work.

There was clearly a cathartic function behind Bacon's work in general, which was rooted in deep-seated psychological traumas and desires. But we should be wary of making too close a link between his life and this painting. Bacon did not make *directly* autobiographical works, nor was he in any way interested in illustrating events from his own life. Indeed, Bacon himself warned against making simplistic judgments relating to the biographical. 'Very few people have a natural feeling for painting, and so, of course, they naturally think that painting is an expression of the artist's mood. But it rarely is,' Bacon noted. 'Very often he may be in greatest despair and be painting his happiest paintings.'[24]

THE AESTHETIC KEY

Painted quickly, *Head VI* conveys a powerful sense of urgency. It was important for Bacon that he worked without planning and with spontaneity. 'In my case all painting...is an accident', he said.[25] For Bacon, painting had to be something primarily instinctual – it is 'an attempt to bring the figurative thing up onto the nervous system more violently and more poignantly'.[26] But it was also necessarily a cultural undertaking, something that gained significance from marrying instinct to specific historically sanctioned conventions. 'The creative process is a cocktail of instinct, skill, culture and a highly creative feverishness. It is not like a drug,' he insisted.[27]

However, at the same time, Bacon has produced a painting that is far from chaotic. As he also noted: 'Great art is deeply ordered. Even if within the order there may be enormously instinctive and accidental things, nevertheless they come out of a desire for ordering and for returning fact onto the nervous system in a more violent way.'[28]

Three pictorial elements constantly recur in many of Bacon's work – a large field that functions as a ground, a human figure (or figures) and the suggestion of a place. The last is normally a round area, a ring, or, as in *Head VI*, a boxlike contour or container, which provides the common limit of both figure and field.

Bacon had the unusual practice of painting on the unprimed side of linen canvas, with the result that the oil paint sits dryly on the surface in places, while in others it is absorbed into the linen's grain. He has moved the brush vertically to produce the striations in the background of the image, while dabbing paint more thickly for the purple robe and the face.

Bacon pushes visual interest into the bottom half of the canvas, leaving the top a dark, looming, void-like space. The curious presence of a window-blind tassel above the head creates a sense of surreal dissonance, while also helping to make the main focus of attention the screaming mouth. As Bacon said: 'I like...the glitter and colour that comes from the mouth, and I've always hoped...to paint the mouth like Monet painted a sunset.'[29] He added that he'd never succeeded.

The boxlike frame keeps attention within the composition: 'I cut down the scale of the canvas by drawing in these rectangles which concentrate the image down,' he said.[30] He has also organized the

painting so that the tassel, the centre of the gaping mouth and a button on the coat are placed on the vertical golden section (the proportion that lies just off-centre of a composition), which is particularly pleasing to the eye. But what we see there is very far from beautiful.

THE EXPERIENTIAL KEY

Bacon made a clear distinction between what he called the 'brain' and the 'nervous system', or between the activity of thinking and of feeling. For him, a painting's purpose was to work as directly as possible on the latter. 'Some paint comes across directly onto the nervous system', he said, 'and other paint tells you the story in a long diatribe through the brain.'[31] The experiential dimension was paramount. As the philosopher Gilles Deleuze notes in his study of Bacon, he effectively 'rips the painting away from all narrative but also from all symbolization', and, as a result, we experience 'the violence of sensation – in other words, the act of painting'.[32]

There is an unfinished, furtive quality to *Head VI*, as if Bacon wished to convey the feeling that he has caught something only vaguely glimpsed, or perhaps just too horrible to bring into sharp focus. There is a powerful sense of things falling, or of pressure exerted from above. The face seems to be dissolving into the background. Or is it emerging?

The boxlike structure gives the impression that the figure is presented as an exhibit in a gruesome fairground booth or at a zoo. The fact that it seems to be enclosing the figure, and could be made of glass, also suggests that the scream is silent, which adds to the horror of the moment Bacon depicts. This is an unheard cry, a gesture of futility. The thin white lines, which suggest a cage or glass box, are drawn in semi-perspective, which counters the evanescent feeling and flatness of the black brushstrokes. But, at the same time, this structure is not very solidly depicted – it is only tentatively inserted or asserted. In fact, the whole painting is a clash between flatness and the suggestions of illusionary space in the face, the robes and the cage. The perfunctory use of the oil medium, the drab colour, the inelegant brushstrokes and the centralized organization of the composition give the work a deliberate ugliness. These features combine

with the subject matter to convey a powerful sense of inner necessity, as if anything other than this treatment would be inauthentic.

The overwhelming feelings associated with the painting are of dread, horror and claustrophobia. Bacon asks us to share in his vision of the world, to recognize a 'terrible' beauty we would rather ignore. As he said: 'I've always hoped to put over things as directly and rawly as I possibly can, and perhaps, if a thing comes across directly, people feel that that is horrific.'[33] Bacon forces us to look upon a scene that seems to have been ripped from the world of current affairs, while also alluding to history, and, in this case, the history of art. He forces the unresolved confusion he creates into a definitive state, one that resonates within a deep cultural context. In *Head VI*, the device of the cage, the cropping of the image at the bottom of the composition and the fact that the work was intended to be framed behind glass, enhance the sense that we are being put at a distance.

THE THEORETICAL KEY

Bacon declared that what was unique about modern existence was that 'man now realizes that he is an accident, that he is a completely futile being, that he has to play out the game without reason.'[34]

While he was developing his mature style, the Existentialists were arguing that art must begin from the fundamental recognition that humanity exists in a meaningless universe. Jean-Paul Sartre claimed that 'man is condemned to be free' and lives in a raw state of pure sensations before he defines himself and takes on the fixed identity mandated by society. He said that 'hell is other people', but also that human life is necessarily involved with others.[35]

Albert Camus declared that 'at the heart of all beauty lies something inhuman',[36] and that the ability to choose suicide is the ultimate proof of freedom. Existentialism advocated a state of continuous revolt against the values of the status quo, because only then can true authenticity be embraced, and stoically celebrated what Camus called 'the gentle indifference of the world'.[37]

But perhaps a closer link in sensibility with Bacon can be made to another Irishman, the writer Samuel Beckett. Both addressed what Bacon called the 'brutality of fact', demonstrating in their work that,

even when human life is stripped of any consoling meaning, it is still possible to embrace the intensity of life, the capacity for endurance grounded in the experience of being alive. Although Beckett, like Bacon, took a bleak view of human nature, he claimed it was simply an honest and truthful response to the world, and that he was actually an optimist – or that his body was optimistic. As Bacon put it, the 'nervous system' always instinctively seeks gratification and fulfilment, even while psychologically or spiritually one might be close to despair. And so, as Beckett wrote: 'You must go on, I can't go on, I'll go on.'[38]

THE SCEPTICAL KEY

Committed to the idea of the image, Bacon felt the role of the artist was to generate new and unsettling pictures. But his interest in a specific relationship to this image reveals the essentially reactionary nature of his practice. Unlike other modern artists, who questioned the necessity of figurative style, channelling their creative energies into exploring new forms of expression, or who rejected the overtly expressive in favour of a detached attitude to the creative process, or who used their work to draw the viewer into a greater participatory role, Bacon remained largely hobbled by traditional views about painting. Despite his use of exaggeration and distortion, and his choice of deliberately unsavoury subjects, he insisted that a painting must communicate to the viewer through an in-built message conveyed in an essentially familiar way.

Bacon stage-managed his self-image. He was a showman who knew how to manipulate his audience, deftly presenting himself as a decadent genius. He produced some powerful and original work from the mid-1940s to the late 1950s, but after that merely reused a tried-and-trusted formula, and his work became increasingly trite and predictable. With the passage of time, Bacon's imagery looks increasingly 'gothic' in the pejorative sense. It is melodramatic theatrical staging in the style of the Grand Guignol, a dramatic entertainment with sensational and horrific contents that betrays an almost adolescent exaltation of misery, brutality, misogyny and self-hatred. Rather than seeking to use art as a form of reparation

and affirmation, Bacon deliberately exploited it to indulge his – and our – worst fantasies.

THE MARKET KEY

Head VI was exhibited in 1949 in Bacon's first one-man show at the Hanover Gallery, London. It was purchased from that dealer by the Arts Council of Great Britain in 1952. Six years later, Bacon moved to the more commercial Marlborough Fine Art, which had a reputation for lobbying for solo exhibitions of their artists in renowned museums. Soon Bacon's work was selling for record prices, and he was exhibiting in major museums.

When Bacon died, he made John Edwards, his closest friend in the last sixteen years of his life, the sole heir to his paintings and properties. In 1999 the estate sued Marlborough Fine Art, alleging, among other things, that it had grossly underpaid Bacon for his works in London and resold them through another branch at much higher prices. But the lawsuit was dropped in early 2002.

In 2007, another of the *Popes* series, *Study from Innocent X* (1962), sold for $52,680,000 at Sotheby's New York, at the time a record for the artist at auction. Six years later, *Three Studies of Lucian Freud* (1969) set the world record at the time for the most expensive piece of modern art ever sold at auction when it went for $142,405,000 at Christie's, New York.

FURTHER VIEWING

Arts Council Collection
Guggenheim Collection
The Hugh Lane, Dublin
(Francis Bacon Studio)
Musée National d'Art Moderne,
Centre Georges Pompidou, Paris
Museum Ludwig, Cologne
Museum of Modern Art, New York
Tate Britain, London

Francis Bacon: A Brush with Violence
(2017), a film directed by Richard
Curson Smith
*Love Is the Devil: Study for a Portrait
of Francis Bacon* (1998), a film
directed by John Maybury

FURTHER READING

Ernst van Alphen, *Francis Bacon and the
Loss of Self*, Reaktion Books, 1992
Gilles Deleuze, *Francis Bacon: The Logic
of Sensation*, Continuum, 2003

Christophe Domino, *Francis Bacon:
'Taking Reality by Surprise'*,
trans. Ruth Sharman,
Thames & Hudson, 1997
Daniel Farson, *The Gilded Gutter Life
of Francis Bacon: The Authorized
Biography*, Vintage Books, 1994
Martin Harrison and Rebecca Daniels,
Francis Bacon: Incunabula,
Thames & Hudson, 2008
Michael Peppiatt, *Francis Bacon:
Anatomy of an Enigma*, Weidenfeld
& Nicolson, 1996
David Sylvester, *The Brutality of Fact:
Interviews with Francis Bacon*,
Thames & Hudson, 1987
Armin Zweite and Maria Müller, *Francis
Bacon: The Violence of the Real*,
Thames & Hudson, 2006

MARK ROTHKO

Black on Maroon, 1958

Oil paint, acrylic paint, glue tempera and pigment on canvas,
266.7 × 381.2 cm (105 × 150 in.)
Tate, London

One of the leading Abstract Expressionists, Mark Rothko (1903–1970) produced *Black on Maroon* as part of a commission in 1958 to provide a group of paintings for the Four Seasons Restaurant in the Seagram Building in New York. The lack of overt symbolism or content in Rothko's paintings has led them to be interpreted in radically different ways – as explorations of colour relations or as evocations of deep, timeless emotions. While Rothko's work is classified as American abstract art, and often discussed as representing a radical break with European art, detailed study reveals the continuing relationship between his painting and traditional European subjects and aesthetic goals.

THE HISTORICAL KEY

Rothko belongs to a generation of American artists preoccupied with establishing a uniquely *American* style painting. They argued that only in America was it possible to bring to maturity and transcend European art's most important characteristics. These artists became known collectively as the Abstract Expressionists; other important figures include Jackson Pollock, Clyfford Still, Willem de Kooning, Franz Kline, Hans Hofmann, Barnett Newman, Adolph Gottlieb and Robert Motherwell. Together, they forged a new kind of painting that, in terms of sheer scale and technical bravura, made European art look domestic and antiquated almost overnight.

After labouring on the Four Season's commission for two years, Rothko decided to abandon it, as he had concluded that the location was unsuitable. The numerous works he produced in the meantime are now known collectively as the Seagram Murals. This single painting should not therefore be considered as a unique piece, but rather as part of a sequence comprising a kind of frieze or environmental installation. As such, it belongs more to the tradition of the public mural produced for the church, the nobility and the state than to the conventions of the private 'easel' painting.

More than an arrangement of colours on a flat surface, *Black on Maroon* subtly draws on the imagery and symbolism with which viewers will be familiar from other works of art, their cultural heritage and their experience of everyday life. For example, the painting's

composition can be understood to allude to a window, or to suggest the doors of an imposing building. Invoking Rothko's Jewish heritage, it might also be understood to allude to the doors of a tabernacle, or the open pages of a great book, like a Torah, seen from above. Another important art-historical relationship is with the tradition of the sublime in Romantic painting. Parallels can be drawn with the paintings of Caspar David Friedrich and J. M. W. Turner. As a concept, the sublime emerged in the eighteenth century, when it was intended to represent the contrary of the beautiful. The latter, through the depiction of reassuring and visually attractive imagery, evokes feelings of pleasure, but the sublime deliberately courts extreme emotions such as terror and ecstasy through the depiction of awe-inspiring mountains, stormy seas or vast empty vistas. Here, confusing forms and blurred outlines emphasize the vastness of scale, suggesting absence rather than presence, or what cannot be represented rather than what can, without any attachment to the imagery of nature. Like other works by Rothko, *Black on Maroon* also draws on landscape paintings that imitate atmospheric effects – mists, fogs, hazy panoramas, twilight, etc. – the featureless immensities of the natural world. His work has been described as 'abstract sublime',[39] in that these atmospheric effects are now removed from their relationship to a specific natural environment.

But Rothko's work also stems from a very different art-historical lineage. Almost every day for months between 1949 and 1950 Rothko stood in front of Matisse's *The Red Studio* (p. 20), newly acquired by the Museum of Modern Art, New York. From that experience, Rothko learned that a field of colour could have a powerful emotional effect on the viewer. More broadly, this places Rothko's paintings in a long tradition of Western art that prioritizes colour and the emotions over line, the rational and the analytic. But it also links Rothko not so much to a northern European Romantic tradition associated with the sublime as to the School of Paris, suggesting a different aesthetic reading of his work as more decorative. He brings to fruition the experiments of artists who liberated colour from its subordination to line and uncoupled painting from the role of imitating the three-dimensional world, placing it instead at the service of sensual expression.

THE AESTHETIC KEY

Visually, what is most striking about *Black on Maroon* is its sheer scale. It is by far the biggest painting to have been discussed so far in this book. The work's flatness is especially pronounced, as Rothko has laid on paint and created forms that lie parallel to the surface. He divides the plane into discrete shapes, but the fact that these shapes run parallel to the edges of the canvas means that a frame within a frame is produced, which thereby ensures the shapes appear flat. By removing any suggestion of figurative representation within the rectangle of canvas through the substitution of a field of colour and the shape of the forms, Rothko focuses our attention on the materials with which he has made the work.

But, at the same time, Rothko juxtaposes the perception of flatness with a sense of deep, indeterminate space, which is produced by optical means. Rather than using the convention of perspective, he exploits the tendency of colours to be themselves spatial, in the sense that the central pale-maroon shapes seem to sit further away from the eye than the deep maroon-black forms that frame them. But these spatial locations are by no means secure, and there is a degree of oscillation between the forms, as they jostle to maintain the surface tension. The result is a strangely elusive and moody space.

THE EXPERIENTIAL KEY

In front of *Black on Maroon* in the room dedicated to the Seagram Murals at Tate Modern, London, we immediately become aware of how this large single work relates to the other equally large paintings hanging there. The effect is environmental; it is as if we are *within* a total work, rather than outside an individual one. In addition, our experience has an added temporal or narrative dimension, in that we see the paintings in relation to each other.

Rothko radically reduces the degree of visual detail and contrast in the painting itself. It is difficult to decide what is figure and what is ground. Are the two pale-maroon rectangles at the centre the figures, and the darker areas the ground, or are these central rectangles the same ground as we see around the edges, and so are holes in the dark

figure? As a result of this ambivalence, we perceive the mercurial nature of the visual. The painting invites us to understand it in two ways, engaging us not as static observers but as animated actors. If we look at it from a distance, we sense its ambiguous spatiality. The effect is rather like the after-image created by looking at a window and then closing our eyes. But, when we move up close, the painting's flat, wall-like surface imposes itself. These two experiences should be incompatible, but somehow Rothko uses them to set in motion a process characterized by transformation.

By abandoning the 'normal' perceptual basis of looking at a static, figurative picture, Rothko has introduced a level of awareness that is directed inwards and characterized by the tracing and erasing not only of perceptual but also psychic boundaries. The dominance of the fields of colour enhances our emotional engagement, as colour is inherently an emotional trigger. From a perceptual viewpoint, the effects produced by Rothko are analogous to the limited information we garner from the periphery of the visual field, or in twilight and dimly lit spaces, when there are no visible contours, no overall contrast, or insufficient or ambiguous and unstable perceptual cues, and our minds resort to filling in the gaps.

The lack of visual form is compensated for by acts of imaginative projection. When familiar content seems to be missing, memory becomes a vital stimulus, leading us away from the outer realm of perceptual experience towards the inner realm of thought and imagination – the inner-directed regions of consciousness. What has been left out, erased or concealed plays on our mind. Inevitably, these absences are multiple, conflicting and irresolvable. Such awareness of absence invites us to ask questions and generates a potentially fruitful space of uncertainty. Instead of the missing content imposing itself in the way visible content would, it releases the work from the restrictions of prescribed meanings, facilitating freedom of the imagination and the open construction of hypotheses.

THE BIOGRAPHICAL KEY

Mark Rothko was born Marcus Rothkowitz, of Jewish parents, in Dvinsk, Russia, in 1903. When he was ten years old, his family

emigrated to Portland, Oregon. Although he began to study at Yale, he dropped out, and by 1923 was living as an artist in New York. However, it was not until about 1949, when Rothko was in his mid-forties, that he found his signature style.

For Rothko, who saw himself as part of a long tradition of artists who believed that art had to be revitalized, the main goal of painting was to convey a sense of what he called 'tragedy'.[40] As a Jew who had lived at the time of the Holocaust, he must have felt very acutely this emotion, which was perhaps also affected by something akin to survivor's guilt. Rothko rejected the idea that his work was concerned with decorative colour relations. He insisted that, although his paintings were devoid of any obvious subject matter, people's strong reactions, such as breaking down and weeping, proved his paintings were capable of communicating the essential content of great and noble art. Rothko considered himself an unrelenting critic of the society that rewarded him with fame and wealth on aesthetic grounds he could not control. This paradox may have contributed to his decision to commit suicide in 1970.

THE THEORETICAL KEY

Rothko's decision to abandon figurative representation cannot be understood in purely stylistic or aesthetic terms – it must be linked to an upbringing in Judaism, which mandates that the divine cannot take on material form. Within a broader cultural context, Rothko's aniconism can be related to Platonic and mystical traditions, in which it is believed that embracing the spiritual means escaping the world of appearances in order to move into alignment with the 'ground of being', the 'primal' or the 'One'. It is this experience that Rothko hoped *Black on Maroon* would evoke.

Rothko's interest in the idea of tragedy came in part from his reading of Friedrich Nietzsche. The German philosopher stressed that reality exists independently from any ability to think about it, and is wholly indifferent to human existence and oblivious to human values and meanings. In such circumstances, so Nietzsche declared, 'the highest values devalue themselves'.[41] But the ensuing sense of meaninglessness did not necessarily lead to despair. Rather,

Mark Rothko in his New York studio, 1960. Photograph by Rudy Burckhardt

it could be celebrated as an invigorating intellectual discovery. The pursuit of the void was a modern kind of heroism, signalling the willingness to reject illusory consolations. A new kind of art was required, one that could face up to radical negation and rebuild culture beyond 'nothingness'.

Psychologically, Rothko's painting may evoke what Freud termed the 'oceanic feeling'.[42] It brings awareness that everything is connected to everything else. But, as Freud argued, this feeling is a grave danger to the security of the firmly structured and 'mature' ego. To embrace the 'oceanic feeling' means regressing to a dedifferentiated state of zero tension dangerously tied to the 'death drive'. *Black on Maroon* displays this ambivalence. Rothko orchestrated effects intended to wean the viewer away from the solid geometry of the external world and from the security of an ego-centric reality. However, his attempt to share an 'oceanic' subjectivity is also suffused with considerable anxiety concerning the consequences of such boundary-free fusion. In this sense, *Black on Maroon* is simultaneously a vision of union *and* of suffocating entrapment. Is it an invitation to enter a womb or a tomb?

THE MARKET KEY

Rothko's self-fashioning as an artist was closely linked with the idea of the artist as an outsider, and as a staunch opponent of bourgeois values. To an acquaintance, Rothko declared that his intentions in taking up the restaurant commission were malicious: 'I hope to paint something that will ruin the appetite of every son of a bitch who ever eats in that room,' he announced.[43] But, in the event, the 'richest bastards in New York', as he called them, would be spared the indigestion.[44]

In 1965, the Tate Gallery in London began discussions with Rothko about a possible donation. Three years later, *Black on Maroon*, then known by another title, was donated to the gallery. Finally, in 1970, a suite of pictures arrived in London. Since then, Tate's Seagram Murals have nearly always been on display in a dedicated room, offering an oasis of meditative reflection in the gallery.

THE SCEPTICAL KEY

Rothko's work reveals one of the major problems with abstract art in general: its vulnerability to arbitrary readings. Indeed, Rothko struggled with the way his works were often misinterpreted, an inevitable consequence of their simplicity. For example, many considered him a consummate colourist, but Rothko roundly rejected this idea. He was therefore the victim of the very reductive approach he had taken.

There has been much speculation about Rothko's reasons for first pursuing the lucrative commission that led to the series of paintings of which *Black on Maroon* is a part and then, much later, turning it down. It seems surprising that he accepted a commission that inevitably cast his work as a decorative backdrop to expensive dining. His confusion around the commission demonstrates Rothko's ambivalence about the artist's role in society. Although he denied it, Rothko also sought success, and in a sense, wanted to have his cake and eat it. He was keen to uphold the heroic stance of authentic outsider, but also craved recognition and financial reward.

FURTHER VIEWING

Museum of Modern Art, New York
National Gallery of Art, Washington DC
Rothko Chapel, Houston, Texas
Tate Modern, London
Whitney Museum of American Art,
 New York

FURTHER READING

David Anfam, *Abstract Expressionism*,
 Thames & Hudson, 1990
David Anfam, *Mark Rothko: The Works
 on Canvas*, Yale University Press,
 in association with the National
 Gallery of Art, Washington DC,
 1998
Dore Ashton, *About Rothko*, Oxford
 University Press, 1983
James E. B. Breslin, *Mark Rothko:
 A Biography*, University of
 Chicago Press, 1993

Anna C. Chave, *Mark Rothko: Subjects
 in Abstraction*, Yale University
 Press, 1989
Annie Cohen-Solal, *Mark Rothko:
 Toward the Light in the Chapel*,
 Yale University Press, 2015
Miguel López-Remiro (ed.), *Mark
 Rothko. Writings on Art*, Yale
 University Press, 2006
Glenn Philips and Thomas Crow (eds),
 Seeing Rothko, Getty Research
 Institute, 2005
Robert Rosenblum, *Modern Painting
 and the Northern Romantic
 Tradition: Friedrich to Rothko*,
 Icon, 1977
Christopher Rothko (ed.), *The Artist's
 Reality: Philosophies of Art*, Yale
 University Press, 2006
Lee Seldes, *The Legacy of Mark Rothko*,
 DaCapo Press, 1996
Diane Waldman, *Mark Rothko, 1903–
 1970: A Retrospective*, Harry
 N. Abrams, 1978

ANDY WARHOL

Big Electric Chair, 1967–68

Acrylic and lacquer applied to screen print on canvas, 137.2 × 185.3 cm (54 × 73 in.)
Musée National d'Art Moderne, Centre Pompidou, Paris

In the late 1950s, artists began make a new kind of art based on the consumer products and the advertising copy of contemporary mass culture, adopting the styles and techniques of commercial artists. The borderline between high and mass culture became fluid, as Andy Warhol (1928–1987) engaged with the nature of contemporary society, and, in particular, with the pervasiveness of the mass media and with transformations in lifestyle and beliefs caused by new communication technologies and consumerism. Pop art tends to be associated with banal images of logos and mass-produced products, but, in *Big Electric Chair*, Warhol deals with something altogether more unsettling.

THE BIOGRAPHICAL KEY

Warhol was born Andrew Warhola in 1928 in Pittsburgh, Pennsylvania, of working-class Slovakian immigrants. In 1949, not long after his father's death, Warhol moved to New York City, where he soon became one of the city's most successful commercial illustrators. But by the early 1960s, Warhol's ambition was to be fêted as a fine artist. In 1962, he exhibited for the first time his now-iconic *Campbell's Soup Cans*, which immediately declared through choice of subject and style that Warhol intended to bring mass-consumer culture into the rarefied world of avant-garde art.

Two years later, Warhol opened his studio, the Factory. This cavernous, silver-painted warehouse quickly became a vibrant hub of creative activity, where the artist collaborated with an ever-shifting circle of artists, filmmakers, writers, photographers, actors, musicians and hangers-on. He explored many different media, including photography, sculpture, video and film (over sixty), and several books. A magnet for the glamorous New York demi-monde, the Factory was the scene of legendary parties. Warhol avidly embraced his own celebrity; he behaved more like a film or pop star than an artist.

In the 1970s, Warhol became a modern-day society portraitist, making silk-screen portraits of the wealthy on commission, while in the 1980s he moved into television and celebrity magazine publishing. He died suddenly, aged fifty-nine in New York, of complications following a routine operation.

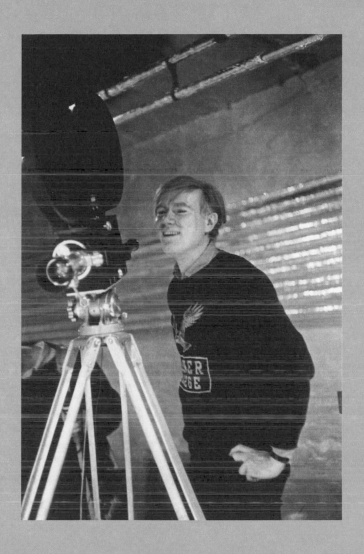

Andy Warhol, 1964. Photograph by Eve Arnold

While the style and subject matter of *Big Electric Chair* reveal little about the character of the artist who made it, the life and work of Andy Warhol are nevertheless inextricably linked. Warhol's homosexuality greatly influenced his work, for example, helping to shape his relationship to the art world. Several works have their roots in gay underground culture. Warhol was also a practising Byzantine Catholic (a Roman Catholic of the Orthodox rite, the faith he inherited from his Slovakian immigrant parents), which also informs his practice as an artist.

The art historian Thomas Crow argues that there are three distinct Warhols: the self-created one who made numerous pronouncements and stage-managed his public persona; the Warhol whose interests and passions figure in his work; and the Warhol who explored a subculture far removed from the world of art. This third Warhol is rarely discussed in an art-historical context. Often the first Warhol conceals the second, acting as a smokescreen to hide the fact that his work functions much as art has always has done – that is, as the expression of a personal voice within a context determined by the specific culture of the artist.

Warhol was a barometer of social change, and signals the assimilation of the artist into mass culture. The image of the artist starving in his or her garret was replaced by the concept of the artist as a 'smooth operator' working within a complex system based on sophisticated communication media and economic exchange.

THE HISTORICAL KEY

Big Electric Chair and the forty other versions of the same photographic source – a press photograph of the electric chair in which Julius and Ethel Rosenberg were executed in 1953 for passing designs for nuclear weapons to the Soviet Union – belong to a larger series entitled *Death and Disaster* that Warhol began in 1962. Other works in the same series, also based on press photographs, include paintings of a race riot, an aeroplane crash and a road accident involving an ambulance. Warhol was representing the dark underbelly of the American dream – the American 'nightmare'. The electric chair, which had been invented in the second half of the nineteenth century,

was first used in 1890, and when Warhol began his series in 1964, this method of execution had been outlawed the year before in the state of New York, where the last two executions occurred in the Sing Sing State Penitentiary.

From a broader art-historical perspective, the *Death and Disaster* series belongs within the tradition of *vanitas* painting, which depict *memento mori* – symbols such as skulls or decaying flowers, and are intended to remind viewers that death is inevitable and that they should live their lives in the light of this sobering fact. Despite the use of silk-screen printing and the decorative application of colour, *Big Electric Chair* has considerable emotional impact.

At the time the screen prints were made, Warhol's use of a highly charged imagery culled from the contemporary news had the shocking effect of reintroducing into American painting the figurative content that had seemingly been banished by Abstract Expressionism. By introducing an element of parody into this work through its scale and use of two fields of flat colour separated by a straight diagonal line, Warhol seems to allude to the geometric abstraction of the period as practised, for example, by Ellsworth Kelly or Kenneth Noland. Warhol stains the purity of such pristine chromatic fields with the image of an electric chair.

THE THEORETICAL KEY

Warhol's style and technique imply a deliberate withdrawal of judgment, symbolic reference, expressive commitment and desire to offer aesthetic fulfilment. The mechanical repetition of potent images divests them of any expressive power, rendering them banal. In this way, Warhol mimics how photographs within the mass media in general are emptied of meaning. As he said in 1963: 'When you see a gruesome picture over and over again, it doesn't really have an effect.'[45]

Warhol's work amounts to a critique not only of the implicit values and beliefs underlying the stylistic conventions associated with abstract art, but also, beyond the specific world of fine art, of the values of a society in which art is understood to function as a privileged medium for the communication of higher, essential meanings.

Instead, Warhol presents us with an art that reflects the reality of a world in which images produced by technology have eclipsed the real. A photograph of an electric chair no longer functions as a sign or symbol in the conventional sense. Instead, it signals the absence of any referent, the loss of meaning in a world dominated by countless representations. In semiotic terms, Warhol sets in motion the pure play of the signifier, which is liberated from the task of referring to a specific meaning – or a signified. Thus, the central characteristic of Warhol's work is its ability to turn the experience of art into a discourse on emptiness. *Big Electric Chair* demands only to be read.

THE AESTHETIC KEY

It is difficult to assess *Big Electric Chair* from an aesthetic point of view. It does not seem to lend itself to the kind of analysis that helps to enrich our understanding of, say, Matisse or Rothko. However, through the very act of making a painting, Warhol was inevitably still involved in a tradition that was inherently concerned with isolating on a rectangular flat surface an aspect of the world that is intended for contemplation. In this sense, Warhol was certainly concerned with aesthetic experience, and is worth considering the formal values of *Big Electric Chair*, because it challenges several tacit assumptions about the meaning of aesthetic values in relation to modern art. Warhol's preference for appropriated photographic imagery and for repetition through mechanical reproductive techniques, the lack of individual touch within his paintings and the seeming disassociation between image and colour all bring into question core aesthetic norms, especially those established around Modernist notions of formal, abstract, pictorial values.

At first, all Warhol's pictures of the electric chair may seem to be identical, but, actually, no two are alike. In the various versions made by Warhol the original photograph is framed or cropped in different ways, suggesting that Warhol considered visual and compositional issues, as well as how these choices serve to convey meaning. For example, some works from the series are cropped to include the sign 'SILENCE' from the original photograph. The crudity of the silk-screen process also means that each print on canvas is different on

the level of the mark. The lithographic ink adheres to each surface in unique ways, and so, although the positive image has not been made through the application of a brush to a canvas, it nevertheless betrays the traits of a specific moment and process.

Big Electric Chair is clearly the result of a number of formal decisions. The electric chair sits firmly on the golden section, the area just to the side of dead centre, a traditional compositional device. The choice of colour, which contributes to the emotional mood, is also striking. Within the series as a whole, colours vary considerably from austere greys, brooding reds and purples, to the more visually pleasing pinks and red and blue of this work. In this painting, the areas of colour have also been composed – the red layer reaches only partly across the surface, and towards the bottom of the canvas forms a diagonal line against the underlying pink. Indeed, the strong colour and large size of this work give it a powerful visual impact, suggesting affinities with the abstract art of the period.

THE EXPERIENTIAL KEY

When his paintings were made, Warhol's subject matter, style and technique all implied for viewers a deliberate lack of emotional motivation on the part of the artist. Warhol's own comments also confirmed that, as far as he was concerned, his work was devoid of any expressive intention, and he publicly resisted any attempt to imbue his works with profound significance, denying that they could amount to any form of social statement.

Viewers at that time were used to contemporary figurative styles that blatantly conveyed the subjective input of the artist through selective distortions, exaggerations of colour and bold brushwork (for example, the paintings of Francis Bacon; p. 95). The American art scene was dominated by Abstract Expressionism, art that repudiated the figure altogether, while also claiming to embody profound spiritual content (see Rothko; p. 110). In stark contrast, Warhol set himself the task of reproducing the familiar signs of contemporary mass culture using a printing process that severely limited any possibility of introducing the personal touch of the artist, and through this touch, awareness of expressive engagement.

However, there is no denying the emotional charge delivered by *Big Electric Chair* today. We have become accustomed to the expressive potential of art that appropriates popular imagery, uses technology to help production, and adopts a stylistically neutral, non-expressive technique. The muted and deadpan drama of Warhol's image visualizes the point at which violent death enters the political, thereby exposing us to the uncomfortable disconnect between the imagined realm of social harmony and the sudden, traumatic possibility of annihilation and death.

From an experiential perspective, death is an especially powerful theme, though it can all too easily descend into bathos and cliché. But this is not the case with *Big Electric Chair*. Warhol has created a dramatic contrast between fullness and emptiness, while managing to avoid the obvious through visual understatement. Our eyes are drawn to the solitary chair, which seems in danger of dissolving into the incoherence of the bluish-black background. The chair's uncanniness is enhanced by the loss of detail caused by the primitive printing process, producing an effect that is similar to how things look in twilight, or under very poor lighting. The painting has a vagueness, elusiveness and ambiguity that is associated with memories and dreams. Poignancy is also increased by the contrast between the morbid subject matter and the large field of delicately decorative colour on to which the image has been printed.

In *Big Electric Chair*, despite the lack of figures and the degrading of the matter-of-fact photographic source through the crude mechanical printing process, we are made aware of an absent human presence, and also of what awaits him or her. The chair stands in for – is an indexical sign of – the body that will sit, or has sat, in it – a body that we know is either dead or has only moments left to live. Psychologists have shown that one of the most powerful visual analogues for death is the perception that something is absent, but how such absence can be visually suggested is a complex problem, because absence is not the same as blankness or emptiness.

THE MARKET KEY

This version of *Big Electric Chair* was donated to the Centre Georges Pompidou, Paris, in 1976 by the Menil Foundation, in memory of John de Menil, one half of a couple who were important art patrons. At that time, Warhol was significantly under-represented in the French museum's collection.

In 2014, a mustard-yellow *Little Electric Chair* (1965), which, as the title suggests, is smaller than the work under discussion, realized $10,469,000 at Christie's, New York. Three years later, one of several signed, limited-edition screen prints on paper of the same subject fetched £6,875 at Sotheby's London.

Silver Car Crash (Double Disaster) (1963), from the same wider series as *Big Electric Chair*, set a record at auction for a Warhol when it sold in 2013 for $105,445,000 at Sotheby's New York. Although it had been estimated to sell for in excess of $60 million, this figure was just the opening bid, and, after a three-way bidding contest, it easily exceeded the previous record for a Warhol of $71.7 million.

Because of the relative ease with which a work by Warhol can be forged, and the large number of editions the artist produced, an Andy Warhol Art Authentication Board was founded in 1995. But it has been the subject of costly litigation, having refused to authenticate certain seemingly *bono fide* works. It was therefore dissolved in 2012.

THE SCEPTICAL KEY

For a brief period – between 1962 and 1968 – Warhol produced some very significant work. Thereafter, he created little of importance, preferring to spend time as a society portraitist and celebrity.

But Warhol's art has to be taken seriously for his social criticism in which he reveals art's complicity with capitalism. The Romantic myth of the artist as a bohemian outsider and the Modernist myth of the artist as part of a subversive avant-garde had largely repressed such complicity. By contrast, Warhol displayed the true status of the artist in contemporary society – a worker within the creative industries in the wider capitalist system.

In retrospect, Warhol's adoption of a mechanical reproductive process and his use of appropriated photographic imagery signal the fateful moment when art linked itself to mass-consumer society and its values. When Warhol resisted the attribution of meaning to his work, he perceived that any significance it conveyed must be understood within the context of a burned-out society, emotionally traumatized and cauterized by the mass media.

FURTHER VIEWING

Andy Warhol Museum, Pittsburg
Museum of Modern Art, New York
Tate Modern, London

Andy Warhol: The Complete Picture
(2002), a film directed by
Chris Rodley

FURTHER READING

Victor Bockris, *Warhol: The
 Biography*, De Capro Press, 1997
Germano Celant, *Andy Warhol:
 A Factory*, Kunstmuseum
 Wolfsburg, 1999
Thomas Crow, 'Saturday Disasters:
 Trace and Reference in Early
 Warhol', in Annette Michelson (ed.),
 Andy Warhol (October Files), MIT
 Press, 2001
Arthur C. Danto, *Andy Warhol*, Yale
 University Press, 2009
Jane Daggett Dillenberger, *The Religious
 Art of Andy Warhol*, Continuum
 International Publishing Group, 2001

Mark Francis and Hal Foster,
 Pop, Phaidon, 2005
Wayne Koestenbaum, *Andy Warhol*,
 Penguin, 2003
Annette Michelson (ed.), *Andy Warhol*,
 MIT Press, 2001
Marco Livingstone and Dan Cameron
 (eds), *Pop Art: An International
 Perspective*, Rizzoli, 1992
Marco Livingstone, *Pop Art:
 A Continuing History*, Thames
 & Hudson, 2000
Stephen Henry Madoff (ed.), *Pop Art:
 A Critical History*, University
 of California Press, 1997
John Russell and Suzi Gablik (eds),
 Pop Art Redefined, Frederick
 A. Praeger, 1969
Andy Warhol, *The Philosophy of Andy
 Warhol (From A to B and Back
 Again)*, Harcourt Brace Jovanovich,
 1975
Andy Warhol and Pat Hackett, *POPism:
 The Warhol '60s*, Harcourt Brace
 Jovanovich, 1980
Andy Warhol and Pat Hackett, *The Andy
 Warhol Diaries*, Warner Books, 1989

YAYOI KUSAMA

Infinity Mirror Room – Phalli's Field, 1965

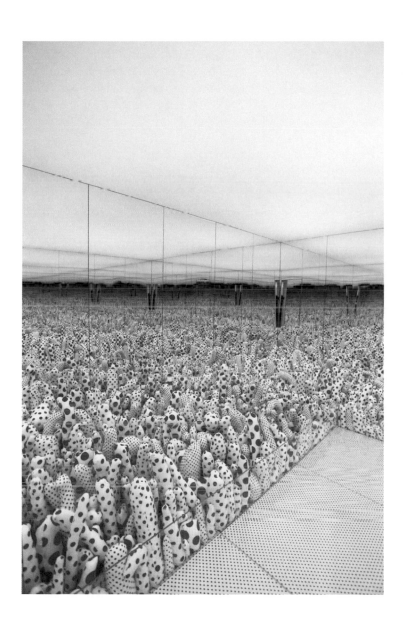

Remade 1998
Mixed-media installation, 311 × 476 × 476.5 cm (122½ × 187½ × 187⅝ in.)
Museum Boijmans Van Beuningen, Rotterdam

The mirror installations of Yayoi Kusama (b. 1929) have become some of the most broadly popular artworks of today, and *Infinity Mirror Room – Phalli's Field*, first created in 1965 and later remade, was definitely ahead of its time. It seems to resonate with the contemporary 'wired' experience, in which, through the power of virtual reality, the boundaries of the self have been exponentially expanded. Kusama channels her mental illness to artistic ends, thereby unwittingly creating a powerful world, a psychological equivalent for the technologically induced reality we now inhabit.

THE EXPERIENTIAL KEY

We enter through a door. The floor within is covered with countless oddly shaped stuffed fabric objects covered in red-on-white polka dots – what Kusama called 'a sublime, miraculous field of phalluses'.[46] The mirrored walls transform the contents into multiple vistas of fathomless depths, which also inevitably include our own reflections. This is an intensely experiential encounter. We are almost literally thrown into the work. The field of polka-dotted objects seems to be half horror-movie prop, half children's toy. Catching sight of ourselves endlessly reflected is rather disconcerting, and certainly not what we usually expect from an encounter with an artwork. We may feel oppressively – vertiginously – destabilized, pleasurably suffused by a sense of limitlessness, or just delighted with the opportunity it offers for a striking selfie.

The repetitive red dots maximize the normal perceptual experience that divides the visual field into figure and ground, confounding the process by equalizing the 'figures' – the red dots – with the 'ground' – the white areas. Furthermore, rather than allowing us to divide the room into discrete areas of focused attention, as we usually would, the repetition of the same coloured round shapes, which are multiplied endlessly by the mirrors, means that we perceive the same shape across almost the whole of our visual field. The polka dots' indiscriminate proliferation emphasizes the sensation of sameness. It is an especially graphic way of suggesting that everything is connected to everything else. 'Polka dots can't stay alone,' Kusama explained. 'When we obliterate nature

and our bodies with polka dots we become part of the unity of our environments.[47]

Kusama suffers from psychotic episodes, which she describes as involving the sensation that her bodily boundaries are breaking down as she is absorbed into her surroundings. She seems compelled to find visual equivalents for this unsettling experience, and to share it, so that the experience can then be brought under control for a while. She claims the polka dots 'symbolize disease', and are like a virus. There is something destructive about their ubiquity. 'If there's a cat, I obliterate it by putting polka dot stickers on it,' she said. 'I obliterated myself by putting the same polka dot stickers on myself.'[48]

For Kusama, these hallucinations are profoundly disabling, and cause overwhelming anxiety, while also giving her a feeling of a heightened, ecstatic reality. This indicates that there is a potentially destructive outcome to the loosening of the boundaries of the self. But Kusama also implies that her psychotic episodes reveal what is in fact a universal, deep-seated yearning for oneness, and that this experience is also ultimately what we all crave – although we are too fearful to embrace it. Kusama wants us to experience the blissful sense of a radical decentring of the self, when it is no longer possible to feel differences from others and the world.

THE BIOGRAPHICAL KEY

Yayoi Kusama describes herself as an 'obsessional artist'. She says that the key motivation behind making art is the temporary achievement of psychological balance and integration. As she declares: 'I don't consider myself an artist; I am pursuing art in order to correct the disability which began in my childhood.'[49] Her art is therefore not only the symptom of an illness, but also its cure.

Kusama was born in Nagano Prefecture, central Japan, into a once wealthy and powerful family whose status had declined as a result of Japan's rapid westernization and modernization. During her childhood and adolescence, she lived in a country that had emerged as a forceful and aggressive imperial power. But in 1945, when Kusama was sixteen years old, massive air raids, and then the atomic bombings of Hiroshima and Nagasaki, subjected Japan to levels

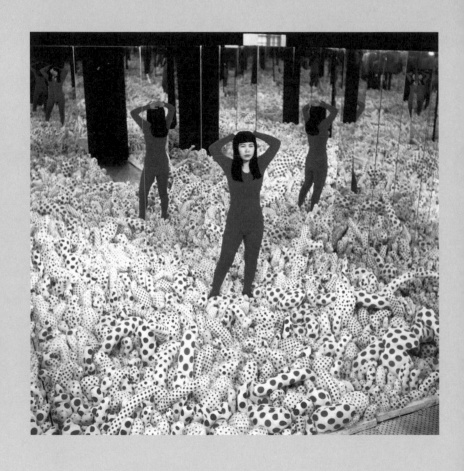

Yayoi Kusama posing in *Infinity Mirror Room – Phalli's Field*
in the Castellane Gallery, New York, 1965. Photographer unknown

of horror and devastation on an unprecedented scale, followed by humiliating defeat. Her decision to become an artist was therefore made against the background of an occupied country on the verge of physical, economic and moral bankruptcy.

Kusama was one of the first Japanese artists of her generation to leave Japan for America. She moved first to Seattle in 1957, then to New York in 1958. There, she quickly gained a critical reputation for her polka-dot covered objects and *Infinity Net* paintings, works related to the Minimalist tendency in the art of the period, in which highly reductive procedures were explored by artists. She had begun using net-like compositions and the polka dot when she was a child, finding that such compulsive mark making offered a way to cope with an unstable mental condition.

In 1973, Kusama returned to Japan, where she was hardly known as an artist. It was a very different country from the one she had left. In the interim, Japan had made great strides, and was well on the way to becoming one of the most prosperous nations in the world. The Japanese art world was also closely engaged with cultural developments in the West.

Two years after her return, Kusama had her first psychotic episode, and in 1977 she voluntarily entered a psychiatric hospital in Tokyo. She has remained there ever since, using a purpose-built studio in the grounds close by. In the 1990s, there was a revival of interest in her art, and, at first, as in the case of *Infinity Mirror Room – Phalli's Field*, Kasuma made new versions of earlier work. But later, and particularly since 2009, she has worked on a vast number of new paintings.

It is difficult to separate Kusama's bizarre persona from her art. The numerous images of her posing with, or in, her own work, taken over a period of fifty years, give the impression that Kusama consciously considers that her persona and her work are inseparably connected.

THE THEORETICAL KEY

Feminist theories have historically pointed out that the dominance of men within society has meant that the way the ego perceives itself is determined by the influence of the male gaze. Women, in a sense, 'turn themselves into' objects of male desire. As a result,

a major goal of feminism is to wrest the construction of the ego-self free from control by the male-dominated gaze.

In her work, Kusama challenges the process of objectification. The sheer proliferation of mirrors and phalli (a symbol of male power) in *Infinity Mirror Room – Phalli's Field* drives the normal conditions that prevail in patriarchal society to the point of breakdown. The work maximizes the narcissistic fantasy, while pushing it to an extreme point where it threatens to collapse, splintering into a million reflections, and thereby potentially allowing release from the hold of the patriarchy over consciousness. Kusama gives compelling visual form to the idea that the ego is illusory and that we are one with everything else.

In psychoanalytic theory, awareness of primal limitlessness is traced to an adult's memories of life in the womb. These memories are suffused with the pleasurable feeling of union with the mother before birth and prior to the intervention of the father, who destroys the sense of oneness. When babies first look in a mirror, they encounter something that looks like a discrete and unified whole, and from this misperception conclude that the reflection is who they are. This ego-self is inherently narcissistic. It proceeds to project its own reflection onto everything it sees, separating and segregating things into discrete, irreconcilable parts.

As noted in the discussion of Mark Rothko (p. 110), Freud called the craving for a less structured sense of the self the 'oceanic feeling', seeing it as a dangerous symptom of what he termed the Nirvana principle. This terminology indicates it is within Eastern cultures that the experience of boundary-free fusion is most assiduously explored, and, unlike in the West, is actively encouraged as a potential sign of enlightenment.

Kusama's work can also be usefully interpreted from within a world view that has a very different set of structured and rational procedures through which to attain awareness of oneness. For example, in Buddhism, considerable emphasis is placed on the idea that the self is fundamentally an illusion, and that, with the aid of practical meditative and physical exercises, a seeker after enlightenment can embrace the 'not-self'. A central symbol in Japanese Buddhism is 'Indra's net', which is said to stretch out infinitely in all directions, and within which diamonds multiply the structure endlessly. Indra's net

visualizes the deep truth of the infinitely repeated interdependency of all things in the universe.

Nowadays, Indra's net has also to be invoked as a fitting analogy for the experience of the Internet, in which digital data has extended information storage and dissemination to what seems like infinity: when I googled Yayoi Kusama, I got 264,000 results in 0.48 seconds.

THE HISTORICAL KEY

Infinity Mirror Room – Phalli's Field was first shown in 1965 in the Castellane Gallery, New York. It was the first of what would become known as *Infinity Mirror Rooms*. Since then, Kusama has produced more than twenty different installations using the same mirror principle, and today these installations are some of the most popular art experiences.

In the early 1960s, Kusama made polka-dot sculptures and laboriously repetitive *Infinity Net* paintings. It was in part to reduce the burden that Kusama had imposed on herself by adopting the time-consuming and repetitive work that she began to stage solo performances in a mirrored studio, and then installed *Infinity Mirror Room Phalli's Field*. The constructed box of reflective surfaces allowed her to overcome physical limitations, while also letting the viewer become a participant in the work. The practice of painting is transformed into a three-dimensional, performative event. The precedent for this metamorphosis can be found in the Happenings of the American artist Allan Kaprow and others during the 1950s and 1960s, in which the barrier between art and life is broken down by engaging viewers as active participants.

Another point of reference is apparent in the Dutch 'Nul' and German 'Zero' art groups, with whom Kusama was closely linked in the 1960s, and who experimented with emptiness, mirrors, electric lights and kinetics. On a longer historical perspective, there is a debt to the Italian Futurists and the Dadaists, although the idea of fusing art and life can be traced at least as far back as the mid-nineteenth century and the nineteenth-century German composer Richard Wagner's concept of the *Gesamtkunstwerk* (the total work of art) or even to the more general belief central

to religious art that a work must be a transformative event, rather than simply an aesthetic experience.

But the Eastern philosophical, religious and artistic concepts familiar to Kusama as a Japanese artist were also crucial influences. Indeed, Eastern culture was an important motivation behind the move towards abstraction in Western art in general, and, from the 1940s, the influence of Japanese Zen Buddhism was especially widespread. Its impact on Western art can be seen in the dynamism of the calligraphic gesture and the idea of emptiness or void. Thus, Kusama's cultural background connected in important ways with tendencies in Western art.

THE AESTHETIC KEY

Focusing on the psychopathological dimension of Kusama's work risks ignoring the role of aesthetic considerations, which help to create a balance in her work so that potentially overwhelming psychological obsessions are mediated by a ritual process.

Within the context in which Kusama found herself – the New York art world – a kind of sanctuary from where to contain her psychological instability was initially provided by the key formal concerns of the dominant aesthetic ideas of the period. Kusama found she could connect with the avant-garde through the affinities it seemed to share with aspects of her cultural background. These characteristics placed emphasis on emotional detachment, and were visually characterized by the preference for simple, flat, repetitive forms, the use of one colour and the creation of all-over, unified compositions.

The meaning given to the formal language of Western art was cast in the United States in primarily material and pragmatic terms, implying that a work of art was something to be honed back to its primary, specific qualities in order to rid it of illusion, but Kusama redirected these formal concerns via the aesthetics of her native Japan. *Infinity Mirror Room – Phalli's Field* uses characteristics of American Minimalist art in three-dimensional space in order to express more fully the sensation of infinity. Because an encounter with *Infinity Mirror Room – Phalli's Field* means also becoming part of it, the possibility of adopting a position of aesthetic distance, which

is considered a central premise of Western art, is greatly diminished because it provides a space for intellectual and emotional reflection. Instead, it is supplanted by a new possibility: a participatory aesthetics.

THE MARKET KEY

From as early as the 1960s, Kusama's work was especially well received in the Netherlands, where it was shown more frequently than anywhere else in the world. It is therefore fitting that, in 2010, the Museum Boijmans Van Beuningen, Rotterdam, purchased *Infinity Mirror Room – Phalli's Field*. As the museum explains on its website, it entered the collection 'partly thanks to a generous gesture by the artist herself'. Because the original 1965 work had been a temporary installation, it no longer existed, and this version is therefore a reconstruction dating from 1998. It differs from the original in covering a room entirely with floor-to-ceiling mirrored walls, whereas in 1965 the mirrors were installed over roughly twenty-five square metres of the gallery and did not reach the ceiling.

Kusama has one of the highest financial turnovers of any living woman artist, and, as of late 2017, holds the record for the highest price paid at auction for any work by a living female artist. An *Infinity Net* painting, *White No. 28* (1960), sold at Christie's, New York in 2014 for $7,109,000 many times over the estimate of $1,500,000–$2,000,000. A touring exhibition from 2017 to 2019, called 'Yayoi Kusama: Infinity Mirrors', which includes *Infinity Mirror Room – Phalli's Field*, has proven immensely popular. The show broke attendance records at the Hirshhorn Museum and Sculpture Garden in Washington DC in early 2017, and the Broad in Los Angeles sold all fifty thousand tickets in the first hour for its leg of the tour later in the year.

THE SCEPTICAL KEY

Kusama's now seemingly ubiquitous eye-popping visual style stimulates the brains of citizens already suffering from sensory overload in today's technological society. *Infinity Mirror Room – Phalli's Field* offers a kick that, for some, wears off quickly. The experience is

novel, but it also has an impersonal aspect, and brings with it a sense of inevitability – we have no choice but to succumb to its optical proliferations in ways that potentially act to counter the novelty.

Kusama has fed, and been fed upon by, a confession-obsessed pop culture. Her decision to share the state of her mental health arguably appeals to our highly developed narcissism, and seems to chime perfectly with the culture of the selfie. Hashtags to Kusama's mirror rooms are hugely popular, and, in recent exhibitions, visitors queue up to enter the installations so that they can take pictures of themselves taking pictures. As *The Guardian* newspaper reported in 9 November 2017: 'On Instagram, the Broad's geotag summons a seemingly endless stream of photos of museumgoers – individuals, couples, children – holding smartphones up to Kusama's reflective surfaces.' In the 1960s, Kusama's installations were genuinely liberating and challenging encounters. Today, in contrast to Indra's net reflecting the pure mind, they present the viewer with mirrors that reflect the bottomless narcissism of our times.

FURTHER VIEWING

Other Infinity Mirror Rooms:
The Broad, Los Angeles, California:
*Infinity Mirrored Room – The Souls
of Millions of Light Years Away* (2013)
Louisiana Museum of Modern Art,
Humlebaek: *Gleaming Lights
of the Souls* (2008)
Mattress Factory, Pittsburgh,
Pennsylvania: *Infinity Dots
Mirrored Room* (1996)
Phoenix Art Museum, Arizona:
*You Who Are Getting
Obliterated in the Dancing
Swarm of Fireflies* (2005)

Yayoi Kusama Museum, Tokyo
Madame Tussauds Hong Kong (includes
a wax figure of the eighty-seven-
year-old Kusama in an entire
gallery devoted to the artist)
Matsumoto City Museum of Art,
Nagano
Museum of Modern Art, New York
Tate Modern, London

*Yayoi Kusama's Self-Obliteration,
a film* written by Yayoi Kusama
and directed by Jud Yalkut (1968)
Yayoi Kusama: I Love Me (2008),
a documentary

Yayoi Kusama, *Infinity Net: The
Autobiography of Yayoi Kusama,*
University of Chicago Press, 2011
Frances Morris (ed.), *Yayoi Kusama*, exh.
cat., Tate Modern, London, and
Whitney Museum of American Art,
New York, 2012
Akira Tatehata, Laura Hoptman,
Udo Kultermann and Catherine
Taft, *Yayoi Kusama*, revised and
expanded ed., Phaidon Press, 2017
Mika Yoshitake and Alexander
Dumbadze (eds), *Yayoi Kusama:
Infinity Mirrors*, exh. cat., Hirshhorn
Museum and Sculpture Garden,
Seattle Art Museum, The Broad,
Los Angeles, Art Gallery of Ontario,
Toronto, and the Cleveland Museum
of Art, 2017–18
Lynn Zelevansky, Laura Hoptman, Akira
Tatehata and Alexandra Munroe,
*Love Forever: Yayoi Kusama, 1958–
1968*, exh. cat., Los Angeles County
Museum of Art and Museum of
Modern Art, New York, Walker Art
Center, Minneapolis, Museum of
Contemporary Art, Tokyo, 1998–99

FURTHER READING

Jo Applin, *Infinity Mirror Room –
Phalli's Field*, Afterall Books, 2012
Bhupendra Karia (ed.), *Yayoi Kusama:
A Retrospective*, exh. cat., Center
for International Contemporary
Arts, New York, 1989

JOSEPH BEUYS

The Pack, 1969

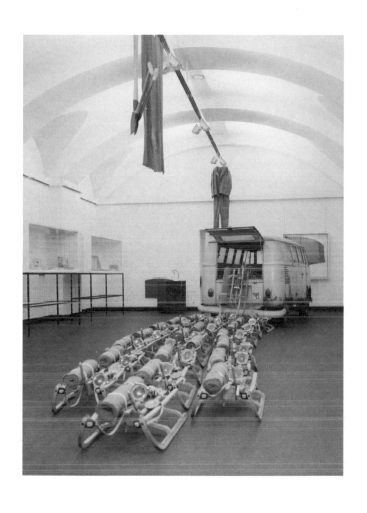

Multimedia installation, dimensions variable
Museumslandschaft Hessen Kassel

During the 1960s, a number of artists explored an expanded idea of both the artwork and the artist. Joseph Beuys (1921–1986) was one of the most important. For a time, he was closely associated with the international group Fluxus, which specialized in provocation and testing the boundaries of art, but to limit Beuys to membership of a specific movement fails to do justice to his protean character. *The Pack* is one of Beuys's most autobiographical works. His life story, as the artist himself narrated it, has the aura of myth about it, and is couched as a hero's tale of death and rebirth. Indeed, Beuys marks the moment when the artist themself becomes the work of art.

THE HISTORICAL KEY

The Pack consists of twenty-four sledges emerging from the back of a Volkswagen camper van. The sledges seem to be heading off towards some destination in an orderly formation, with a roll of felt, a lump of animal fat and a torch strapped to each one. For Beuys, the various objects in *The Pack* function as idiosyncratic personal symbols, alluding to perennial human desires and struggles.

Together, the objects on the sledges are meant to be a survival kit; Beuys explained: 'The flashlight represents the sense of orientation, then felt for protection, and fat is food.'[50] The Volkswagen van may be a symbol of a modern German society overly wedded to technology, but we can also consider that Beuys took into account the potential of this technology to serve as a vehicle – literally – for liberation, because this Volkswagen model was an especially popular choice among the hippy counterculture of the period.

The title alludes to the sledges resembling a pack of dogs or wolves. This reference to the animal world signals Beuys's belief that things made by humans will not be sufficient in the current crisis. Indeed, he felt humanity was in dire need of rescue, and it was only through contact with nature that this could be achieved. 'This is an emergency object: an invasion by the pack,' Beuys wrote. And, as Caroline Tisdall has commented, 'In a state of emergency, the Volkswagen bus is of limited usefulness, and more direct and primitive means must be taken to ensure survival.'[51]

When Beuys made *The Pack*, Germany was still divided along Cold War lines. In 1961, the Berlin Wall had been built, a confirmation that the division between West and East Berlin was seemingly permanent. From the mid-1960s, a student-led protest movement grew in strength in Western Europe as a whole. Beuys was closely involved in the German manifestations, where the call was for greater democracy, more transparency concerning the Nazi past, denuclearization, rejection of American-style consumerism and protest against imperialistic involvement in Vietnam. In 1967, some of the largest demonstrations in the history of the German Democratic Republic took place, shaking the nation to the core, and they were put down with considerable brutality. During May 1968, protests took place throughout Europe – most dramatically in Paris, though also in West Germany. But the expected revolution never happened, and the mood among radicals in 1969 was fast turning to disillusionment, and a growing sense of impending disaster.

THE BIOGRAPHICAL KEY

The only child of a devout Catholic couple, Joseph Beuys came of age during the Nazi period, joining the Hitler Youth in his teens and the Luftwaffe during the Second World War. At this time, he had what he claimed was the pivotal experience of his life. In the winter of 1943 the plane in which he was travelling was shot down over the Crimea and he was rescued by Tartar nomads. They coated his body with fat and wrapped him in felt to keep him warm. For this reason, fat and felt came to represent for him primary symbols of the benevolent life force.

Beuys was acutely aware of the burden of guilt he and his fellow German citizens carried on account of Nazism. Writing in 1945, Carl Jung described the nature of Germany's collective guilt: 'It cares nothing for the just and the unjust, it is the dark cloud that rises up from the scene of an unexpiated crime. It is a psychic phenomenon, and it is therefore no condemnation of the German people to say that they are collectively guilty, but simply a statement of fact.'[52] However, ordinary Germans sought to cope with the trauma largely through repression.

Joseph Beuys at the Solomon R. Guggenheim Museum, New York, 1979.
Photograph by Alfred Eisenstaedt

In Beuys's opinion, Nazism – and, above all, the tragedy of the Holocaust – had occurred not so much because of social conditions prevailing in Germany during the 1920s and 1930s as because German society had been especially susceptible to the rationalist culture that pervaded the West in general. In this culture, logic, analysis, efficiency and practical goals dominated and perverted human nature.

Beuys suggested that the only way to heal not only the deep spiritual wound caused by Nazism but also the all-pervasive malaise of Western society was to forge links with more primal levels of human nature, and to reconnect with healthier ways of life. The division separating art from life was considered an artificial one by Beuys. He believed that a new artistic principle, which would heal the wound of modern society, was required to bridge the divide. The role of the artist was akin to that of those individuals within traditional societies responsible for connecting the human and spirit worlds, thereby helping to heal physical and mental illness – shamans.

Beuys discussed his work frequently in relation to healing, casting himself as a shaman, and had an optimistic belief in humanity's will to survive. He thought that people have a natural tendency to desire the good and the beautiful. But, in a situation of social unrest, he felt the artist must extend his or her activities well beyond the production of objects for aesthetic pleasure or spiritual insight. Not only did Beuys become involved in ritualised actions in galleries and beyond, but in 1967 he also helped to found the German Student Party. Later, in 1973, he set up the Free International University for Creativity and Interdisciplinary Research with others. Beuys also became a founding member of the West German Green Party in 1980.

Beuys belongs within the post-Romantic tradition in which the artist takes on the special role of visionary seer. The charismatic persona he crafted is one of the most striking in modern art. He was always seen in public wearing a felt hat and fisherman's jacket, a look now immortalized in countless photographs. His many performances and lectures, engagement in debates with the public, teaching activities and political activism are all part of what makes him an important cultural figure.

THE AESTHETIC KEY

Beuys's use of 'poor' or non-artistic objects in *The Pack* is characteristic of his whole oeuvre. He begins with Duchamp's idea of the readymade, but imbues found objects with special symbolism, a process informed by his belief in humanity's ability to make ordinary things extraordinary through the power of the imagination. He did not work with marble or bronze, preferring instead items encountered in everyday life – practical, useful artefacts rather than objects intended for aesthetic contemplation.

One cannot approach Beuys's work with the expectation that it will deliver an aesthetic experience founded on the considered arrangement of forms and colours. However, by broadening our understanding of the aesthetic to incorporate anything that has been removed from the realm of practical knowledge and goals, and set up as being worthy of perception for its own sake, it is possible to read *The Pack,* like Beuys's work in general, and like much Post-Modern art, as an aesthetic object.

For example, the frame or plinth, which are a necessary prerequisite for aesthetic experience, surrounding or elevating the work and making it something removed from the rest of the world, has expanded in Beuys's work beyond the edges of the canvas or the space immediately around the sculpture to become the walls and floor of the gallery itself. In this sense, the artist has incorporated the actual institution within which the work of art is seen into the work itself.

More importantly, central to Beuys's expanded aesthetic is his concept of social sculpture. This involved the integration of political awareness with the making of art. Rather than being directed towards the creation of a segregated space for the contemplation of an art object, he intended his practice to engage viewers directly, making them active participants. To this end, following Duchamp's insight but casting it in a more utopian light, Beuys considered that everything could potentially be art – that every aspect of life is available for creative transformation.

THE EXPERIENTIAL KEY

When we encounter *The Pack*, we immediately sense that the distanced and detached feeling that usually separates our real space from the illusionistic or pictorial space of the artwork is no longer so great. The medium of mediation – the intermediary of the fabricated image or object – has been replaced by *real* objects existing in *real* space. Walking around this installation, we can see that it comprises elements from everyday life.

But at the same time, when it comes to making some kind of sense of the collection of familiar objects Beuys presents, we are likely to feel confused. For some viewers, the fat in *The Pack* may have rather less positive connotations than those attributed to it by Beuys, while the grey felt could bring to mind Nazi uniforms rather than benevolent insulation. We may experience the ambiguity of his work as a way of keeping things open, offering a gratifyingly diverse range of potential meanings, or, then again, we may conclude that he creates opacity or frustrating arbitrariness.

Central to Beuys's belief was the need to engage the viewer in ways that transform us from passive members of an audience into collaborators in his social sculpture. Beuys stated that everyone is an artist – that is, everyone is capable of acting artistically, because art is a way of life, an attitude, rather than a set of learned skills or a profession.

THE THEORETICAL KEY

In his statements and interviews Beuys frequently emphasized that modern Western society had fallen out of balance by relying too heavily on the faculty of reason. Society had become addicted to the rationalistic mindset that is necessary for the development of science and its exploitation through technology. To counter this influence, Beuys drew attention to the mystical, irrational and natural dimensions of consciousness. He wanted to 're-enchant' modern society.

Beuys's work is deeply informed by his study of an eclectic range of thinkers, ranging from Jesus to the German philosopher Rudolf Steiner. Steiner's anthroposophy was especially important because

in it Beuys found confirmation for his belief that the spirit-deadening forces within modern society could be countered through embracing intuition and imagination, while directing creative energy towards both personal and societal transformation. Steiner's philosophy of life synthesized world traditions with recent developments in science to forge a practical system for integrating mind, body and soul, which included the foundation of the Waldorf Schools network. It was from Steiner that Beuys took the idea that art should be envisaged not as a specialized profession but rather as a general attitude to life that stressed the human need for mental and physical integration, and therefore that the artistic attitude should pervade everyone's whole life. Beuys echoed Steiner's activist social philosophy when in 1972 he made a poster of himself striding forward with the slogan *'La Rivoluzione siamo Noi'* (We are the revolution), indicating that social transformation must start from human beings.

THE SCEPTICAL KEY

Beuys was an inveterate mythmaker. While self-invention is common in the field of art, we should nevertheless pause to consider that several eyewitnesses contradict Beuys's autobiographical stories. For example, there were reportedly no Tartar tribesmen in the region of his plane crash. Beuys's exploitation of the personality cult that he built up around him, in order to legitimize his practice, might even be said to link him to the very totalitarian politics he sought to oppose.

Now that Beuys is dead, can we hope to revive the value with which his personality imbued his project, solely through encounters with the works that remain? What is left once his commanding persona is no longer present? Are we not reduced to the status of the passive student of Beuys's eccentric philosophical musings and his eclectic and arbitrary manipulations of materials?

Because of the unique nature of the objects Beuys chose to imbue with such resonances, it can be difficult to interpret their meaning. The sledges may conjure up an innocent childhood pastime, while the way they are falling out of the bus can seem humorous. But it is just as likely that the sledges are making a dangerous crossing over some terrible frozen waste. The fat and felt components are especially

opaque, and to understand their significance requires delving into Beuys's own personal mythology, in which felt symbolizes warmth and safety, and fat represents sustenance. The torch is perhaps more obvious – it illuminates the darkness, helping to find the way. But such ambiguity suggests that Beuys's work lacks any coherent symbolic framework.

The symbols Beuys presents are like esoteric relics, and are mostly incomprehensible without the aid of exegesis, which effectively empowers the 'gatekeepers' of modern art – fellow artists, critics, curators, academics and collectors – but disempowers everyone else. And even when meaning is provided, it often seems so deliberately ambiguous, or resolutely personal, as to be of limited value for others. Despite the claim that he was making social sculpture, based on participation and dialogue, we actually apprehend Beuys's works statically and passively, and cannot have access to any interior that would make them resonate within our own experience.

Once *The Pack* and other works by Beuys have been located in a museum, and their meaning securely curated, the openness the artist so cherished is inevitably lost. His work then functions in ways that are extremely traditional. Indeed, it becomes even more dependent on the social conventions of the frame provided by state or privately run institutions of art than the apparently retrogressive works Beuys claimed to be superseding.

Beuys's concept of social sculpture was intended to resist the reduction of art to a commodity and merchandise, its role within a capitalist system based on inequality and exploitation. To this end, he continuously sought ways not only to present art in non-modifiable forms, such as in ephemeral performances and lectures, but also to bring art into close alignment with other aspects of social life, so that it could be transformed into a way of life, not an object. Nevertheless, as a revered member of the art system, Beuys has also inevitably been co-opted by the market. Powerful institutions have taken on his concerns, to become venues within which protests can be safely voiced, while at the same time also serving to maintain the status quo.

It was reported in 2017 that one of Beuys's other works occupying the same gallery space as *The Pack* in the Neue Galerie at the Staatliche Museen Kassel – a felt suit suspended from the ceiling

– had fallen victim to a moth attack. It seems likely that, without the prompt action of the museum, the contents of the survival kits on the sledges would have been next. In other words, there are sound, if banal, reasons why sculptors used to make their works in marble or bronze.

THE MARKET KEY

The Pack is today one of the most prized works in the permanent collection of the Neue Galerie of the Staatlich Museum at Kassel. Since the 1960s the museum has also regularly been used as a temporary exhibition space for one of the most celebrated quinquennial exhibitions of radical contemporary art – 'documenta'. Beuys himself was a frequent participant – for 'documenta 7' in 1982, for example, he proposed to plant seven thousand oaks throughout the city of Kassel, each paired with a basalt stone. The planting went on long after his death.

An individual sledge from 1969, equipped with the same survival kit, fetched $350,500 at Christie's, New York in 2011. It was one of an edition of fifty (plus five designated by Beuys as not for sale), each with a plaque guaranteeing its originality. In 1970 the same multiple could have been purchased at the affordable price of $75.

FURTHER VIEWING

Kassel, Germany: throughout the
city Beuys planted oak trees
next to basalt boulders from 1982
Dia:Chelsea, New York: Beuys planted
oak trees and basalt stones on the
street near the gallery in 1988
Hessisches Landesmuseum, Darmstadt
Museum Schloss Moyland,
Bedburg-Hau
Musée National d'Art Moderne, Centre
Georges Pompidou, Paris
Tate Modern, London

FURTHER READING

Alain Borer, *The Essential Joseph
Beuys*, ed. Lothar Schirmer,
Thames & Hudson, 1997
Jon Hendrik, *Fluxus Codex*,
Harry N. Abrams, 1988

Hannah Higgins, *Fluxus Experience*,
University of California Press, 2002
Alison Holland (ed.), *Imagination,
Inspiration, Intuition: Joseph Beuys
and Rudolph Steiner*, exh. cat.,
National Gallery of Victoria,
Melbourne, 2007–8
Claudia Mesch and Viola Michely (eds),
Joseph Beuys: The Reader, MIT Press,
2007
Gene Ray, Lukas Beckmann and Peter
Nisbet (eds), *Joseph Beuys: Mapping
the Legacy*, Distributed
Art Publishers, 2001
Mark Rosenthal, *Joseph Beuys: Actions,
Vitrines, Environments*, exh. cat.,
Menil Collection, Houston, Texas,
and Tate, London, 2004–5
Heiner Stachelhaus, *Joseph Beuys*,
Abbeville Press, 1991
Caroline Tisdall, *Joseph Beuys*, exh. cat.,
Solomon R. Guggenheim Museum,
New York, 1979–80

ROBERT SMITHSON

Spiral Jetty, 1970

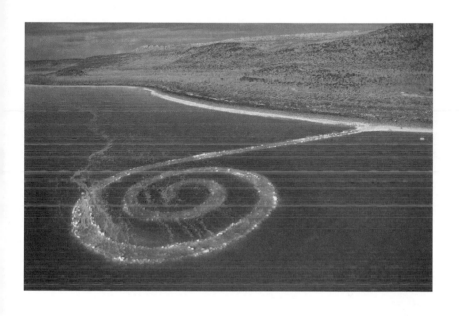

Mud, precipitated salt crystals, rocks,
water coil, 457 [if unwound] × 4.5 m (1500 × 15 ft)
Rozel Point Peninsular, Utah
Dia Art Foundation, New York

On the previous page is a photograph taken soon after the construction of *Spiral Jetty*, the 'earthwork' created by Robert Smithson (1938–1973) at Rozel Point peninsula on the north-east shore of Great Salt Lake, about one hundred miles north-west of Salt Lake City. *Spiral Jetty* engages with the dimension of time as much as space. It isn't something simply to be contemplated. In making *Spiral Jetty* Smithson suggests that a modern artist should no longer be limited by the conventions that separate a work from the world, turning it into an object of contemplation. Instead, an artist must be involved in creating an environmental event that is immersive, overwhelming and sublime – a total work of art.

To this end, *Spiral Jetty* wasn't conceived as a single, sculptural work – however immense – and the project also included a film, documentary photographs and an essay. Smithson thereby brings to fruition the participatory aesthetic that has slowly been gathering strength over the course of a century. Rather than considering the artwork as autonomous, static and complete, Smithson treats it as inherently open, awaiting completion by the involvement of the viewer.

THE EXPERIENTIAL KEY

This is a work that invites animation. It must be actively experienced. Reaching *Spiral Jetty* has been likened to a pilgrimage. The inhospitable territory means that, in order to view it, we must travel in a truck or vehicle with high ground clearance. Working outside a gallery space or urban environment allowed Smithson to increase the scale of his art massively and to place the piece in natural surroundings. *Spiral Jetty* dwarfs us. But the work itself is dwarfed by the Great Salt Lake – 75 miles long by 50 miles wide, and almost as salty as the Dead Sea – and by the seemingly endless desert scrubland and distant mountains. Within this vast space *Spiral Jetty* functions as a focal point, drawing the surroundings around itself and the visitor.

In the film Smithson made of the work in the same year, aerial shots evoke the vastness of the space within which it is sited, and the dazzlingly bright sun's reflection in the bizarrely coloured lake. It is edited with a sequence of Smithson running along the work's length

towards its innermost point. We are transformed into an engaged participant, because walking along the spine from the lakeshore to the centre and back is an essential part of the experience of *Spiral Jetty*.

Smithson recognized the potential of *Spiral Jetty* as a deeply transformational experience, declaring, 'No ideas, no concepts, no systems, no structures, no abstractions could hold themselves together in the actuality of that evidence'.[53] But we should remember that what we are actually discussing here is a *photograph* of *Spiral Jetty*, taken soon after its completion. We are not in the presence of the actual work, nor are we in the presence of the work as it is today.

Spiral Jetty was always intended to evolve, but the water levels of the lake at the time Smithson began the work were particularly low because of drought. By 1972 the level had risen, so *Spiral Jetty* became completely submerged. Smithson had intended to enlist time as his collaborator, but it was never his intention for the forces of decay to work quite so rapidly, and before he died in 1973 he considered adding rocks to make the earthwork more visible.

In the late 1990s, nature, helped by human-induced global warming, caused a new drought, thereby exposing *Spiral Jetty* again. This time it resurfaced in a significantly different state from the original one, because, while underwater, sparkling white salt crystals encrusted the basalt, turning the spiral a glowing white. The experience of *Spiral Jetty* continues to change. Today, the water of the lake has receded almost one hundred metres. The basalt appears dark against the dry salted bottom of the lake, while the receding of the water means visitors can run on the dry lake bed between the spiral, instead of being obliged to remain on the part Smithson intended for walking.

A single photograph can evoke very little of an encounter with the real thing, nor can it serve as a record of the transformations that have occurred since the photographer took the picture. The date given for Spiral Jetty is therefore misleading. As the work is intentionally in a state of continuous evolution, it should rightly read '1970 – present'.

THE AESTHETIC KEY

In order to construct the earthwork, Smithson hired contractors who used two dumper trucks, a tractor and a large front-loader to shift

over six thousand tonnes of black basalt rocks and earth. The result is a spiral 1,500 feet long and 15 feet wide, coiling counterclockwise away from the shore into the lake.

Smithson's decisions regarding specific materials and form were determined by his desire to relate the work closely to the location. The basalt rocks were sourced from extinct volcanoes in the area, while the shape itself was inspired by the molecular structure of the salt-crystal deposits found throughout the lake. What initially attracted Smithson to the north arm of the lake was the striking red-violet water. Caused by microbes, this colour is a side effect of the fresh water supply to the area being cut off due to the construction of a causeway by the Southern Pacific Railroad in the late 1950s. The vivid colours can be seen to great effect in the film Smithson made and to some extent in this photograph. At different times of day the water also shifts from turquoise, orangey brown, pale green to cobalt blue.

Despite the conceptual underpinnings of his practice, Smithson's choice of the location for *Spiral Jetty* was primarily determined by a range of familiar aesthetic considerations. As he noted: 'My own experience is that the best sites for "earth art" are sites that have been disrupted by industry, reckless urbanization, or nature's own devastation.'[54] He was especially drawn to the unearthly qualities of Rozel Point peninsula, which he likened to a ruined and polluted science-fiction or post-apocalyptic landscape, or a world untouched by humans. As Smithson wrote: 'Slowly, we drew near to the lake, which resembled an impassive faint violet sheet held captive in a stoney matrix, upon which the sun poured down its crushing light.'[55]

At the same time, however, Smithson considered it essential to undermine the principal prerequisite of the aesthetic experience as understood in the Western tradition. Rather than *Spiral Jetty* offering the permanence and unchanging qualities normally expected of an object of aesthetic contemplation, he immersed his work within an expansive environment. He deliberately incorporated transitory effects occurring over time, caused by the natural forces of wind, rain, temperature and climate change, and by the social forces of technological and economic development. *Spiral Jetty* was intended to be in a constant state of change – it was built in the full knowledge that it would very rapidly (in geological terms) decay. The unsteady, volatile relationship between the chaos and order produced by natural

forces, and by human attrition and intervention, are an intrinsic part of the new aesthetics of Smithson's work.

THE HISTORICAL KEY

Smithson belongs to a generation of American artists who reacted against the dominance of Abstract Expressionism, as practised, for example, by Mark Rothko (p. 110), by abandoning painting and the idea that art was primarily about creating something for self-expression and/or aesthetic contemplation. In addition, they rejected Pop art's acquiescence to the imagery and styles of the mass media. They instead engaged with Minimalism, an austere and reductive style epitomized by simple, repetitive geometric shapes. Minimalism was deliberately devoid of symbolism, and used industrial materials and forms, but Smithson and his peers redirected the Minimalist aesthetic away from the industrial to the natural environment, and towards a range of associations related to art history and recent scientific research.

Smithson adopted non-art and industrial materials but sought to reconnect with organic forms and to expand the possibilities of the open-ended experience of the artwork. He discussed his work in relation to concepts derived from far beyond conventional art practice. In particular, Smithson set about questioning the relationship between natural and human-made objects, moving between the gallery and locations lying far from those usually associated with the display of art. He used drawings, photography, film and texts to document these interventions. Unlike Modernist art, *Spiral Jetty* is radically impure. The intention of the artist is no longer to give expression to a form but rather to animate the wider environment within which his work functions. Sculpture becomes part of both a material and conceptual field, and the form it takes depends on the form of its background. Only when this environment is fully expressed, does it become possible to understand the form of the work itself.

For his *Non-Sites* projects, begun in 1968, Smithson situated mirrored surfaces and natural found objects within the gallery, while for his *Sites* projects, begun in 1969, he searched for desolate and unappealing areas, placing mirrors within them and photographing

the results. It was from the *Sites* series that Smithson developed the idea of making more permanent interventions within nature. These subsequent works became what he described as 'Land art', or 'earthworks', a term taken from a science-fiction novel he was reading at the time. Smithson intended his earthworks to have grand, mythic resonances. The huge scale of *Spiral Jetty* evokes the great monuments of past civilizations, such as Stonehenge or the pyramids, while the spiral shape is common throughout nature – from vast galaxies to the crystal. No doubt because of this omnipresence, it has had sacred significance for many human cultures – for example, Southwest American Indian rock art depicts reverse spirals connected to a horizontal line.

Smithson helped inspire an international movement, Land Art, which first attracted widespread attention as a result of exhibitions featuring the photographic and drawn documentation of artists' far-flung works or proposals for works. Primarily an American phenomenon, Land Art largely depended on the ready availability of wildernesses, which offered artists vast unpopulated spaces within which to experiment. The possibilities of the large-scale work first explored in Abstract Expressionist paintings were exploited and massively extended. Land artists worked within an expanded field, where the boundaries between sculpture and architecture, sculpture and landscape, and landscape and architecture became ambiguous.

THE THEORETICAL KEY

Smithson was an accomplished critic and essayist, who drew on eclectic sources ranging from science-fiction novels and psychological theory to art history and the latest scientific research. In his landmark 1968 essay, 'A Sedimentation of the Mind: Earth Projects', he effectively provided the earthworks of the Land Art movement with their theoretical grounding.

Smithson placed considerable emphasis on the role of concepts and ideas in the genesis and interpretation of his work, questioning the premise that art is involved primarily with visual perception. 'The "visual" has its origin in the enigma of blind order – which is in a word, language. Art that depends only on the retina of the eye,

is cut off from this reservoir or paradigm of memory,' he wrote.[56] He was especially interested in entropy, the second law of thermodynamics, which states that energy inevitably depletes to a state of inert uniformity. This means that there is an inherent lack of order or predictability within matter, leading to a decline into disorder or a state of exhaustion. In other words, any structure or system, natural or human-made, will sooner or later collapse. Smithson's special interest in rocks and rubble was therefore influenced by their status as the material evidence of the slowing and cooling of the earth – of entropy. As he wrote: 'In order to read the rocks we must become conscious of geologic time, and of the layers of prehistoric material that is entombed in the Earth's crust.'[57]

Through an awareness of deep geological time and the relentlessness of the entropic process Smithson challenged what he saw as the limited perspective offered by a humanist culture that assumed the separation of the human from the natural world. For entropy also extends to the human world, so the same fate awaits the humblest human artefact and the most noble monuments of civilization. Nature will always triumph, in spite of all the heroic attempts to stop or arrest it.

And yet, as Smithson added, art making must go on. 'Museums are tombs, and it looks like everything is turning into a museum,' he wrote. 'Painting, sculpture and architecture are finished, but the art habit continues.'[58]

THE BIOGRAPHICAL KEY

Robert Smithson was born in Passaic, New Jersey, in 1938. He briefly studied painting and drawing in New York City in the late 1950s. In 1963, he married fellow artist Nancy Holt, who also went on to create Land Art. By 1964, Smithson had switched from painting to sculpture, and soon had settled into a way of working that involved frequent trips to visit quarries, industrial wastelands, and the deserts and wildernesses of the American West and Southwest. In the summer of 1973, while surveying a site for a new project, *Amarillo Ramp*, the small aeroplane in which Smithson was travelling crashed, killing all on board – Smithson, the pilot and the photographer.

A key premise for Smithson was that artists should not use their art as a means of self-expression or aesthetic contemplation . Rather, art was an arena in which to address pressing social, philosophical and spiritual concerns.

Smithson's work cannot be understood without taking into account the subversive role attributed to art by his generation during a period of great social unrest in the United States. Minorities and the younger generation were protesting against the inequalities and constraints of the status quo, and against American involvement in the Vietnam War, advocating the radical transformation of American society. In particular, Smithson's work resonates with the widely felt belief among the young that modern society must return to basics and reconnect with nature.

THE MARKET KEY

The Dia Art Foundation has owned *Spiral Jetty* since 1999, when it was donated by Smithson's Estate. Dia, which leases the lake bed from the State of Utah Division of Forestry, Fire and State Lands, collaborates closely with two organizations in Utah – the Great Salt Lake Institute at Westminster College (GSLI) and the Utah Museum of Fine Arts at the University of Utah (UMFA) – who also engage in the advocacy and protection of the work. Dia is committed not only to preserving *Spiral Jetty*, but also to making it more accessible.

Smithson's decision to produce earthworks was motivated by a wish to resist the commodification of art. Land Art, which is characterized by isolated sites, large-scale works and its temporary nature, cannot readily be sold by a commercial gallery or at auction. Even so, this has not prevented Land Art entering the market as valuable cultural collateral through the documentary data produced by artists and others. Smithson's estate possesses photographs of his completed projects, in addition to drawings for projects completed or planned, and the photographs that remain in the estate cost from $50,000 to $200,000.

Robert Smithson, 1969. Photograph by Jack Robinson

THE SCEPTICAL KEY

Although Smithson adopted the pose of the detached social scientist, the rhetoric he deployed in discussing *Spiral Jetty* was largely couched in familiar and rather hackneyed terms relating to the myth of an inspired artist forging his creation in a sublime landscape. But what was briefly an open-ended, unframed, unnameable entity, sited in a location consciously chosen because it couldn't be classified or accessed easily, has now been thoroughly assimilated and 'domesticated'.

In facilitating greater accessibility to the site, by means such as installing signs at key junctions, there is the risk that the meaning of *Spiral Jetty* as something located in a far-flung wilderness will be undermined. Thousands of people have visited what was once an artwork in a deliberately inaccessible location. This process even extends to the very entropic processes Smithson saw as being a potent challenge to the dominant institutional, managerial mindset – since 2012, the Dia Art Foundation has begun recording through photographic documentation the changes occurring over time through geospatial aerial photography in May and October each year. The results can be viewed online.

Today, *Spiral Jetty* is far less impressive than the photograph illustrating this text and Smithson's film suggest. The relationship between the jetty, the surrounding site and entropic processes has been radically destabilized, if not neutralized. The great majority of encounters with *Spiral Jetty* are via photographic images, which freeze the work in time, frame it and turn it into an aesthetic object. Smithson's original intentions have therefore been derailed. *Spiral Jetty* is now, foremost, something to be looked at in a photograph and to be read about in books and online. Rather than enacting its meaning, it has become a sign of it. It has been reduced to the status of a studied object, absorbed into the mainstream narratives of art.

Numerous photographic reproductions, as well as a wide variety of contextualizing and theorizing studies, have drawn *Spiral Jetty* safely into an institutional framework. There, it is organized around the standard art-historical categories of sublime landscape, expressive goals involving traditional notions of spiritual awe or contemplation and reverent accounts of the artist. We are therefore left wondering

what really remains in the actual earthwork of the original intentions of Smithson, now that it has been overwhelmed by climate change, taken into custodial care and transformed into a work of art to be classified alongside other art objects.

FURTHER VIEWING

Other earthworks:
Emmen, Holland: *Broken Circle/Spiral Hill* (1971)
Tecovas Lake, Amarillo, Texas: *Amarillo Ramp* (produced posthumously in 1973)

https://www.diaart.org/visit/visit/robert-smithson-spiral-jetty
https://www.robertsmithson.com/earthworks/amarillo_300c.htm
http://www.brokencircle.nl/index_eng.php

Des Moines Art Center, Iowa City
Menil Collection, Houston
Museum of Contemporary Art, Chicago
Museum of Modern Art, New York
Philadelphia Museum of Art

Spiral Jetty (1970), a film directed by Robert Smithson
Troublemakers: The Story of Land Art (2015), a film directed by James Crump

https://www.robertsmithson.com

FURTHER READING

George Baker, Bob Phillips, Ann Reynolds and Lytle Shaw, *Robert Smithson: Spiral Jetty*, University of California, 2005
John Beardsley, *Earthworks and Beyond: Contemporary Art in the Landscape*, Abbeville Press, 2006
Jack Flam (ed.), *Robert Smithson: Collected Writings*, University of California Press, 1996
Robert Hobbs, *Robert Smithson: Sculpture*, Cornell University Press, 1981
Jeffrey Kastner, *Land and Environmental Art*, Phaidon, 2005
Lucy Lippard, *Overlay. Contemporary Art and the Art of Prehistory*, New Press, 1995
Ann Reynolds, *Robert Smithson: Learning from New Jersey and Elsewhere*, MIT Press, 2003
Gary Shapiro, *Earthwards: Robert Smithson and Art after Babel*, University of California, 1997
Eugenie Tsai (ed.), *Robert Smithson*, University of California Press, 2004

ANSELM KIEFER

Osiris and Isis, 1985–87

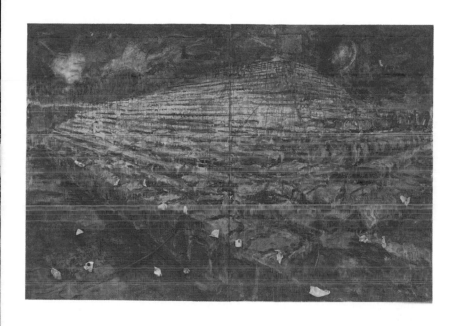

Oil and acrylic emulsion with additional three-dimensional media,
379.7 × 561.3 × 24.1 cm (149½ × 221 × 9½ in.)
San Francisco Museum of Modern Art

Anselm Kiefer's paintings from the 1980s, including *Osiris and Isis*, are one of the many signs that the story we have been tracing through modern art so far – in which styles are judged to develop through linear progression and supersession – has come to an end. In the period of Post-Modernism, artists consciously appropriated hybrid historical styles in defiance of the purity associated with Modernist aesthetics. But Post-Modernism represents not so much the termination of Modernism as its splintering. Indeed, from today's perspective, the so-called Neo-Expressionism of the late 1970s and 1980s can be seen to announce the birth of the eclectic pluralism that is now the dominant feature of the contemporary art world.

THE BIOGRAPHICAL KEY

Anselm Kiefer was born in 1945, just months before the end of the Second World War. Between 1942 and 1945 one million tonnes of bombs were dropped on Germany, razing whole cities. Kiefer's family home was among those bombed, and he recalled that in the bleak post-war period he had no toys. As already noted in relation to Joseph Beuys's work (see p. 144), the emotional toll of growing up in a defeated, ruined and impoverished country – one that was now divided into rival Cold War ideological states – was greatly exacerbated by Germany's universally reviled recent past.

This dark legacy made an indelible mark on Kiefer and his generation. But, unlike Beuys, who was about twenty years older and had fought in the war, Kiefer was too young to have experienced Nazism directly, though he lived in the shadow of its memory. This generational difference meant Kiefer had a greater willingness to engage with its legacy and to expose the still-unacknowledged trauma. He wanted to confront Germany with its taboos. So, while Beuys had felt it necessary to deal with this painful history using highly ambiguous imagery, imbued with a personal alchemical symbolism, Kiefer aimed to make more obviously manifest the collective experience of Germans through his own use of symbols. He therefore began to use his art as a site within which Germany's trauma could be confronted through the repetition of controversial collective images, symbols and rituals. He actively engaged with explicit shared narratives.

Anselm Kiefer, 1991. Photograph by Ursula Kelm

But while Kiefer initially focused on Germany's complex relationship to its past and the legacy of Nazism, by the mid-1980s, when he painted *Osiris and Isis*, his aim was not so much to evoke the specific events of German history as the much larger issue of the relationship between the timeless myths of world civilizations and the dysfunctional nature of contemporary society. His notion of linear history increasingly ceded to a vision of cyclical, mythic time. For, as Kiefer asserted, 'the further back in time I go, the further into the future'.[59]

THE HISTORICAL KEY

Stylistically, *Osiris and Isis* is an example of Neo-Expressionism. It can be related to the works of such other artists as fellow Germans Georg Baselitz and Sigmar Polke, the Italians Sandro Chia and Francisco Clemente, and the American Julian Schnabel, who, in the late 1970s and early 1980s, all sought ways to revive expressive figurative painting. They did so after a period when many of the most ambitious artists had rejected ideas of expressive content, abandoning painting because it was too closely allied to traditional values, and too easily exploited as merchandise (see Beuys, p. 144; Smithson, p. 156; Kruger, p. 180).

Osiris and Isis relates to other works made by the artist between 1984 and 1987 that address the ambivalent benefits of energy technologies – human-made resources that have the power both to preserve life and to destroy it. In 1986, during the making of the painting, the Chernobyl nuclear-reactor disaster occurred, an event that graphically demonstrated the destructive power of technology, bringing Armageddon seemingly a little closer.

The pyramid-like structure of Kiefer's work, which is made from applying clay and oil paint to the surface of the canvas, is more akin to the stepped Maya temples of Mexico than the Egyptian context suggested by the work's title, emphasizing that it is far from being a literal illustration of the myth named. Rather, Kiefer has a more universal message in mind. Within many cultures, a pyramid represents the point where heaven and earth connect, where the celestial and the earthly are close. In his painting, at the apex of the structure,

at the borderline to the celestial where a sacrifice might be made, Kiefer has attached the electronic circuit board of a television. Long braids of burned and corroded copper wire hang out from the painting's surface and down the facade of the structure, falling to the base, where seventeen shards of porcelain have been soldered on with molten lead.

Although Kiefer argues that it isn't necessary to delve into the complex background to his works, and that seeing them is enough, it is useful to focus on the title of this painting as a primary aid to interpretation. *Osiris and Isis* is a direct reference to an ancient Egyptian myth. Set, god of the desert, storms, disorder, violence and foreigners, is jealous of his brother Osiris's benevolent power as Lord of the Underworld and Judge of the Dead, and so murders his rival by trickery. Finally, however, helped by Isis, Osiris's loyal wife, Osiris is reborn. Along with their son Horus, Osiris finally gets revenge over Set and reclaims his throne. Osiris epitomizes the wise leader, Isis symbolizes the loyal wife and helper, and Set embodies evil, envy and hatred. The myth pits good against evil. The central theme is that hope and life can emerge from despair and death.

The pyramid-like structure, which also looks like a stack of books, is made through applying clay, a material used by the Egyptians not only to manufacture bricks for building but also to inscribe hieroglyphic texts on its surface. A circuit board is made to facilitate communication – which here is cast as the vital act of communication taking place between the earth and heaven, humanity and the gods – but the circuitry is destroyed, so Kiefer's work gives the overwhelming impression of a failure of communication and impending catastrophe. The mood of his painting is decidedly ominous. *Osiris and Isis* is pervaded by a sense of decay and destruction. Kiefer seems to be suggesting that knowledge, symbolized by the pyramid and the electronic circuit board, can be used for good or evil, but is more likely to be exploited for destructive goals.

THE AESTHETIC KEY

Kiefer maintained a link with more Conceptual-art practices by incorporating texts and photographs into his work, while also

producing large-scale figurative paintings. Stylistically, he looked back before the Modernist period, and reintroduced into contemporary painting many of the preoccupations of German Romanticism, such as the yearning for spiritual transcendence. He also self-consciously appropriated in his earlier work the aesthetics of early twentieth-century German Expressionism, particularly woodblock prints, reviving its raw, exaggerated figurative style.

In the early 1980s, Kiefer's brushstrokes became more forceful. He began loading the surfaces of his often-monumental canvases with straw, shellac, sand, earth, lead, clay and other extraneous organic and inorganic materials, scrawling enigmatic texts across the terrain he produced.

The massive scale of *Osiris and Isis*, its dark almost monochrome colours, its worn and pitted surface, the way it juts out from the wall by a good fifteen centimetres, and the dramatic subject matter, all indicate that Kiefer is exploiting the aesthetics of the sublime (see Rothko, p. 110). This sense of awe is enhanced by the use of perspective, which gives viewers the impression that they are located at the foot of the pyramidal structure, looking up. But the way Kiefer has painted the work suggests that this solid architecture is extremely vulnerable, that the monument could at any moment collapse and that something terrible has, or is about to, happen.

THE EXPERIENTIAL KEY

Like Kiefer's work in general, *Osiris and Isis* is fundamentally ambiguous. While some kind of narrative content is implied, it seems to lie beyond anyone's powers of interpretation, suspending the viewer instead in a sea of semantic vagueness. This elusiveness connects Kiefer's work to nineteenth-century Romanticism and Symbolism, movements that demonstrated that meaning is not something fixed and determined, but rather an elusive feeling or mood.

But endeavouring to interpret the symbolic meaning of the myth that gives *Osiris and Isis* its title risks distracting us from the visceral experience of Kiefer's work itself. He has joined together two large canvases to produce a work that seems almost as big as the structure it depicts. We feel overwhelmed by the size of painting. Indeed, a major

feature of Kiefer's work in general is its sheer monumentality. The artist evokes a powerful feeling of devastation by the rough, pitted surface and the use of dark, brooding colours, without depending on imagery and mythical meaning. Indeed, Kiefer marshals the materiality of painting to engage us at an embodied level that heightens our awareness of the here and now.

By emphasizing the overwhelming might of the natural and the human-made world, Kiefer communicates a powerful sense of existential powerlessness. The building up of a complex surface terrain serves to confuse the easy reading of forms. The vastness of scale, and the suggestion of absence rather than presence, or what cannot be represented rather than what can, imply a suggestive aesthetic that is ungraspable and far from the quantifiable, objective world.

More than any other work in *Seven Keys*, *Osiris and Isis* makes the link between the senses of sight and touch an important aspect of how we respond to it. The work's surface invites us to experience the painting with our tactile sense. While sight facilitates the gathering of general conceptual knowledge through spatially detaching us from what we perceive, touch verifies and brings conviction through providing specific knowledge revealed intimately via close physical contact. Touch concerns two bodily functions – the tactile and the kinaesthetic – awareness of the movements of our body that orient us in relation to our environment. Kinaesthesia helps us to construct our world through multiplying points of contact, immersing us in what we perceive. We use the relation of our sense faculties to our muscles and other body parts so as to feel the position and movement of our bodies, and then react by having appropriate thoughts and making decisions. Our sense of touch and the kinaesthetic thereby help build a stronger and a more authentic awareness of a three-dimensional and temporal world than the sense of sight.

THE THEORETICAL KEY

For Kiefer, the central purpose of art is to confront the ultimate questions of human existence. He relates his work closely to philosophy, literature and history in order to explore the grand themes of spirituality and transcendence, fear and hope, terror and despair.

Like Beuys, Kiefer perceived that the German people's burden was a specific historical instance of the pervasive sense of dread that is the inevitable lot of humanity. This feeling has become especially disturbing in an age obsessed with the benefits of technology and with a reality limited to what rationalism can reveal.

Mysticism, and especially Cabbala, and alchemy are central to Kiefer's work, which can be read as an exploration of perennial spiritual themes. Kiefer is influenced in particular by the writings of the psychologist Carl Jung, who saw the goal of the arts as bringing about spiritual renewal through connecting to what he termed 'archetypes', thereby integrating all aspects of the human psyche. Jung argued that the unconscious is full of symbols. Dreams reflect not only the individual unconscious, as Freud argued, but also what Jung called the 'collective unconscious', a shared resource of archaic experiences that are represented through archetypes, universal symbols that spontaneously emerge in people's minds. Jung saw parallels between ancient myths, dreams and psychotic fantasies, arguing that mythologies – the stories a society tells itself – are a key to understanding the complexities of the human mind. Jung noted that such esoteric traditions as mystical Cabbala and alchemy conceal important archetypes in their arcane symbolism and proto-scientific research into metals, and carry wisdom concerning the spiritual quest for inner transformation. Jung also believed that Christianity had suppressed the role of evil in human life, failing to recognize that God has a shadow side that must be confronted in order for true spiritual awakening to be achieved.

Kiefer especially draws on writers influenced by Jung in the field of anthropology and the history of religion who have developed theories about the evolution of human societies that link culture to deep, recurring themes. Mircea Eliade, for example, described the way humankind divides experience into the fundamental categories of the sacred and the profane. The sacred reveals itself as something wholly different from the profane. 'By manifesting the sacred,' Eliade wrote, 'any object becomes something else, yet it continues to remain itself, for it continues to participate in its surrounding cosmic milieu.'[60] As a result, Eliade argued that all human cultures envisage that there are three cosmic levels – earth, heaven and the underworld – and the *axis mundi* (centre of the world), which might be symbolized by

a pole, pillar, tree, ladder, mountain, or tall structure like a pyramid, links together all three cosmic levels.

In the case of *Osiris and Isis* the dominant archetype is that of the pyramid – which is the *axis mundi*, symbol of the union of the terrestrial and celestial. Kiefer also dwells on destruction and darkness – the power of the underworld – and this can be interpreted as an attempt to incorporate the shadow on the symbolic level of art. Kiefer thereby uses art as a therapeutic practice for personal and social healing.

THE SCEPTICAL KEY

In the process of shifting his theme from the specifically historical to the generalized mythical, Kiefer's work can be accused of losing any ability to challenge unreflective assumptions. Many of his paintings lack any real grounding in contemporary reality.

Through the continual reiteration of the subject of disaster, Kiefer has, arguably, neutralized the unsettling and potentially subversive power of this subject matter, rendering it normal and palatable. Indeed, behind the manifold signs of apparent trauma, Kiefer actually has a comfortable world view in which religious, mystical and esoteric traditions, together with a medley of myths culled from different cultures, operate in tandem, and all orchestrated by the artist-magician.

While the subject matter is generic, the style of Kiefer's work has also settled into a 'grand manner', bringing to mind the paintings of historical subjects in the nineteenth-century art academies, whose members produced vast works intended to glorify the nation state. In contemporary society, this glorification comes via an inversion of the old values, so that the tragic, abject and repressed – the anti-heroic – and the inelegant, rough-hewn and violated become affirmations of the status quo. While *Osiris and Isis* and other works by Kiefer have richly allusive iconography that may be grist to the intellectual mill, they also indicate to some commentators the return of a kind of vague, larger-than-life rhetoric that many Modernist artists sought to expunge from their work. While appearing accessible, Kiefer's work has become increasingly ambiguous and difficult to read.

THE MARKET KEY

The brooding and ominous content of Kiefer's works, as well as their huge scale, difficulties of installation and practical conservation issues, all make his oeuvre a problematic acquisition. The San Francisco Museum of Modern Art purchased *Osiris and Isis* directly from Kiefer's studio in 1987. The local press was soon up in arms over the price tag – reportedly $400,000 – which was an astronomical sum for a museum to pay for an artist who, at the time, was still largely untested in the marketplace.

Today, however, *Osiris and Isis* is recognized as one of Kiefer's most important works. He has become a major artist, commanding huge prices all over the world. *Let a Thousand Flowers Bloom* (1999) was sold at Christie's, London, in 2007 for £1,812,000, making it Kiefer's most expensive artwork. But the work sold again at the same auction house in 2014 for almost two-thirds that price – £1,202,500 – an indication that the art market is, in essence, an unpredictable place for investment.

FURTHER VIEWING

Hall Art Foundation, Reading, Vermont
Hamburger Bahnhof, Museum für
 Gegenwart, Berlin
Kunsthalle Mannheim
MASS MoCA, North Adams,
 Massachusetts, in collaboration
 with the Hall Art Foundation
Museum of Modern Art, New York
San Francisco Museum of Modern Art
Solomon R. Guggenheim Museum,
 New York

Kiefer's former studio, Barjac,
 near Nîmes

Over Your Cities Grass Will Grow
 (2010), a documentary
 directed by Sophie Fiennes

FURTHER READING

Daniel Arasse, *Anselm Kiefer*, Thames
 & Hudson, 2014
Michael Auping, *Anselm Kiefer: Heaven
 and Earth*, exh. cat., Modern Art
 Museum of Fort Worth, Musée
 d'Art Contemporain de Montréal,
Hirshhorn Museum and Sculpture
 Garden, Smithsonian Institution,
 Washington DC, and San Francisco
 Museum of Modern Art, 2005–6
Dominique Baqué, *Anselm Kiefer:
 A Monograph*, Thames & Hudson,
 2016
Matthew Biro, *Anselm Kiefer and the
 Philosophy of Martin Heidegger*,
 Cambridge University Press, 2000
Andréa Lauterwein, *Anselm Kiefer/Paul
 Celan: Myth, Mourning and Memory*,
 Thames & Hudson, 2007
Rafael López-Pedraza, *Anselm Kiefer:
 The Psychology of 'After the
 Catastrophe'*, George Braziller, 1996
Mark Rosenthal (ed.), *Anselm Kiefer*,
 exh. cat., Art Institute of Chicago,
 Philadelphia Museum of Art,
 Museum of Contemporary Art,
 Los Angeles, and Museum of
 Modern Art, New York, 1988–89

BARBARA KRUGER

Untitled (I shop therefore I am), 1987

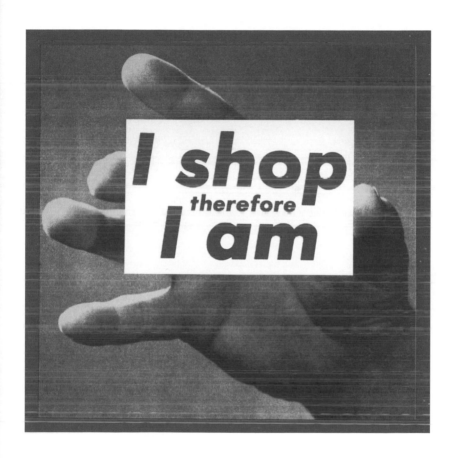

Photographic silkscreen on vinyl, 282 × 287 cm (111 × 113 in.)
Modern Art Museum of Fort Worth, Texas

181

In the 1960s, avant-garde art became particularly politicized, and linked to revolutionary social change. By the 1970s, however, any hope of bringing about such change had waned, and the idea of participating in politics was abandoned in favour of engaging at the level of signs in institutional critique and identity politics. It was argued that while actual revolution may no longer be viable, repressive social norms could be undermined from within through attacking the representations generated by society. Barbara Kruger's (b. 1945) art practice is dedicated to drawing attention to the connection between capitalism, symbolic systems such as art and the manipulation of desire.

THE BIOGRAPHICAL KEY

Barbara Kruger was born in Newark, New Jersey, in 1945 and now lives and works in New York and Los Angeles, where she teaches at the University of California. After leaving art school in New York, she successfully worked as a designer and editor with a number of publications in New York. But like Andy Warhol in the late 1950s and early 1960s, Kruger wanted to pursue a career in fine art. By the 1970s among the avant-garde the stylistic gap between commercial mass media and radical fine art had narrowed considerably, and any distinction between the two was now made primarily on the level of attitude rather than form. Thus, to a greater extent than was the case with Warhol, Kruger could transfer her graphic-design skills directly into the fine-art context.

In 1973, Kruger was selected for the prestigious Whitney Biennial exhibition, and her career took off. Her early work juxtaposed words with her own photographic images, but soon Kruger began using found images from magazines and newspapers, overlaying them with short slogan-like texts. Gradually expanding her choice of media and contexts, Kruger today opts for prints, photographs, electronic signs, carpets and installations, displayed on billboards, buses, T-shirts, cups and in department stores. She also curates projects, as well as writing about art and culture.

As a woman coming of age in the 1960s and 1970s, Kruger was especially influenced by feminism. In her work, she questions the

status quo, believing that what passes for reality is a false consciousness imposed by the ruling phallocratic – male-centred – elite that is disseminated and naturalized through the mediation of images. Throughout recorded history, feminists point out, women have been defined as the inferior 'Other'. They are classed as a deviation from the 'natural' and 'normal' male, and constantly subjected to oppression, while being obliged to emulate or copy the so-called normality constructed by men. For feminists, analysing the distinction between sex and gender is therefore crucial. While the former constitutes a biological difference, the latter is a socialized difference imposed by men – the result of conditioning, not biological determination. As Simone de Beauvoir would have it, woman is not born, but rather becomes woman through socialization, and gender difference is a product of language – of symbolic systems – rather than anatomy.

THE HISTORICAL KEY

Within a society increasingly influenced by the commercialized mass media, and controlled by the forces of global corporations, artists felt compelled to confront the fact that art itself was embedded within a web of mediating systems involved in sustaining power relations. It was therefore necessary to question not only the art of the museums, but also any form of modern art that did not sufficiently demonstrate its critical political purpose, or that failed to address sufficiently the complicity of art with power interests. Abstract art's preference for the immediate, the pure, the real and the essential, revealed through the focus on aesthetic form, spiritual transcendence or self-expression, was judged to have failed to bring art into a critical relationship with the social world. Indeed, the very notion of the aesthetic had now to be questioned and rejected as hopelessly compromised by its complicity with a repressive system.

A fundamentally 'anti-aesthetic', idea-based practice developed, for which the work of Marcel Duchamp (see p. 56) was an important early model. This anti-aesthetic was fused with a commitment to identity politics – that is, artists engaged with the social and political implications of the concepts they presented, relating their work to issues of gender, race or political ideology. Culture was approached

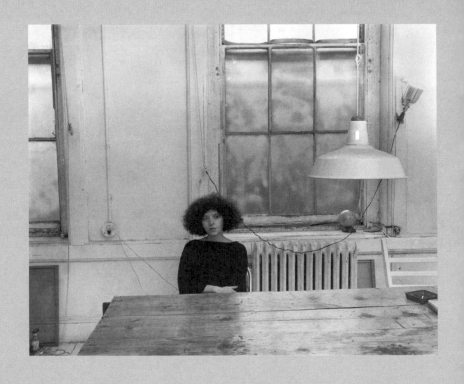

Barbara Kruger, 1982. Photograph by Peter Bellamy

as a complex body of social 'texts'. Thus Kruger begins from a central premise of Post-Modern theory which is that perception is neither natural or objective because it is socially determined, and therefore implicated in a mechanism of control. Values and identity are cultural constructs, not stable and objective truths or entities, and this means judgments of taste are bound to social position, gender and ethnicity.

Even the notion of the self is understood to be produced through systems of power, which often masquerade as being natural, or are simply imposed from above. This self is actually a discourse the result of language rather than something natural or absolute. As the philosopher Michel Foucault declared, 'power is everywhere' – it is an everyday, socialized and embodied phenomenon, a major source of social discipline and conformity, diffused and borne out in discourses and knowledge, and going far beyond politics, or what Foucault termed 'regimes of truth'.[61]

By the time Kruger's generation came to study art, universities – and especially literature and fine art departments – had become enclaves from which to launch radical critiques of society on the level of 'social texts'. Almost all areas of experience were deemed to be texts to be read and decoded. The neo-avant-garde of which Kruger became part made language its principal focus. Artists indulged in a general confusion of traditional categories, using fragmentary and appropriated imagery, and strategies of impermanence, repetition, accumulation, the sequential and the discursive. They rejected the conventional hierarchy between art, design, popular literature and other kinds of apparently non-artistic symbolic systems. As the critic Craig Owens argued at the time, the challenging art of the late 1970s and early 1980s – for example, the work of Kruger or other neo-avant-garde women artists such as Cindy Sherman, Sherrie Levine and Jenny Holzer – was informed by an 'allegorical impulse', in which 'one text is read through another, however fragmentary, intermittent or chaotic their relationship may be'.[62]

THE THEORETICAL KEY

'My work has always been about power and control and bodies and money,' Kruger explains.[63] Symbolic systems play an essential role

in the reproduction of social structures of domination, and serve to justify society as it is. 'Who is granting power? Who's withholding power?' Kruger asks. 'What are the systems of absence, presence, seen, unseen, heard, unheard?'[64]

In the nineteenth century Karl Marx noted that, under capitalism, people are prone to what he termed 'commodity fetishism'. A 'commodity' is an object – a product bought and consumed that is valued for its own sake rather than for the amount of real labour expended to produce it – while 'fetish' is a word used by nineteenth- and early twentieth-century anthropologists in relation to premodern cultures to refer to an object invested with magical power.

In the industrial society of the time, Marx observed that people largely derived their sense of identity from both their role as industrial labour and their status within a social class, and so commodities were largely associated with the social hierarchy. However, in today's post-industrial society, new economic conditions have changed the means of production and evened out social hierarchies. While the industrial society described by Marx had been organized around the production and consumption of commodities, contemporary post-industrial or post-modern society is arranged around simulation and the play of images and signs, and commodities hold immense power.

After the 1960s the right to individual free self-expression and determination became increasingly valued as a prerequisite for personal well-being, and, instead of class or collective allegiance, emphasis was placed on individual choice, and these choices often boiled down to choices between commodities. The slogan (*Untitled*) *I Shop Therefore I Am* has been described as the 'mantra' of this post-industrial society. It is a parody of the famous dictum of the seventeenth-century philosopher René Descartes, *cogito, ergo sum* (I think therefore I am). By substituting 'shop' for 'think', Kruger transforms the dictum into a critique of the values of post-industrial society. Descartes declares that it is thanks to the capacity for sustained reflective thought that the surest grounds for establishing the certainty that one exists are provided. Kruger, by contrast, suggests that this ideal has been usurped by the forces unleashed in advanced capitalist society, giving the commodity immense psychic value.

People feel satisfied both materially and spiritually by owning products, and if someone isn't shopping, they don't exist – they don't have any substance and value. Within post-industrial society, shopping is therefore much more than just an activity for the procurement of the necessities for survival; it has now become the principal arena within which individuals seek to construct their awareness of existing. People use product brands to define who they are, and, as Kruger noted, because women are deeply involved in this consumerism, and are turned into commodities themselves, it is they who suffer most from this new culture, causing a trivialization of their lives, and yet further alienation.

THE EXPERIENTIAL KEY

Kruger suggests that, as art itself is a sign system embedded within a matrix of power relations, we must be aware of this duplicitous status and not indulge the myth of art as free self-expression or limit ourselves to the aesthetic appreciation of form. Kruger wants us instead to consider the experience of art as equivalent to the reading of a socially compromised code. Her interest in the relationship between words and images derives from the ability of language to persuade. 'Pictures and words seem to become the rallying points for certain assumptions,' she observes. 'There are assumptions of truth and falsity and I guess the narratives of falsity are called fictions. I replicate certain words and watch them stray from or coincide with the notions of fact and fiction.'[65]

In experiencing her work, we become participants in the activity of decoding the beliefs of the society within which we live. In this specific case, Kruger directs us to consider how under capitalism commodities are increasingly invested with the magical powers to guarantee well-being and forge identity. In a recent interview, Kruger remarked that it would be wrong to think that society has changed since 1987 when she made *(Untitled) I Shop Therefore I Am*. Indeed, because of online shopping and the proliferation and targeted specificity of social media on the Internet, 'Things are like they were but multiplied in terms of the intensity of commodity culture'.[66]

THE AESTHETIC KEY

For Kruger, the aesthetic attitude is deeply suspect, and must be subsidiary to critical goals. Nevertheless, the artist has developed a highly characteristic and consistent visual language. She adopts the norms of advertising, using a style that has evolved in response to market imperatives. The nature of the relationship between text and image in advertising is based on the assumption of the short attention span of the viewer/consumer, and determined by strategies of persuasion that occur mostly at an unconscious level. Advertising design is devised so that it can be cheaply reproduced and easily read, and involves the juxtaposition of short, memorable texts in attention-grabbing typography with images.

Specifically, Kruger consciously appropriated the Modernist design pioneered by Russian Constructivists such as Alexandr Rodchenko, and the Bauhaus in Weimar Germany. Her visual language overtly makes reference to a specific history of Modernist aesthetics, and her preferred typography is the sans-serif font called Futura, designed by Paul Renner in 1927 – the most influential font design in the Bauhaus era. In Renner's time, Futura came to symbolize the optimistic vision of rational and technological society. By the 1950s the use of sans-serif fonts like Futura had been absorbed into the commercial mainstream, just like many other early twentieth-century avant-garde innovations, such as cropping photographs, the close-up, asymmetrical and dynamic composition, and simplicity of design. Kruger therefore effectively reappropriated the Modernist style, which, through its absorption by advertising, had lost its relationship to any revolutionary agenda, in order to exploit it once again as a deconstructive weapon. She uses the aesthetic conventions and technologies of the mass media against themselves, subverting the commercially motivated messages from within.

As is usual in Kruger's work, in *Untitled (I Shop Therefore I Am)* a black-and-white stock photograph functions as the ground over which she has photocollaged a white box within which red text appears in clear typography. Sometimes Kruger colour tints the photograph, and reverses the text/ground relationship, so that the

text is white and the ground black or red. The manner in which she has juxtaposed the rectangular box of text and the open hand sets up an ambiguous relationship between the verbal and the visual signs, in which the former could be either part of the representational world of the latter or superimposed on it. Is the hand holding the slogan, showing it to the viewer as if it is a business card or some specimen? Or is the text collaged on top of the photograph, and in that case, the hand is reaching out to take something – a product, perhaps?

THE SCEPTICAL KEY

The slogan 'I shop therefore I am' is snappy, and it points to an unfortunate truth about our society. But it is both an exaggeration and a generalization. While based in social reality, the message ends up reducing complex issues to simplistic and abstract terms that can then easily be manipulated and reassimilated. Indeed, the reduction to a slogan means that, regardless of the content – social critique or sale's pitch – the effect is essentially the same. The text is too generalized to be politically useful.

In fact, Kruger's work has given advertisers additional leverage through which the viewer/consumer can be more successfully lured; by co-opting the style of her work, commercial interests can offer to their clients an insider's reference to elite art world culture, adding niche glamour to a product or activity. For several years in the early 2000s, Kruger partnered with the London department store Selfridges to create a so-called 'anti-marketing' campaign using slogans like 'I Shop Therefore I Am'. But the critical insight of Kruger's slogans were simply inverted and turned into a knowing affirmation.

As one *New Yorker* critic put it in 2017, 'What began as a way of subverting the vernacular has become a part of the vernacular itself.' But the fate of Kruger's art was predictable from the beginning. Indeed, Kruger's case suggests that avant-garde strategies of institutional critique in general often end up providing ammunition for the erstwhile 'enemy'. By opting for the stylistic norms of the advertising world, and locating her critique at the level of abstract identity politics

rather than institutional politics – where real, piecemeal change might be achieved – Kruger fails to establish any real relationship with the issues she critiques. She can make only symbolic gestures that are soon reabsorbed into the system they are intended to oppose. This situation also suggests that, as a guiding artistic principal, the idea of 'criticality' based on identity politics should itself be critiqued.

THE MARKET KEY

One of the central concerns of Kruger's generation was to free art from its commodity status. By engaging in identity politics, Kruger also saw her role as extending well beyond the making of artefacts, and she has consistently participated in social-protest movements. In Kruger's case, these priorities meant adopting the visual language of advertising, employing word and image in order to deconstruct social customs and using mass-produced technology. This also offered the possibility of showing her works across a wide variety of platforms and markets at accessible prices. *Untitled (I Shop Therefore I Am)*, for example, can be purchased online as a canvas print, paper bag, shopping bag, T-shirt, pillow, throw, duvet cover, quilt, wall tapestry, rug, travel mug, iPhone, iPad and laptop skin, wall clock and several other items.

But *Untitled (I Shop Therefore I Am)* also has a more conventional high-art status. It exists in two different limited editions of large screen prints on stretched vinyl. For the first edition, Kruger used a black ground and a white text. A similar size work from 1985, *Untitled (When I Hear the Word Culture I Take Out My Checkbook),* sold at Christie's, New York in 2011 for $902,500, though the estimate was between $250,000 and $350,000.

FURTHER VIEWING

The Broad, Los Angeles
Hammer Museum, Los Angeles
National Gallery of Art, Washington DC

FURTHER READING

Yilmaz Dziewior (ed.), *Barbara Kruger: Believe + Doubt*, exh. cat., Kunsthaus Bregenz, 2014
Barbara Kruger, *Picture/Readings*, Barbara Kruger, 1978
Barbara Kruger, *No Progress in Pleasure*, CEPA, 1982
Barbara Kruger, *Remote Control: Power, Cultures, and the World of Appearances*, MIT Press, 1993
Barbara Kruger, *Barbara Kruger*, Rizzoli, 2010
Barbara Kruger and Phil Mariani (eds), *Remaking History*, Bay Press/Dia Art Foundation, New York, 1989
Barbara Kruger: We Won't Play Nature to Your Culture, exh. cat., Institute of Contemporary Arts, London, and Kunsthalle Basel, 1983–84
Barbara Kruger (Thinking of You), exh. cat., Museum of Contemporary Art, Los Angeles, 1999
Barbara Kruger, exh. cat., Modern Art Oxford, 2014
Kate Linker, *Love for Sale: The Words and Pictures of Barbara Kruger*, Harry N. Abrams, Inc., 1996
Brian Wallis (ed.), *Art After Modernism: Rethinking Representation*, New Museum of Contemporary Art, New York, 1984

XU BING

A Book from the Sky, 1987–91

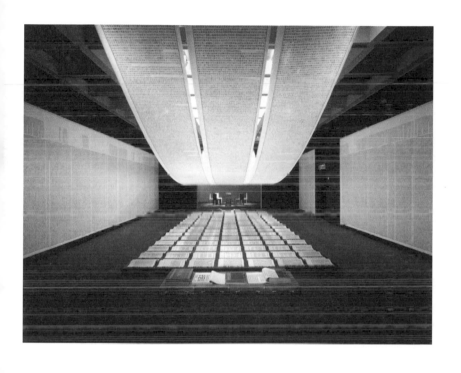

Mixed media, dimensions variable
Hong Kong Museum of Art

Craftsmanship and traditional aesthetic values are central to the success of Xu Bing's (b. 1955) *A Book from the Sky*, one of the most powerful and subtle of recent indictments not only of authoritarian regimes but also of the links between language and power. This is a Chinese instance of the 'shock of the old' delivered by the Post-Modernist aesthetics, which, in the late 1970s in the West, began to supersede the blunted subversiveness of Modernism's incessant 'shock of the new'. *A Book from the Sky* forces illiteracy on all Chinese people, producing an absurd version of the cultural levelling that Mao and the Communists claimed socialism was bringing about. But wider contexts also suggest themselves – for example, the impact of globalized Western capitalist culture, in which all languages undergo transformation, and some are lost for ever. Indeed, capitalism has influenced languages in a much more insidious way than communism – advertising, for instance, has made language more banal and commercial.

THE HISTORICAL KEY

A Book from the Sky caused a sensation when it was first shown in Beijing in 1988. Associated with the Republic of China's New Wave of Fine Arts movement, Xu Bing (b. 1955) was criticized by both official Communist apparatchiks, who saw the work as wilfully obscure, and progressive artists and critics, who considered it too traditional.

As Xu explained, this work was intended to combine 'the jumbled knot of socialism, the Cultural Revolution, the Reform Period [the period after Mao's death in China], Westernization, modernization'.[67] Through an installation consisting of what look at first glance like four thousand Chinese characters printed in four traditional stitch-bound books, with wall-mounted texts and hanging scrolls, Xu addresses the use and misuse of language, the clashing of past and present in his native China. The four volumes form a rectangle on the ground, with the scrolls hanging down from above, suggesting the duality of earth and heaven.

The Chinese title of the work, *Tiānshū*, literally means 'divine writing', a term used to refer to religious texts, but it can also mean 'gobbledegook' or 'double Dutch', that is, obscure or illegible writing.[68]

For, in fact, Xu's texts are completely meaningless from a linguistic point of view. He deliberately invented characters with no grammatical function, although all of them are based on the structures of real Chinese writing. Xu aimed to make a book that fails to perform its essential function. It is an empty book that still looks in every way like a real book. As the contemporary Chinese poet Bei Dao put it, Xu's characters 'are nothing but a pictograph that has lost its sound'.[69] Xu used the conventions of Chinese writing and traditional woodblock printing to subvert time-honoured ideas, launching an assault not only on language and on contemporary Chinese culture, but also on the role of language in general.

The specific context for Xu's exercise in forced illiteracy is the impact of communism on the Chinese language. During the Cultural Revolution (1966–1976), while Xu was a child and teenager, a concerted campaign was launched to smash the four 'olds' – old ideas, customs, culture and habits. In the process, the Communists aimed to purify the Chinese language, ridding it of so-called reactionary elements.

To encourage widespread literacy, Mao ordained that the characters of Chinese writing must be simplified. Written slogans were primarily based on patterns in everyday Chinese speech, because short rhythmic phrases were considered the clearest way of speaking, but at the same time, the Communists also plundered classical Chinese works, employing old rhythmic phrases to get their messages across. Language, which was strictly censored, was turned into propaganda.

Inevitably, Mao's purges affected not only language but also those who used it. As Xu later noted, Mao's radical impact on Chinese culture was 'most deeply rooted [in] his transformation of language.... To strike at the written word is to strike at the very essence of the culture. Any doctoring of the written word becomes in itself a transformation of the most inherent portion of a person's thinking. My experience with the written word has allowed me to understand this.'[70]

THE BIOGRAPHICAL KEY

From a young age, Xu Bing was made painfully aware that language could be easily influenced and manipulated, that it could be used to

liberate or control. Like his whole generation in communist China, Xu directly experienced the massive upheavals of the Cultural Revolution. Such changes were especially traumatic for Xu because he was the son of an academic, who taught at Beijing University, and a librarian mother – the very people condemned by Mao for obstructing China's movement towards socialism. Xu writes: 'At the time there was a saying: "Use your pen as your weapon and shoot own reactionary gangs." My father was a reactionary.'[71] Xu had grown up surrounded by traditional culture and thousands of books. His parents taught him age-old calligraphic techniques at home from a young age, but as a teenager he was forcibly separated from his parents to be 're-educated' according to official policy, and sent to the provinces to work in a farming commune.

The Tiananmen Square protests in 1989 were a turning point for Xu. The government censored his activity. But it was by choice rather than compulsion that he chose to emigrate to the United States in 1990, and later to become an American citizen. In 1999 Xu was the first Asian-American to be awarded the prestigious MacArthur Foundation Fellowship, which is awarded for extraordinary originality and dedication to creative pursuits.

Xu adapted easily to his role as a global artist, and is much in demand. *A Book from the Sky* was followed in 1996 by a series of installations entitled *Square Word Calligraphy,* for example, in which Xu created a hybrid fusion of Chinese and English writing systems whereby English words are compressed into Chinese character forms.

In 2008, Xu returned to Beijing, where he accepted a prestigious academic post, as he believed that the political climate had once again made artistic expression more feasible in China and that his responsibilities as an artist would be better fulfilled there. In his more recent works, Xu explores cross-cultural dialogue, while focusing particularly on the subtle deconstruction of traditional Chinese landscape painting.

THE AESTHETIC KEY

The subversive impact of *A Book from the Sky* depends on Xu's ability to convincingly appropriate traditional Chinese aesthetics. His

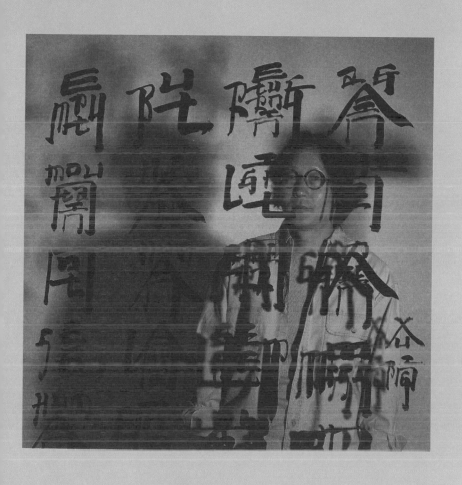

Xu Bing, undated. Photograph by Michael L. Abramson

training as a printmaker prepared him for the laborious and skilful task of carving each individual piece of movable type from pear wood by hand, using font styles from the Song and Ming Dynasties. Xu, who taught himself the necessary techniques for printing, had to show the printers how to compose and print using woodblock moveable type. The books, which come with wooden cases, were printed on folded leaves of paper traditionally used in the printing of religious works such as Buddhist sutras. The work's high quality, even when judged by the standards of the traditional printing technology Xu appropriated, is revealed in the meticulous attention paid to the inking of the blocks.

The inherent formal qualities of Chinese written characters, combined with Xu's use of traditional technology and manner of presentation, mean that the aesthetic level of the text-based medium is much more pronounced than it would be in a similar exercise in Western printing. Western art since the Renaissance, and until the challenge of Modernism, is characterized by the separation of reading space and image space, a process aided and abetted on the one hand by the imperatives of optical realism, and, on the other, by the invention of the printing press.

In East Asia, by contrast, the ideographic nature of writing itself, and the high status of the art of calligraphy, remained dominant into the twentieth century. The same tools – a brush, ink and paper or silk – were used for writing and for making images, and were combined within a picturing system that was based on visual notation. A rectangular flat surface was therefore the site for graphic inscription in general, unlike in the West, where two-dimensional surfaces were set aside for writing – first by hand, then by mechanical printing.

THE EXPERIENTIAL KEY

When encountering *A Book from the Sky,* almost everyone except those who know the language will have as an initial impression the idea that they are seeing examples of actual traditional Chinese characters, transposed to a setting more usually reserved for visual art.

When the work was first shown, even some Chinese viewers apparently felt compelled to look in esoteric dictionaries to find the

meaning of the characters, and needed assurance that they really were unreadable, but this fact soon became obvious to native speakers. For the rest, the knowledge that these books actually contain a pseudo-language must be imparted via a supplementary commentary rather than by an encounter with the work itself. Xu's installation therefore makes us more than usually aware of the cultural divide through the different experiences had by viewers from a range of cultural backgrounds.

Xu's work is a reminder that the act of seeing is also always an act of reading, a fact that is far more consciously acknowledged in Chinese culture, because writing is not alphabetic. At the same time, because no one can understand this pseudo-writing, we are forced to interpret it in a less culturally conditioned way, in which the visual is no longer so colonized by language. For, broadly speaking, any drawing or painting will function within a spectrum that at one end has the fully discursive sign – such as a visual symbol or an ideogram – and, at the other, the purely gestural mark, which is without any semiotic value beyond that of signalling the 'indexical' presence at one time of the person who made the mark. *A Book from the Sky* confuses these categories, shifting us between semiotics and sensation.

THE THEORETICAL KEY

The broadest context for understanding what is at stake in Xu's work is the nature of writing itself. Western scripts are alphabetic or phonographic, using visual symbols to serve as the equivalents for speech. Chinese script, by contrast, is only partially phonographic, differing from Western scripts in being predominantly logographic – the characters have meaning by themselves, independently of speech. In both alphabetic and logographic writing systems, shapes are used as signifiers – as units of linguistic information. This means that literacy depends on the learning of a code – in China, children must memorize a large number of unique written characters, nowadays approximately four thousand logograms or composite shapes. Writing is therefore always closely allied with those who control and disseminate knowledge.

A central argument of much post-structuralist philosophy is that language is self-referential – the meaning of a word only derives from

its location within a system. Language does not map directly onto the real. Rather, it is based on social convention. Continuous restructuring and reimagining of words and their meanings is therefore necessary if they are to be imbued with living significance.

Jacques Derrida, the philosopher who was especially influential during the period Xu developed his practice, argued in works such as *Of Grammatology* (1967) that through the process of deconstruction, as he termed it, anything when read closely enough will lose its meaning. Indeed, there is never any fixed meaning, no centre, only a constant play or circulation in which no absolute truth is present. For Derrida, 'logocentrism' was found in cultures where writing is secondary or parasitical to speech, and he claimed that in China, as the written word has never been subordinated to speech, graphic traces – producing images and words – dominate over the logical or 'logocentric'. Derrida therefore argued that, because Chinese writing lacks a distinct oral structure, it is naturally immune to the problem of 'logocentrism' that lies at the centre of Western metaphysics.

Xu exploits expectations aroused by an existing cultural and linguistic framework, subverting them through the presentation of empty signifiers. By destroying writing as a code, he reimagines it as pure visual play. He turns language into pictures, and moves away from Derridean deconstruction, a mode of analysis that concentrates on inventive reading, producing what can be described as an instance of 'applied grammatology' – or a mode of composition that concentrates on inventive writing.

While Derridean deconstruction has interesting parallels with aspects of Xu's background culture, *A Book from the Sky* also invites a reading in relation to the traditional Chinese Taoist and Chan (Zen) Buddhist belief that the deepest truths can never be captured by words alone. As the Taoist classic the *Tao Te Ching* (fourth century BC) declares: 'The Tao that can be spoken is not the eternal Tao / The name that can be named is not the eternal name.'[72]

In this light, Xu's new 'heavenly text' has been rendered deliberately illegible in order to evoke the inexpressible essence of ultimate reality. It juxtaposes the vision of a higher, timeless and perfect 'book' with the inevitably imperfect and historically contingent examples that are produced by human cultures.

THE MARKET KEY

A Book from the Sky was the centrepiece of Xu's first exhibition in the United States, held between 1990 and 1991. Since then Chinese art has become highly profitable because of a confluence of forces: – the more open political situation; the emergence of a thriving global art market focused on new territories; the intrinsic novelty of Chinese works; and the ways the artists have sidestepped the more complex issues posed by Western art since the 1950s, thereby offering more obviously expressive and aesthetically pleasing works, often in the form of paintings. By contrast, Xu's work suggested a specifically Chinese take on the avant-garde's critique of signs.

A Book from the Sky has been exhibited numerous times throughout the world. Copies of the books are in the collections of the British Museum in London, the library of Harvard University, Queensland Art Gallery in Brisbane, and in public and private collections in Japan. The Hong Kong Museum of Art's version was acquired in 2000 with partial funds from the Bei Shan Tang Foundation, a philanthropic organization in Hong Kong. In 2014, Sotheby's Hong Kong sold another version for HKD$1,060,000.

THE SCEPTICAL KEY

The success of Chinese artists in the 1990s was often driven by political and market forces rather than the intrinsic value of the works involved. Chinese art supplied welcome novelty value within a Western art world that at the time was heavily leaning towards Conceptual, anti-aesthetic strategies. Xu's work, which mixes attractive traditional aesthetic values and content with an explicitly conceptual strategy, has been welcomed by many art-world professionals, especially curators and critics, who are committed to intellectual approaches to art. But while the conceptual rigour of the work may be interesting as a Chinese 'take' on post-structuralist theory, its deliberate exploitation of archaic Chinese conventions feeds into clichéd notions of the 'exotic' East, thereby ultimately consolidating the Western imperialistic agenda.

Furthermore, the experience of induced illiteracy at the centre of the work is really only an issue for Chinese-language readers, while for the rest of us it is necessary to treat *A Book from the Sky* as a purely hypothetical presence. Its ambiguous meaning is really a lack of sufficient, inherent, cultural value. Xu himself admitted as much when he said, 'customary modes of thought are thrown into confusion, creating obstacles to connections and expression.'[73]

FURTHER VIEWING

Asia Art Center, Taipai
British Museum, London
Freer Gallery of Art and Arthur M.
 Sackler Gallery, Smithsonian
 Institution, Washington DC
Fukuoka Asian Art Museum
Library of Harvard University,
 Cambridge, Massachusetts
Museum Ludwig, Cologne
Museum of Modern Art, New York
Queensland Art Gallery, Brisbane

FURTHER READING

John Cayley, 'Writing (Under-) Sky:
 On Xu Bing's *Tianshu*', in Jerome
 Rothenberg and Steven Clay (eds),
 *A Book of the Book: Some Works
 & Projections about the Book &
 Writing*, Granary Books, 2000

Britta Erickson, *The Art of Xu Bing:
 Words Without Meaning, Meaning
 Without Words*, exh. cat., Arthur
 M. Sackler Gallery, Smithsonian
 Institution, Washington DC, 2001–2
Paul Gladston, *Contemporary Chinese
 Art: A Critical History*, Reaktion
 Books, 2014
Jiang Jiehong (ed.), *Burden or Legacy:
 From the Chinese Cultural
 Revolution to Contemporary Art*,
 Hong Kong University Press, 2007
Jerome Silbergeld and Dora C. Y. Ching
 (eds), *Persistence/Transformation:
 Text as Image in the Art of Xu Bing*,
 Princeton University Press, 2006
Hsingyuan Tsao and Roger T. Ames
 (eds), *Xu Bing and Contemporary
 Chinese Art: Cultural and
 Philosophical Reflections*,
 SUNY Press, 2011

BILL VIOLA

The Messenger, 1996

Video/sound installation
colour video projection on large vertical screen
mounted on wall in darkened space
amplified stereo sound, continuous loop
projected image size 4.3 × 3 m (14 × 10 ft)
room dimensions 6.1 × 7.9 × 9.1 m (20 × 26 × 30 ft)
performer: Chad Walker
Solomon R. Guggenheim Museum, New York

The Messenger is the only work in *Seven Keys* that uses new technology as its medium, the only one that is time based, and the only one that can be seen in more than one place. Bill Viola (b. 1951) effectively transforms cinema into a new, more powerful medium, pushing the possibilities of art into new territory, where it is no longer a case of simply engaging the sense of sight to look at a static object, but also the faculties of hearing and movement.

Viola achieves this through linking the new with the old. He has been called the 'Rembrandt of the video age';[74] the dramatic narratives of Baroque art are given great sensory actuality. Viola represents literally what could once only be implied or imitated using paint.

THE EXPERIENTIAL KEY

We enter a blacked-out room in which a large screen is installed. The video begins with the vague, distorted image of a naked man floating far down in a dark expanse of water, illuminated from the top right by a ray of hazy bluish light. As the film is in slow motion, he rises very gradually towards us. He breaks the surface, with his body bathed in a fiery orange-red light. While he floats there, staring unblinkingly through us, his gasps for breath are accompanied by the deep, echoing, slowed-down sound of his breathing. Then the man submerges again, dwindling slowly in size as he descends into the murky depths. This process is repeated four times in a continuous loop.

Through the filmed imagery, the large scale, the use of sound and the way he controls the video environment, Viola has ensured that *The Messenger* has a direct and visceral impact on us. The effects and the emotions he orchestrates are far beyond the capacity of traditional forms such as painting, and the experience is more akin to theatre or cinema than to the static arts.

Viola wants us to experience his work through our senses. He generates spatio-temporal dislocations that minimize the role of the analytical mind in making sense of what is seen and heard. Because time has been slowed and stretched, Viola encourages us to look at the images in a different way. He creates a liminal space –

a threshold, boundary or limit – that seems to lie somewhere between the inner world of our minds and the outer world of phenomena.

The Messenger emphasizes the mobility of forms, while the slowly shifting patterns raise doubts about precise location and shape. The fleetingly presented or vague image suggests a kind of endless circulation at the heart of perception. The fading patterns are never static, and the visual field generates a pulsing, liquid sense of space. Vibrations replace boundaries, blurring distinctions between inside and outside. Such loss of clear contrast and stable structure challenges focused vision, eroding the tangibility and legibility of the signs through which we make sense of reality.

But Viola also encourages us to think about the fundamental realities of our existence by binding the sensory impact of his work to timeless archetypal images. He makes a link between what we see and the shared symbols accumulated by civilizations over time in order to communicate the experience of primal cycles and dualities linking creation and destruction, immanence and transcendence.

The Messenger evokes the eternal cycle of birth and death. Water is an elemental force, vital to life, and the source from which life itself originally emerged. It is also the environment within which we exist in the womb. More symbolically, water is often associated with spiritual cleansing – for example in Christian baptism. The man rises from the depths having gained knowledge through total immersion or self-annihilation. He communicates, is gone, then returns once again. Viola's use of water is therefore metaphorical. He stages his scenario to suggest the cycle of emergence and return to nothingness, of life as a brief moment of being within the infinite reality of non-being.

THE AESTHETIC KEY

The slow, unfolding action in *The Messenger*, which is so unlike the aesthetics of cinema or television, the pre-eminent time-based media in our era, produces a hypnotic and uncanny effect. Viola uses sophisticated time-based technology to create a conduit of infinite flow. Active seeing is replaced by the more measured and reflective contemplation of gradually and perpetually transforming elements.

The viewer sees the air bubbles catch the light and glow like silver and the man's body shimmer in the liquidity of the water, then glow fiery red – aspects of the action that would be far less apparent in real time. The orchestration of colours also contributes to a strongly aesthetic effect – the blue light contrasts strikingly with the orange-red, both standing out against the void-like darkness of the water.

By evoking the unrepresentable, the visual arts are able to address what lies beyond the surfaces of the material world. Despite the innovative medium, Viola's video can be related to the aesthetics of the sublime (see p. 113). He proposes that, within the existential crisis the sublime experience brings about, there also lies the possibility of inner transformation. Viola takes the limitations of the mind's conceptualizing powers when confronted with the ungraspably complex to new, technologically facilitated, extremes.

THE HISTORICAL KEY

Viola has played an important role in the development of video as a prominent form of contemporary art. Through videotapes, architectural video installations, sound environments, electronic music performances, flat-panel video pieces and works for television broadcast, he has expanded the scope of contemporary art not only in terms of technology and content, but also in relation to historical context. Indeed, in Viola's practice the traditional resources of painting are effectively rehoused within the new technology, with the result that aspects of the traditional medium take on a more directly sensory character and contemporary resonance.

The figure in *The Messenger* is reminiscent of the elongated, luminous figures of the Mannerist painter El Greco, who produced works of unprecedented spiritual intensity by fusing the tradition of icon painting in his native Crete with the innovations of the Renaissance. But while Mannerist and Baroque artists evoked the transcendent spiritual realm through the medium of oil paint, simulating the effects of divine light emanating from above and piercing the darkness, Viola greatly enhances the range of such effects by using digital technology to introduce movement and light. Furthermore, as video is a time-based medium, the process and change that in the static medium

of painting can only be alluded to are now directly reproduced, but through the use of slow motion are rendered other-worldly.

Viola usually installs his works in spaces associated with contemporary art. In this way, they are connected with the history of other works in such contexts. In the case of *The Messenger*, the link to another history – that of religion – was emphasized because the work was commissioned in 1996 to be projected onto the rear doorway of Durham Cathedral in northern England. It was inspired by the numinous atmosphere and sacred function of the largely twelfth-century Norman architecture.

Considered in this context, the religious implications of Viola's work rise to the surface. The water suggests baptism and the man is Christ, an association reinforced by the title. It is relatively rare to encounter contemporary art in a religious setting. *The Messenger* is an example of the new imaging technology making possible the return of time-honoured themes in contemporary form within an institution that largely ceased being an important inspiration for, and patron of, the arts over three hundred years ago. Indeed, Viola has been described as pioneering a new 'visual theology', and as 're-enchanting' modern art.[75]

THE BIOGRAPHICAL KEY

Bill Viola was born in New York City in 1951. During his studies at Syracuse University in the early 1970s, he discovered the new technology of video. After graduating, he travelled widely, meeting his lifelong collaborator and wife, Kira Perov. In early 1980, they lived in Japan for a year and a half and studied Zen Buddhism, which proved an especially important experience. On their return to the United States in 1981, they settled in Long Beach, California.

Viola has recounted how, when he was six years old, he accidentally fell into a lake. As he sank to the depths, he had an epiphany, in which he saw reality as a glorious illuminated flow of energy. He subsequently found confirmation for the universality and potentially revelatory significance of this experience in his readings of the mystical literature from various traditions, in which the physical world is judged to be illusory, and the real is described as a fluid interaction

of everything in continuous process. Viola insists: 'There's more than just the surface of life – the real thing is under the surface.'[76]

Subsequently, Viola came to consider water to be a primary visual metaphor for this deeper reality. Furthermore, he also considered that video itself, as he puts it, is a form of 'electronic water', insofar as it is a technology involving the flow of electrical impulses.[77] He recalls that his first experience of a video screening reminded him of the blue light of the water in the lake into which he fell as a child.

Viola adopted the medium of video at a time when the new imaging technologies, such as film and television, were largely associated with commercial profiteering and mere entertainment. As Viola argued, 'The big responsibility right now is to develop an understanding and awareness of the effects these images have.... The entire society is illiterate, and they are being controlled by the people who can read, that is the controllers of these images, the image-makers.'[78] Despite their use in commercialized exploitation, Viola believes that the photographic media have a special capacity to capture the living essence of people – as he puts it, they can 'hold it well enough that we have some feeling'.[79]

In his work, Viola seeks not only to counter the way mass media trivialize the image, but also, importantly, to attack the limitations of the avant-garde. He emphasizes that, while an artist is professionally connected to a cultural discourse and must seek some kind of accommodation within it, what ultimately compels him or her to make art should be some private and deeply personal spiritual or psychological insight.

Viola might be seen as wresting video technology from the control of the mass media, using it to address what can broadly be termed as the 'sacred'. He uses video as part of a lifelong journey towards self-knowledge; he believes in the mystical insight that this journey will necessitate a process of self-negation, a movement inwards involving self-annihilation and rebirth. Resisting the commercial exploitation of imaging media by many within the artistic avant-garde, Viola considers video to be potentially 'a keeper of the soul'.[80]

Bill Viola, 2001. Photograph by Kira Perov

THE THEORETICAL KEY

Viola's practice is especially informed by Zen, Sufi and Christian mysticism. These traditions share a belief that those who seek the truth must direct their minds away from the outer world and towards an unknown inner world, as the outer world, which is just an illusion or a dream, prevents awakening to the deeper, ultimate reality revealed by the experience of the inner life. The person seeking self-knowledge is on a spiritual journey – an exploration of the limits of this self, a transcending (from the Latin *transcendere*, 'to climb over') that is intended to bring the essence of reality closer. For Viola, it is necessary to question not only the world revealed by the senses but also the reasoning mind. One must forget both oneself and the world to move into intimate alignment with the 'ground of being', the 'primal', the 'One'.

The Messenger is a powerful visual analogy for what is called in Christianity the 'apophatic' process, or *via negativa* (Latin for 'the negative way' or 'by way of denial'). This 'negative theology' teaches that in order to approach God, or the ultimate reality, it is necessary to abandon the material, empirical world, because nothing of material form can offer a likeness of the divine or ultimate reality. As the sixteenth-century Roman Catholic mystic St John of the Cross, an important spiritual thinker for Viola, declared: 'It is evident that faith is a dark night to the soul, and it is thus that it gives light. The more it darkens the soul the more does it enlighten it. It is by darkening that it gives light.'[81]

The Messenger powerfully evokes a sense of connectedness and absence of fixity within the experience of reality. It also reflects Viola's interest in a central Buddhist teaching that the fundamental difference between empirical reality and ultimate reality must be recognized before a true sense of well-being is achieved. Buddhism teaches that attention to ultimate reality reveals that all things arise contingently or conditionally. For, in spite of the empirical world's appearance of solidity, nothing actually has an independent existence of its own, separate from its causes, least of all the self. Things come into being through 'interdependent origination'. Buddhism also teaches that two obstacles prevent the recognition of this interdependence – education and cultural conditioning, and

the innate tendency to rely on our sense perceptions in the pursuit of knowledge.

In secular, psychological terms, the various traditions of spirituality can be understood to seek to externalize the inner-directed dimensions of the mind. The evidece is that when 'deafferentation' (the neural inhibiting of information that allows the brain to experience itself as 'inner-directed', or as mind independent of external input or stimulus) occurs in certain areas of the brain, the mind experiences itself as infinite and as a part of a boundless holistic unity. Research shows that meditation by such practitioners as Buddhist monks brings about significant changes in neural patterns and that entering these regions of the spectrum of consciousness leads to decreased awareness of the boundary between self and others, creating the heightened sensation of belonging to an infinite whole, which, in its turn, brings a profound sense of well-being.

But, as religious teachings and contemporary psychologists point out, exploring the inner-directed aspects of consciousness is often thwarted by deep-seated prejudices underwritten and reinforced by the excessive value placed on technology-dominated reasoning in Western culture. According to the dominant cultural norm in the West, the inner-directed parts of the spectrum of consciousness only lead into subjective obscurity, darkness, confusion, fear, delusion and even madness. Viola's work is an instance of a kind of art that seeks to go against the grain of such cultural assumptions.

THE SCEPTICAL KEY

Viola is one of relatively few contemporary artists to have a large mainstream following, and has generated a quasi-mythical aura around himself. The reasons for his popularity are not hard to find. Viola appropriates the techniques of the Hollywood blockbuster, allowing him to present an easy-to-understand, 'feel-good' vision of universal spirituality that lacks any awkward rootedness in the specifics of time and place, or the complexities of historical teachings. But this assemblage of apparently timeless universality could be said to be powerless in the face of specific real-life situations. In short, Viola draws on world religions to produce what is, arguably, a late

twentieth-century Western – even specifically Californian – world view, which can then be presented as timeless wisdom.

In Viola's own practice, the simplification of belief translates into a simplification of aesthetic means. Furthermore, as video and film are so inextricably tied to a Western technological culture, artists who announce that their work is 'mystical' or addresses the 'sacred', and then use such sophisticated imaging technologies, are liable to be overwhelmed by the hedonistic and commercial logic that defines the society of the spectacle in which we live.

THE MARKET KEY

The Messenger is made in a limited edition of three with one artist's proof. The version in the Albright-Knox Art Gallery, Buffalo, entered the collection soon after it was made, in 1996, courtesy of the Sarah Norton Goodyear Fund. The version in the Solomon R. Guggenheim Museum, New York, was acquired through a gift by the Bohen Foundation in 2000. Viola retains the proof.

Video art is not easy to market. Indeed, one of the original motives for adopting new media during the 1960s and 1970s was to circumvent the commercialization of art. To produce his impressive installations, which are intended for viewing in museums or other public spaces rather than private homes, Viola largely depends on commissions. As a result, his major video installations rarely come on the market. When they do, they sell at high prices: the most expensive video installation in the world, his *Eternal Return* (2000), sold for £377,600 at Phillips de Pury & Company, London, in 2006.

Like other video artists, Viola also creates signed photographic stills, which are sold in a similar way to photographs. The videos themselves sell as limited editions, thereby creating an artificial scarcity, insofar as the bits and bytes of new media art are infinitely, and increasingly, easily reproducible.

FURTHER VIEWING

Castello di Rivoli Museum of
Contemporary Art, Turin
Centraal Museum, Utrecht
Dallas Museum of Art, Texas
Museum of Modern Art, New York
San Francisco Museum of Modern Art
Tate, London

FURTHER READING

Jacquelynn Baas and Mary Jane
Jacob (eds), *Buddha Mind in
Contemporary Art*, University
of California Press, 2004
John G. Hanhardt, *Bill Viola*, ed. Kira
Perov, Thames & Hudson, 2015
Chris Meigh-Andrews, *A History
of Video Art*, Bloomsbury, 2013

Chris Townsend and Cynthia
Freeland, *The Art of Bill Viola*,
Thames & Hudson, 2004
Bill Viola, *Reasons for Knocking at an
Empty House: Writings 1973–1994*,
ed. Robert Violette, MIT Press, 1995
Bill Viola, Stuart Morgan and Felicity
Sparrow, *Bill Viola: The Messenger*,
Chaplaincy to the Arts & Recreation
in North East England, 1996
Bill Viola, *Going Forth by Day*, exh.
cat., Deutsche Guggenheim,
Berlin, 2002
Bill Viola, Peter Sellars, John Walsh
and Hans Belting, *Bill Viola:
The Passions*, exh. cat., J. Paul
Getty Museum, Los Angeles,
in association with the National
Gallery, London, 2003–4

LOUISE BOURGEOIS

Maman, 1999

Cast 2001
Bronze, marble and stainless steel, 895 × 980 × 1160 cm
(29 × 32 × 38 ft)
Guggenheim Bilbao

Louise Bourgeois in an Upper West Side coffee shop, 1992. Photograph by Inge Morath

Although Louise Bourgeois (1911–2010) exhibited from the 1940s onwards, she had to wait until the 1980s before she received major international recognition. She went on to make some of her best work when she was in her eighties and was still making ground-breaking art when she died, aged ninety-eight. Bourgeois's work, which is very eclectic, is concerned with the production of visual symbols that resonate as deep psychological states. Narrative conventions drive her work more than aesthetic considerations. The potent meaning of *Maman* depends on its relationship to psychic life. This gargantuan arachnid is no ordinary spider. Is this spider-mother a protector or a predator – or both?

THE BIOGRAPHICAL KEY

The work of Louise Bourgeois is unashamedly autobiographical, and more evidence of the fact that looking at the details of an artist's life is a primary tool in interpreting his or her work. For Bourgeois, art is a means of acquiring self-knowledge, which, in her eyes, was often, or even mostly, painful, as the human condition is full of dread and anxiety. As she wrote: 'All art comes from terrific failures and terrific needs that we have.'[82] She considered her art making as a 'form of psychoanalysis',[83] a therapeutic exploration, a way to confront her inner demons by tapping into a cultural code that could transform personal trauma into universal meaning.

Born in Paris in 1911 into an affluent family, Bourgeois moved permanently to New York City in 1938 when she married the American art historian Robert Goldwater. She eventually became an American citizen. When Bourgeois was twenty, her mother died. This event so profoundly shook her that, a few days later, she threw herself into a nearby river and had to be rescued by her father. In 1951, the year her father – for whom she evidently harboured very ambivalent feelings – died, Bourgeois began psychoanalysis; she would remain in analysis until the early 1980s.

It was above all the need for nurture and protection, and the fear of abandonment, that fed Bourgeois's preoccupation with the spider. As the title of this particular example suggests, *Maman* is intended to invoke motherhood – *maman* means 'Mummy' in French.

Specifically, Bourgeois is referring to her own mother, for whom she had very deep affection. She describes her as her 'best friend', who was 'deliberate, clever, patient, soothing, reasonable, dainty, subtle, indispensable, neat, and as useful as a spider. She could also defend herself, and me, by refusing to answer "stupid", inquisitive, embarrassing, personal questions.'[84]

Maman therefore celebrates what a mother can provide for a daughter. 'The Spider is an ode to my mother,' Bourgeois explained. 'Like a spider, my mother was a weaver. My family was in the business of tapestry restoration, and my mother was in charge of the workshop. Like spiders, my mother was very clever. Spiders are friendly presences that eat mosquitoes. We know that mosquitoes spread diseases and are therefore unwanted. So, spiders are helpful and protective, just like my mother.'[85]

As Bourgeois also wrote of her mother: 'I shall never tire of representing her. / I want to: eat, sleep, argue, hurt, destroy...'.[86]

THE EXPERIENTIAL KEY

Maman looms precariously over us outside the Guggenheim Bilbao. Its sheer size makes it architectural, with the legs suggesting the Gothic arches of a church. As we stand in the space beneath the eight legs, with the sack of eggs high above us, we are meant – at least according to Bourgeois's explanation – to reflect on the creature's patience and on its nurturing and protective presence.

The slenderness of the legs, holding the immense weight of its tank-like body, imbues the sculpture with a certain delicate fragility and pathos. Perhaps Bourgeois wants to remind us of what it felt like to be a child – when everything seemed huge, sometimes terrifying, and when the massive bulk of our parents offered much-needed, and, if necessary, ruthless protection. Like a creature from a myth or a dream, *Maman* enters our psyche as something fantastic. It is not only unsettling, but also strangely familiar, and in this sense is a classic example of what Freud termed the 'uncanny' (see p. 71). Indeed, much of Bourgeois's work has this weird duality.

Culturally, the spider resonates deep within our imaginations as a creature that is both fascinating and grotesque. The beautiful

web it spins is a device for capturing prey – the spider is an efficient killer. Some are deadly, or, like black widow spiders, sometimes eat their own mate. Spiders regularly feature in nightmares and horror stories. The gigantic size of Bourgeois's spider and the lack of eyes and head also add to its menacing character. These darker implications are certainly present.

THE HISTORICAL KEY

In a career spanning almost seventy years, Bourgeois worked in a wide variety of media, including painting, drawing, printmaking, written text and performance, although she is best known for her sculptures and installations using wood, bronze, latex, marble, fabric and found objects. When she first started exhibiting in the 1940s, her work was indebted to Surrealism, but she went on to be linked with Abstract Expressionism. Later, she took an interest in Post-Minimalism, a style that developed in the 1960s and 1970s and embraced the formal simplicity characteristic of Minimalist art, but rebelled against Minimalism by imbuing work with eccentric forms, unusual combinations of materials, symbolism and overtly personal meaning. But Bourgeois cannot easily be affiliated with any particular movement.

Although the motif of the spider was already present in Bourgeois's drawings from the 1940s, it became increasingly prominent in the 1990s. In 1994, she created her first larger-than-life *Spider* sculpture, which was soon followed by a whole series. The representation of animals to symbolize human attributes is a universal feature of art. A direct link can be made between *Maman* and the oldest examples of human art, such as the Upper Palaeolithic cave paintings in Western Europe, where representations of hybrid figures – part human, part animal – have been found.

A tendency towards anthropomorphism is one of humanity's most characteristic traits. It remains so to this day – it is a stock feature of Walt Disney's animations, for example. But the spider is rarely chosen for this role. Those drawn by the Symbolist artist Odilon Redon, with whose work Bourgeois's have some affinities, are unusual in this sense. But other, more contemporary contexts

also suggest themselves – the controversial technology of robotics and androids, of genetic engineering, or extraterrestrials, such as the terrifying invading machines in H. G. Wells's *War of the Worlds* (1897), and especially, *Alien* (1979), arguably the most famous of all science-fiction horror films.

In retrospect, Bourgeois's work is best seen within the general context of modern art understood as a vehicle for exploring the unconscious, and, in particular, an art of the unconscious as described in Freudian psychoanalysis, which was pioneered by the Surrealists (see Magritte, p. 68; Kahlo, p. 88). In this sense, Bourgeois represents a strand in contemporary art that is essentially a kind of 'late' Surrealism. But, while the Surrealists were most interested in the fantastic and the outrageous that they claimed to discover lurking within the unconscious, Bourgeois's explorations of her own psyche proved to be far more intimate, characterized by vulnerability, anxiety, fear and longing.

Another important context to consider is second-wave feminism. Bourgeois slowly forged a career in a male-dominated sphere, and her success coincides with the emergence of feminism as a powerful cultural force. In her work she dwelled on key themes associated with female experience, such as patriarchal oppression, motherhood and domesticity, while instinctively rebelling against the male-centred values of the art world and the styles it encouraged.

In the 1950s, as she was emerging as an artist, Bourgeois reacted against the especially macho style of the Abstract Expressionists that was in vogue by making modestly scaled and intimate works. In fact, to her mind, the Surrealists were also guilty of perpetuating the patriarchy through making works in which woman features only as an object of male desire. By contrast, what Bourgeois set out to achieve was to make woman the true *subject* of her work, although we should be cautious about labelling her a 'feminist artist'. For, as Bourgeois herself declared, 'There is no feminist aesthetic. Absolutely not! There is psychological content. But it is not because I am a woman that I work the way I do.'[87]

THE AESTHETIC KEY

Maman exists in six more castings. The first was created in 1999 especially for an exhibition at Tate Modern, London. Subsequent castings, including this one in Bilbao, have been made in bronze, a material used by sculptors throughout the ages. Like many bronze sculptures intended for exterior locations, Bourgeois's has a dark-brown patina applied to the surface to protect it from the weather. This may also suggest the secretions on the body of a real spider.

By contrast, the first *Maman* – Tate's – was cast in steel, which is a typically 'contemporary' medium. By opting to cast subsequent versions in bronze, an expensive and complicated medium rarely in use today, Bourgeois signalled that these works were heirs to a long and noble tradition extending from the classical world through the Renaissance to such modern sculptors as Auguste Rodin and Henry Moore, the last major Western artist to work monumentally in bronze before Bourgeois began to use the medium in the 1990s.

THE THEORETICAL KEY

Bourgeois's work is deeply informed not only by her personal experience of undertaking psychoanalysis, but also by the psychoanalytic theory that underpins the therapeutic practice. Perhaps more than that of any other twentieth-century artist her oeuvre offers itself up to interpretation along these lines, and it is possible to read many of her works as almost 'textbook' visualizations of the psychological states and mechanisms of fear, ambivalence, desire, compulsion, depression, guilt, anxiety and aggression as they are understood by Freud and his followers.

In accordance with Freud's theory, Bourgeois assumed that art is a 'symptom'. For Freud, the physical world determines the content of art, rather than the ideal world. The former manifests itself through the psychological dimension, which pits the two fundamental drives against each other – sex and aggression, love and death. The ego, in a perpetual struggle with the id – the desires and fears arising from our animal instincts – seeks through repression and other forms of self-control to conform to the standards of thought and

conduct imposed by the judging super-ego. Within feminist theory, this super-ego is equated with the patriarchal order, which forces women to repress their true nature.

Bourgeois considered that the artistic personality is inevitably traumatized and tormented. Like Kusama (p. 132), she used art as a tool for exorcism, considering that the true artist is fated to endlessly repeat the 'primal scene', as Freud expressed it – the traumas experienced in childhood. Without such therapeutic action, however painful and ultimately futile, an artist would never be able to function within society. As a result, Bourgeois declared, 'Art is a guaranty of sanity.'[88]

THE SCEPTICAL KEY

There is something rather literal about *Maman*. The troubling ambivalence and ambiguity that is central to the art of the unconscious risks being traded in for an easily understandable and decidedly overblown symbolism. Furthermore, by drawing so explicitly on her private traumas, Bourgeois is in danger of having her audience succumb to the tempting idea that art is simply self-expression. Furthermore, her work is articulated and often analysed in the terms of theoretical frameworks such as psychoanalysis that are now considered arcane and overly dogmatic.

THE MARKET KEY

Bourgeois's spiders 'spin' gold. In 2004, the National Gallery of Canada, Ottawa, acquired its own edition of *Maman* for $3.2 million, which amounted to one third of its entire annual budget. Two years later, Bourgeois became the highest-paid living woman artist, after a *Spider* sold for just over $4 million at Christie's, New York. In 2011, Christie's, New York sold another one for $10,722,500, which at the time was the highest price paid for an artwork by any woman artist. But this was surpassed in 2015, when a *Spider* was auctioned by Christie's, New York for an astonishing $28,165,000.

FURTHER VIEWING

Other editions of Maman
(not always on view) :
Crystal Bridges Museum of American
Art, Bentonville, Arkansas
Leeum, Samsung Museum of Art,
Yongsan-gu, Seoul
Mori Art Museum, Tokyo
National Gallery of Canada, Ottawa
Qatar National Convention
Centre, Doha
Tate Modern, London

Easton Foundation, New York
(Bourgeois's former home,
now a foundation dedicated to
archiving her work and research)
Museum of Modern Art, New York
Nasjonalmuseet, Oslo
National Museum of Women in
the Arts, Washington DC
Tate Modern, London

Louise Bourgeois (2008), a film
directed by Camille Guichard
*Louise Bourgeois: The Spider, the Mistress
and the Tangerine* (2008), a film
directed by Marion Cajori
and Amei Wallach

FURTHER READING

Louise Bourgeois, exh. cat.,
Tate Modern, London, 2000
Louise Bourgeois: Maman, exh. cat.,
Wanås Foundation and Atlantis,
Stockholm, 2007
Philip Larratt-Smith and Elisabeth
Bronfen (eds), *Louise Bourgeois:
The Return of the Repressed:
Psychoanalytic Writings*, Violette
Editions, 2012
Frances Morris (ed.), *Louise Bourgeois*,
exh. cat., Tate Modern, London,
2007
Robert Storr, *Intimate Geometries:
The Art and Life of Louise Bourgeois*,
Thames & Hudson, 2016
Deborah Wye and Jerry Gorovoy, *Louise
Bourgeois: An Unfolding Portrait:
Prints, Books, and the Creative
Process*, exh. cat., Museum of
Modern Art, New York, 2017

LEE UFAN

Correspondence, 2001

Oil on canvas, 80 × 100.5 cm (31½ × 39½ in.)
Leeum, Samsung Museum of Art, Seoul

At the time Lee Ufan (b. 1936) was developing his art, East Asia was in the process of becoming both culturally enriched and threatened by contact with the West. Exposure to Western art dramatically transformed how non-Western artists thought about their practice. In Lee's case, the influence was most especially felt in relation to painting styles that emphasized formal values and rejected figurative realism, reducing painting to a core of constituent elements, such as line and colour. Likewise, Western artists had, particularly since the 1940s, been greatly influenced by Eastern styles and ideas. Thus, Lee's work emerges from East–West cultural dialogue and mutually challenging encounters between different traditions, in which artists develop through the continual mixing and blending of styles.

THE BIOGRAPHICAL KEY

Lee Ufan was born in 1936, at a time when his country was a Japanese colony. After Japan's defeat in 1945, the Korean peninsula was arbitrarily divided along the 38th parallel into a Soviet-backed Communist north and a US-backed south. In 1950, when Lee was fourteen years old, North and South Korea descended into a bitter civil war, into which United Nations forces and a newly Communist China were dragged. The Korean War proved to be devastating conflict that ended in stalemate in 1953 with a return, more or less, to the borders of the *status quo ante.*

At the age of twenty, Lee interrupted his studies in Seoul and moved to Japan, graduating in 1961 with a degree in philosophy. By the late 1960s, he was writing about art and playing a leading role in the *Mono-ha* (School of Things) movement, which, through an emphasis on direct encounters with the real world, sought to challenge dominant Western artistic conventions and to forge a specifically East Asian-style modern art.

Lee decided to move to Japan partly because the Republic of Korea was impoverished by recent war, still facing a belligerent Communist North Korea and ruled by a repressive military government. By contrast, Japan – the first East Asian country to embrace Western-style modernization – served as a more secure and open conduit not only for receiving Western culture, but also for realigning a relationship

Lee Ufan in his studio, 1990s. Photograph by Kim Seungsoon

with the West. Lee has gone on to live most of his adult life there, while also often returning to his native South Korea – today a very different place from the one he originally left in 1956.

Lee's dual roles as artist and writer make him an important figure in the development of contemporary art in East Asia. In South Korea, for example, he was instrumental in the mid-1970s in organizing early group exhibitions of Korean artists with whom he shared a number of important stylistic traits and philosophical goals; collectively, they became known as Dansaekhwa (or Tansaekhwa, as it is sometimes written), which means monochrome painting in Korean. Today, Lee is the most famous living Korean artist, although, because he has lived most of his life in Japan, he is also often considered to be a Japanese artist – even by some Koreans.

THE HISTORICAL KEY

Lee makes both paintings and sculptures. For the latter, he uses found materials, juxtaposing the human-made – usually a large steel plate – with the natural – a boulder. His early paintings were records of simple repetitive actions, such as the gesture of running a brush laden with paint across the surface of the canvas in straight lines or in more dynamic freely painted strokes. In the early 1990s, Lee began the ongoing *Correspondence* series, in which one or two or several oversize brushstrokes are added to empty expanses of flat, off-white canvas.

While the painting *Correspondence* has obvious formal similarities with Western abstract art (see Malevich, p. 44; Rothko, p. 110), a reading of Lee's work in terms of influences and appropriations from Western models is based on the false assumption that there is a single master narrative in which the West is the centre and the rest of the world is the periphery. It fails to take into account that modernity impacted on, and unfolded in, Japan, South Korea and China, as in other non-Western countries, according to different time frames, and in response to different imperatives.

Unlike Western paintings, those of East Asia were traditionally painted with the canvas lying on the ground. Often intended to function as scrolls to be rolled and unrolled, they were decorated with

paper or textile mounts, so that the framing edge and the boundary between image space and real space is more permeable than in the Western convention of stretched canvas and wooden frame. While in the West after the Renaissance, the convention was for a painting to imitate a window-like space, in East Asia, until the influence of Western art was felt, a work's surface was considered to be the repository for both image and text. The flat two-dimensionality of the picture plane persisted as part of the representation. Artists deliberately turned unpainted, formless zones of their work into voids to which a viewer was to give equal, or even greater, attention than the forms. In addition, artists emphasized the dynamism of brush and ink on paper or silk, using techniques that aimed for an 'artless art', or a 'technique of no technique', as it was known in Taoism.

THE AESTHETIC KEY

What is most striking about *Correspondence* is the large area of 'untouched' off-white canvas, which constitutes about 80 per cent of the entire surface. Lee seems to consciously emphasize the ground – or in his own terminology, the 'blank' – as much as the figure. He does not let the ground slip into unnoticed and passive insignificance, as is usually the case in Western art. 'Insatiable exploration into the blanks makes me paint,' Lee writes.[89] The 'blank' is far from being just a characterless envelope for the figure – the brushstroke – that Lee lays upon it. 'The blanks are a region repelling such words as "reality" or "ideas",' he explains, 'an ambiguous land inhabited by others which is evoked by the flashes and premonitions of the figures in the picture.'[90]

But while the brushstroke in *Correspondence* may at first look spontaneous, it is in fact the result of considerable premeditation. Lee lies the canvas on the ground – the traditional orientation in East Asian painting – and then uses a piece of paper the size of the intended brushstroke to test positions, before then commencing to paint slowly and decisively with a very large brush loaded with paint. This brushstroke is then tidied up with smaller brushes while the painting is in a vertical position. In this way, Lee incorporates into his practice a more measured and reflective dimension, which serves to counterpoint the natural simplicity of the finished work.

THE EXPERIENTIAL KEY

Do Westerners experience paintings differently from East Asians? Psychological research suggests that, in looking at any scene, Westerners are conditioned to have a distinct bias towards the figure, or towards specific areas of attention, while East Asians are inherently more sensitive to the ground or to the unbroken field. If the ground itself remains an intrinsic part of the whole, then a holistic or global unity is perceived, rather than a segregated field of discrete parts. Such research suggests that East Asians are therefore less likely to experience what psychologists call 'cognitive strain' while trying to scan a total structure, because the action is more habitual. Cultural differences can be tracked through empirical research to the level of deep-seated cognitive processes. What registers for Westerners as inconclusive, uncertain, indeterminate, limitless or cognitively obscure can be appreciated by East Asians as an acceptable state or positive experience.

In this context, *Correspondence* can be considered as an invitation to explore the sensation that the ground – the untouched area – is something worthy of attention. Through emphasizing the empty areas within the composition, Lee creates an intimate link to the emptiness of nature, or the non-human. We sense an ongoing process in which the made and the unmade, the touched and the untouched, the human and the non-human, form and void work in unison to generate an open field of meaning.

This painting is not so much a work to be aesthetically contemplated as a site or place where we can get closer to the indeterminacy without succumbing to it. *Correspondence* is less an object as a way to 'touch infinity'.[91] When we are confronted by it, Lee asks us to question our inclination to see a finite collection of discrete parts that can be divided up and analysed. Instead, we are invited to construe a whole, linking not only the elements within the work itself but also the maker and viewer – producing a unifying space that Lee describes as emptiness.

Lee produces an intermediate space in which we are in dialogue with the work. We are led towards a space that is full of potential, and we become aware of existing in the middle of things – within nature, as Lee would say, or within 'infinity'. Indeed, as Lee writes,

'Human beings have more affinity with infinity than with things identical to themselves.'[92] Everything is open to the invisible flow or breath of life, which is radically impermanent and inherently empty.

THE THEORETICAL KEY

Lee considers that his role as an artist involves contextualizing his practice through written commentaries and analysis. His writings amount to a sustained critique of both Western culture in the light of his own native traditions and his own traditions in the light of Western thought, so as to find not so much a synthesis as a synergy. As a result, Lee explains his practice in ways that often seem difficult to assimilate to familiar Western models. He explores levels of thought and experience that are marginal and unfamiliar in the West.

Lee's work is rooted in traditions from within East Asia, such as Taoism, Confucianism and Buddhism, which he seeks to bring into alignment with aspects of modern Western philosophy, such as phenomenology. Drawing on the writings of Martin Heidegger and Maurice Merleau-Ponty, for example, and combining their perspectives with the Japanese Kyoto School of philosophy that was inspired by Zen Buddhism, Lee has added his voice to the growing critique of human-centred thinking, arguing that the way forward must lie in the rejection of the division that separates the world into subjects and objects. Heidegger and Merleau-Ponty offer a 'phenomenological' understanding of human experience, exploring the fact that seeing is embodied, and addressing the somatic, feeling, emotion, intuition and sensation – that is, the life of the body and of embodied experience, and its relationship to thought.

Drawing on these sources, Lee aims to create an experience that is not just human-centred but also incorporates nature. To this end, he draws on the traditional East Asian belief in the primal energy of *ch'i* (also written as *yi*) that is understood to bring consistency to all of reality through the interaction and intertwining of positive and negative energy, which do not form binary oppositions or dualities but are experienced as complementarity. He sees the human body as offering mediation between the non-material reality of the mind and the physical world.

Lee proposes a relationship between the self and the world that questions Western assumptions, believing that the most important interactions are those made possible by existing in an indeterminate in-between. For example, he writes: 'Rather than my work defining me or the other way round, something different grows in the mutual interaction and response and suddenly comes into existence. This is the context of my work and my position within it. When Lee encounters a canvas with brushes and paint, a work of art comes into existence. Therefore, strictly speaking, it is wrong to say that Lee has painted a canvas with paint and brushes. This would be a Western-European mistranslation.'[93]

Such alternative ways of conceiving the interrelationship between the human and non-human serve to challenge a fundamental assumption within Western thought – that the mind is distinct from, and superior to, the body and the emotions. The Western obsession with reason and clarity, argues Lee, has led to 'brain-centred thinking'. 'In today's industrial urban society, brain-centred thinking is the norm and the body is often ignored,' writes Lee.[94]

THE SCEPTICAL KEY

Despite Lee's claims concerning the importance of the experience of 'encounter' in his work, *Correspondence* can seem to have little intrinsic value in itself. It functions largely as the illustration for an idea. Lee considers it necessary to write about his practice in order to give it meaning. His painting illustrates an idea, rather than the experience emerging from his painting, and while his work trades on the look of spontaneity, it is actually highly premeditated and conceptual.

Just like other non-Western contemporary artists, it seems that Lee cannot but succumb to the dominant ideology of the West. His work functions within an art world that is inherently Western in its values and institutions. As a result, Lee can arguably do little more than provide thought-provoking exoticism. Despite his desire to create an intercultural dialogue, Lee trades on certain culturally entrenched views about East and West. In so far as his art projects the values and prejudices of the imperial – Western – centre on to

the East, and then projects them back again, Lee's work risks being a form of Orientalism – it deals in culturally stereotyped representations that masquerade as immutable essences but actually disguise a prejudice.

While the ease with which Lee produces his sculptures and paintings may seem initially to provide welcome evidence of freedom and lack of prejudice, when his practice is seen in relation to the commercialized art system of the post-industrial world within which it circulates, a work such as *Correspondence* looks little more than a useful strategy of consistency based on repetition.

These suspicions are strengthened by a recent controversy. In 2016, South Korean authorities indicted a number of people for selling forged copies of Lee's paintings. But strangely, and despite the frank admission of the forger, Lee himself claimed that the works were authentic. 'A person's flow and rhythm are like one's fingerprints, which cannot be imitated,' he explained at a press conference, after examining thirteen paintings seized by the National Forensic Service in South Korea and identified as fakes. 'They are undoubtedly mine.'[95]

THE MARKET KEY

When Lee began studying in Japan, the Republic of Korea was an impoverished nation recovering from war. Now it is one of the richest nations on earth. Since the mid-2000s, there has been very great interest shown in Korean Dansaekhwa painting in general and in Lee's work in particular. His global success indicates that non-Western artists now play a significant part in the art world, while also signalling the shifting balance in the relationship between the West and the rest of the world. Today a fluid situation exists, one in which the old hierarchies are challenged, transformed and overthrown.

The record paid at auction for a work by Lee was for *From Point* (1977), which sold at Seoul Auction in 2012 for US$2.2 million.

FURTHER VIEWING

Dia Art Foundation, New York
Korean National Museum of Modern
 and Contemporary Art, Seoul
Lee Ufan Museum, Naoshima
Musée National d'Art Moderne, Centre
 Georges Pompidou, Paris
Space Lee Ufan, Busan Museum of Art

*Touching Infinity: A Conversation with
 Lee Ufan* (2016), a video produced
 for Asia Week New York by the
 Asia Society New York

Joan Kee, *Contemporary Korean Art:
 Tansaekhwa and the Urgency of
 Method*, University of Minnesota
 Press, 2013
Alexandra Munroe (ed.), *Lee Ufan:
 Marking Infinity*, exh. cat., Solomon
 R. Guggenheim Museum, New
 York, 2011
Lee, Ufan, *The Art of Encounter*, trans.
 Stanley N. Anderson, Lisson Gallery,
 London, 2008
Lee, Yongwoo (ed.), *Dansaekhwa*,
 exh. cat., Venice Biennale and
 Kukje Gallery, Seoul, 2015

FURTHER READING

Silke von Berswordt-Wallrabe,
 *Lee Ufan: Encounters with
 the Other*, Steidl, 2008

DORIS SALCEDO

Untitled, 2003

1,550 wooden chairs
Site-specific work, 8th International Istanbul Biennial, 2003

239

Doris Salcedo (b. 1958) considers her practice to be 'a topology of mourning', as she puts it, 'a poetics of mourning', 'a work in mourning' and a 'funeral oration' for the countless victims of political violence.[96] Indeed, for Salcedo, violence has come to define the very ethos of modern society. She can be compared with artists who ask about art's purpose when confronted by the reality of mass and systematic brutality. In this way, Salcedo's work continues the various artistic responses to the question that was posed soon after the Second World War by the German-Jewish philosopher Theodor Adorno. What is permissible in art after Auschwitz?

THE BIOGRAPHICAL KEY

In order to comprehend why Doris Salcedo should be so acutely, indeed, obsessively, aware of violent death, and why she makes it her single theme as an artist, it is essential to know that she is Colombian. She was born, and today works, in Bogotá. She also studied there, before completing an MA at New York University, where she was especially influenced by the work of Joseph Beuys and his concept of social sculpture. In 1985, she returned to Colombia, and has lived there ever since.

Violence has been endemic in Colombian life since the Declaration of Independence in 1810. Hundreds of thousands of civilians have been killed, and millions displaced. In the murderous partisan warfare from 1948 to 1964 known as La Violencia, which Salcedo experienced as a young child, approximately eighty thousand to two hundred thousand Colombians died. Subsequently, in the 1980s and 1990s, while Salcedo completed her studies and began life as a professional artist in Bogotá, more than fifty thousand were killed in the Drug Wars and the guerrilla insurgency. Because of this context, Salcedo is acutely aware of the difference between the powerful and the powerless, and of the pervasiveness of violence in society. Her art is made from the perspective of the victim or the defeated. 'I am a Third World artist,' she declares.[97]

Salcedo is an avowedly political artist. However, her work is very different from the art of those who allow themselves to be co-opted by politics with the intention of settling conflicts, usually through

Doris Salcedo, 2001. Photograph by Rui Gaudencio

producing propaganda of one kind or another. By contrast, Salcedo's art is political in the broadest sense, locating itself *within* conflicts, rather than proposing itself as the solution to them. Salcedo isn't interested in recounting the history of Colombian or any other specific case of violence, nor in narrating a single story – least of all her own. Indeed, as she stresses, 'My work as an artist is not to illustrate these testimonies.'[98] Despite starting with the particular, then, Salcedo avoids specificity. Her interest lies in the *universal* face of violence – the fact that warfare, wherever it occurs, is similar and reduces everyone to victim or perpetrator.

THE HISTORICAL KEY

Images of violence are common in Western art. The Roman Catholic Church authorized countless graphic depictions of the Passion of Christ and the martyrdom of saints, while royalty and the state commissioned many paintings and sculptures commemorating war. Indeed, one of the principal functions of monumental outdoor sculpture was to celebrate military victory and to memorialize heroism in combat.

In modern times, images of real and staged violence have become pervasive because of the mass media. A photograph presents violence in a seemingly objective way that makes a handmade image seem crafted and ornamental, and therefore inherently aestheticizing. At the same time, however, a photograph simply records violence, risking normalizing it.

Artists have to grapple with the challenge of portraying violence while avoiding these pitfalls. Salcedo wants to depict the all-pervasive brutality of today's world in order to bear witness to the fact that 'violence is present in the whole world and in all of us',[99] but she also wants to avoid producing a documentary. She eschews actual image of violence, and rather than depicting violent events, aims to address them in an oblique way that will render the violence more profoundly unsettling.

THE AESTHETIC KEY

Salcedo approaches her tragic subject matter from a perspective that deliberately involves the aesthetic, and her practice involves working with a dedicated team of collaborators in order to produce highly crafted and often complex artefacts. Her concern for the aesthetic is of paramount importance to the impact of her work. It is evident in the level of abstraction she applies, in her close attention to formal criteria such as texture, surface detail, compositional structure and variations in scale, as well as in the time and energy committed to ephemeral works like *Untitled*.

Salcedo describes how the idea for *Untitled* came to her when she was struck by the number of empty lots between buildings in a particular neighbourhood of Istanbul (where she had been invited to participate in a biennial). She learned that they resulted from the forced expulsion of the inhabitants for reasons of ethnic and religious intolerance.

She describes *Untitled* as 'a topography of war inscribed in the midst of everyday life'.[100] The term 'topography' refers to a description or representation of the features of an area, while 'everyday life' is signalled by the location itself and the use of the domestic chair. The private and the political collide, producing a sense of disorientation.

The tightly chaotic stacking of over 1,550 wooden chairs evokes the aftermath of a violent assault, while the chairs' organization in line with the adjacent building facades suggests the attempt to ignore the upheaval and brutality involved. This seems almost to neutralize the devastation wrought by the violence, and alludes to the mechanisms put in place to ensure collective forgetting.

But through the methodical stacking of banal pieces of domestic furniture Salcedo also suggests the poignant absence of the persecuted former inhabitants. As Salcedo puts it, *Untitled* is 'an intense, compulsive piece obsessively inscribed into an opening, a sealed, circumscribed, and airless image'.[101]

The aesthetic dimension provides the important distance from which it is then possible to confront the unspeakable. Through various formal strategies that serve to signal an 'absent' presence, Salcedo casts the shadow of violence upon her objects, rather than the image of violence itself. Emphasis on materiality is crucial, because it is

through the physical object, rather than through an image, idea, concept or narrative, that Salcedo's work succeeds in expressing its uncomfortable proximity to violence. She adopts strategies of indirection and obliqueness, working with traces – with what is barely visible or thinkable and is never quite a representation. Attending to the aesthetic allows her to make work that is 'a passage from suffering to signifying loss', as she puts it.[102]

THE EXPERIENTIAL KEY

In viewing *Untitled*, we draw closer to the victim of violence through silent contemplation. Memory, which exists primarily in time, is given concrete or spatial form and rendered disturbingly prosaic and visceral. We feel that the ordinariness of the humble chair recedes, while everyday life becomes imbued with dread. Salcedo exploits anthropomorphism – the way we can imagine phenomena as potentially human through projecting emotions on to them. A chair signals the absence of a person, and therefore also, potentially, death, which is not so much evoked as signalled by emptiness. The disorderly accumulation of seemingly countless chairs makes us aware of the innumerable people who have been violently displaced, not only in Istanbul, but also everywhere in the world where violence occurs.

Untitled is about making us more aware of what cannot be touched within the touchable, about appearing and disappearing, the never fully graspable, the dislocated in time. It explores the borderline where 'things are formless or monstrous', as Salcedo says.[103] We confront what is absent, or in the process of vanishing, 'the vacuum generated by forgetfulness'.[104] We are thereby brought closer to basic existential reality, revealed by the proximity Salcedo forces upon us to the aura of violence – evoked, suggested or connoted, rather than directly depicted.

Untitled is such an arresting visual metaphor that, even when encountered as a photograph, it remains disturbing. The meaning and emotional impact of the original installation survive the reduced circumstances. Indeed, the knowledge that the original work no longer exists can add further pathos to the struggle with forgetting that Salcedo declares is central to her work. *Untitled*'s ephemeral

status is analogous to the anonymous victims of the violence she addresses, who are saved from total oblivion through taking on first the form of an installation and then an afterlife as a photograph.

THE THEORETICAL KEY

A highly theoretical artist, Salcedo both enlivens and deepens her lectures and interviews with quotations from poets and key contemporary philosophers. In particular, her work is informed by writers who explore absence, silence, emptiness, nothingness and death. The ethical relationship towards the 'other' as victim lies at the heart of Salcedo's practice. She says: 'Art sustains the possibility of an encounter between people who come from quite distinct realities.'[105]

Salcedo struggles with the awareness that she encourages an 'aesthetics' of violence. She cites the French philosopher Jean-Luc Nancy, who writes that violence always makes an image of itself and that the violent person is compelled to *see* the mark they make upon their victim. In this sense, 'violence imprints its image by force', as Nancy writes.[106] To counter this, Salcedo argues that the relation must remain immanent within the image rather than actual.

Salcedo also refers to the writings of another French philosopher, Emmanuel Levinas, who drew attention to the origins of violence, hatred and murder in an individual's striving to grasp hold, control and annihilate the unknown other. To counter the pervasiveness of antagonism towards the 'other', argued Levinas, it is necessary to take responsibility for others through accepting their absolute 'alterity', their true otherness. An ethical position begins when the appearance of the vulnerable 'face' of another person is not treated as a threat. As Salcedo says: 'The philosopher Emmanuel Levinas has helped us to understand that the other precedes me and claims my presence before I exist. In that sense, there is a delay that can never be made up. My presence does not respond to the extreme urgency of its assignment. It only accuses me of having been late.'[107]

But perhaps it is the philosophy of Martin Heidegger – a primary influence on both Nancy and Levinas – who sheds most light on Salcedo's work. Heidegger distinguishes between fear, which is always *of* something, and *angst* – dread or a feeling of deep anxiety

– which is without specific focus, and is not caused by anything in particular. Instead, angst is the inevitable human response to the overwhelming experience of just being alive. Heidegger describes the experience of angst as feeling as though the world is 'drawing' or 'slipping' away, as it turns into something remote and strange. As one encounters primal 'nothingness', one is dislodged from the familiar world; things in everyday life turn into alien and uncanny objects. In this sense, Salcedo's act of 'mourning' can be considered to arise from accounts of the specifics of violent acts but to resonate universally, because it is a lament for the human condition as a whole. Through her art, Salcedo transforms particular moments of fear into the shared experience of existential anxiety.

THE MARKET KEY

It is an indication of the close network of the global art market, and of the recent reduction in violence in Colombia, thanks to peace negotiations between the military and rebel groups, that Salcedo can live and work in Bogotá while also pursuing a successful, high-profile, international career. The contemporary art world counteracts the homogeneity imposed on life by the globalization of capitalist markets by seeking out little-known communities to inject revitalizing doses of novelty and controversy. Although it is on a smaller scale, interest in Colombia as an untapped region for art production and business speculation means that the South American nation is following what is now a familiar trajectory, one already been taken by countries like China, India and Brazil.

Salcedo is a key figure within burgeoning cultural and economic activity in Colombia. However, because she works frequently on time-consuming and large-scale projects and produces few works, she has avoided being transformed into a marketable asset, and her status is not yet fully reflected in secondary market prices. But even ephemeral installations can take on saleable form, and Salcedo has produced a series of limited-edition prints on paper based on the original Istanbul project that are available through the commercial galleries representing her and also at auction.

THE SCEPTICAL KEY

There is a radical disjunction between the form of Salcedo's *Untitled* and its ostensible subject. Salcedo is acutely aware that, through its status as 'art', her work functions within the established play of images and signs that comprise the social world. Contemporary culture is characterized by an unprecedented level of generalized aestheticization in which all forms – including areas of experience once considered non- or anti-cultural, such as violence and brutality – have become part of the general spectacle. The sophisticated aesthetic values of Salcedo's practice, which she claims are intended to distance her work from the brutal aggression she addresses – thereby making possible an arena of contemplative silence, poignancy and intimacy – fatally undercut the impact of the content itself. In this way, it is impossible for the viewer to be transformed into a 'politicized' participant.

Because of her reluctance to give direct expression to violence, the tragic events that motivate Salcedo's installations, and that she invokes through her verbalized intentions, rarely manifest themselves visually. She opts for what can seem like aestheticized obscurity and abstraction, and risks severing any viable, communicable link with the avowedly political subject matter. Her references to the witnesses to violence therefore provide only discursive supplements that validate her work on a purely conceptual level and fail to appear within an encounter with the work itself.

Furthermore, Salcedo's attempt to use art to challenge violence is more or less doomed, because the social milieu and institutional framework within which the vast majority of her works are encountered and interpreted is inherently quarantined from the turbulent world she claims to evoke. It is adept at absorbing and neutralizing anything that threatens to breach its essential custodial role.

Despite Salcedo's claim that the material presence of her work, existing in time and space, is central to its impact, *Untitled* suggests that it can be readily assimilated back into the 'society of the spectacle',[108] where it becomes little more than a striking image and angst-ridden memento. Unless one was in Istanbul in 2003 at the time of the biennial, the only way to encounter *Untitled* is either through a photograph like this, or through hearsay. Indeed, along

with Duchamp's *Fountain* (p.57), Salcedo's *Untitled* is the only work in *Seven Keys* that does not now exist in its original form. But in the meantime, images of *Untitled*, promiscuously disseminated across diverse platforms, have been absorbed into the mass media.

Salcedo risks offering neither consolation nor the opportunity to assume the position of the victim. She has been described as 'our civilization's official mourner'.[109] Although her work clearly draws on the tragedy of her native Colombia and her deep empathy for the oppressed, she can arguably be said to resemble one of those curious individuals who frequents the funerals of strangers.

FURTHER VIEWING

Museum of Latin American Art, Long Beach, California
Museum of Modern Art, New York
San Francisco Museum of Art

'Doris Salcedo's Public Works', a recorded lecture given by Salcedo at the Museum of Contemporary Art Chicago, 2015, available at https://www.youtube.com/watch?v=xdt2vZ9YpwE

FURTHER READING

Mieke Bal, *Of What One Cannot Speak: Doris Salcedo's Political Art*, University of Chicago Press, 2010
Dan Cameron, *Doris Salcedo*, exh. cat., New Museum of Contemporary Art, New York, 1998
Nancy Princenthal, *Doris Salcedo*, Phaidon, 2000
Julie Rodrigues Widholm and Madeleine Grynsztejn (eds), *Doris Salcedo*, exh. cat., Museum of Contemporary Art Chicago, 2015

NOTES

**HENRI MATISSE,
THE RED STUDIO**
1 'The Path of Colour' (1947),
 in Jack D. Flam
 (ed.), *Matisse on Art,*
 E. P. Dutton, 1978, p. 116.
2 Jack D. Flam (ed.), *Matisse
 on Art,* E. P. Dutton,
 1978, p. 36.
3 Ibid. p. 41.

**PABLO PICASSO, *BOTTLE
OF VIEUX MARC, GLASS,
GUITAR AND NEWSPAPER***
4 Quoted in *Saturday
 Review,* 28 May 1966.

**KAZIMIR MALEVICH,
BLACK SQUARE**
5 Quoted in Britta Tanja
 Dümpelman, 'The World of
 Objectlessness: A Snapshot
 of an Artistic Universe',
 in *Kazimir Malevich: The
 World as Objectlessness*
 (originally published 1927),
 Kunstmuseum Basel/
 Hatje Cantz, 2014, p. 27.
6 Kazimir Malevich, 'The
 World as Objectlessness'
 (1927), quoted in Britta
 Tanja Dümpelman (ed.),
 *Kazimir Malevich: The
 World as Objectlessness,*
 Kunstmuseum Basel/
 Hatje Cantz, 2014, p. 191.
7 Quoted in Roger Lipsey,
 *The Spiritual in Twentieth-
 Century Art,* Dover
 Publications Inc.,
 2004, p. 131.

**MARCEL DUCHAMP,
FOUNTAIN**
8 Robert Hughes,
 *The Shock of the New: Art
 and the Century of Change,*
 Thames & Hudson, 1990.

**RENÉ MAGRITTE,
THE EMPTY MASK**
9 Quoted in Simon Morley,
 *Writing on the Wall: Word
 and Image in Modern Art,*
 Thames & Hudson, 2003,
 p. 88.
10 Odilon Redon, 'Suggestive
 Art' (1909), reprinted in
 Herschel B. Chipp, *Theories

 of Modern Art: A Source
 Book by Artists and Critics,*
 University of Chicago
 Press, 1968, p. 117.
11 Michel Foucault, *This Is Not
 a Pipe,* trans. and ed. James
 Harkness, University of
 California Press, 1982.
12 René Magritte, Anne
 Umland, Stephanie
 D'Alessandro, *Magritte:
 The Mystery of the
 Ordinary, 1926–1938,* exh.
 cat., Museum of Modern
 Art, New York, Menil
 Collection, Houston, and
 Art Institute of Chicago,
 2013–14.

**EDWARD HOPPER,
NEW YORK MOVIE**
13 *Quoted in* Gail Levin,
 *Edward Hopper: An
 Intimate Biography,* Rizzoli,
 2007, p. 349.
14 *Quoted in* Gerry Souter,
 *Edward Hopper: Light and
 Dark,* Parkstone Press
 International, 2012, p. 179.

**FRIDA KAHLO, *SELF-
PORTRAIT WITH
CROPPED HAIR***
15 Adrian Searle in *The
 Guardian,* https://
 www.theguardian.com/
 culture/2005/jun/07/1
 (visited 1 April 2018).
16 Quoted in Hayden Herrera,
 *Frida: A Biography of Frida
 Kahlo,* Harper & Row, 1983,
 p. 107.
17 Quoted in 'Frida Kahlo, *Self
 Portrait with Cropped Hair',*
 MoMA Highlights, Museum
 of Modern Art, 2004, p. 181.
18 André Breton, 'Frida
 Kahlo de Rivera', quoted
 in Christina Burrus,
 *Frida Kahlo: 'I Paint
 My Reality',* Thames
 & Hudson, 2008, p. 66.
19 Christina Burrus, *Frida
 Kahlo: 'I Paint My Reality',*
 Thames & Hudson, 2008.
20 Museum of Modern
 Art, *MoMA Highlights,*
 Museum of Modern Art,

 New York, revised 2004,
 originally published 1999,
 p. 181. Available online at:
 https://www.moma.org/
 collection/works/78333
 (visited 20 April 2018)

FRANCIS BACON, *HEAD VI*
21 *George Steiner: A Reader,*
 Penguin Books, 1984, p. 11.
22 Daniel Farson, *The Gilded
 Gutter Life of Francis Bacon:
 The Authorized Biography,*
 Vintage Books, 1994.
23 Quoted in John Gruen,
 *The Artist Observed:
 28 Interviews with
 Contemporary Artists,* 1991,
 A Cappella Books, p. 3.
24 Ibid. p. 5.
25 David Sylvester,
 *The Brutality of Fact:
 Interviews with Francis
 Bacon,* Thames & Hudson,
 1987, p. 16.
26 Ibid., p. 12.
27 Ibid., p. 56.
28 Ibid., p. 59.
29 Ibid., p. 50.
30 Ibid., pp. 22–23.
31 Ibid., p. 174.
32 Gilles Deleuze, *Francis
 Bacon: The Logic of
 Sensation,* Continuum,
 2003, p. xiv.
33 David Sylvester, *The
 Brutality of Fact: Interviews
 with Francis Bacon,* Thames
 & Hudson, 1987, p. 48.
34 Ibid., p. 28.
35 Jean-Paul Sartre, *Huit Clos
 (No Exit),* 1944, in Jean
 Paul Sartre, *No Exit and
 Three Other Plays,* Vintage
 International, 1976, p. 45.
36 Albert Camus, 'An Absurd
 Reasoning' (1942), in *An
 Existentialist Reader: An
 Anthology of Key Texts,*
 ed. Paul S. MacDonald,
 Routledge, 2001, p. 157.
37 Albert Camus, *L'Etranger
 (The Outsider),* 1942, trans.
 Stuart Gilbert, Penguin
 Books, 1972, p. 120.
38 Samuel Beckett, *The
 Unnamable,* Faber & Faber,
 1953, p. 134.

MARK ROTHKO,
BLACK ON MAROON
39 Robert Rosenblum, *Modern Painting and the Northern Romantic Tradition: Friedrich to Rothko*, Icon, 1977.
40 'Personal Statement' (1945) in Miguel López-Remiro (ed.), *Mark Rothko: Writings on Art*, Yale University Press, 2006, p. 45.
41 Friedrich Nietzsche, *The Will to Power* (c. 1887), trans. Walter Kaufmann and R. J. Hollingdale, Vintage Books, 1968, p. 9.
42 Sigmund Freud, *Civilization and Its Discontents* (1930), in Peter Gay (ed.), *The Freud Reader*, W. W. Norton, 1995, p. 725.
43 Rothko in an interview in 1970, quoted in *Mark Rothko. The Seagram Mural Project*, exh. cat., Tate Liverpool, 1988–89, p. 10.
44 Ibid.

ANDY WARHOL,
BIG ELECTRIC CHAIR
45 Quoted in Hal Foster, 'Death in America', in Annette Michelson (ed.), *Andy Warhol*, MIT Press, 2001, p. 72.

YAYOI KUSAMA, INFINITY MIRROR ROOM – PHALLI'S FIELD
46 Quoted in Jo Applin, *Infinity Mirror Room – Phalli's Field*, Afterall Books, 2012, p. 1.
47 Ibid., p. 77.
48 Interview with Midori Matsui in *Index Magazine*, 1998, http://www.indexmagazine.com/interviews/yayoi_kusama.shtml (visited 25 March 2018)
49 Quoted in Alexandra Monroe, 'Obsession, Fantasy and Outrage: The Art of Yayoi Kusama' in Bhupendra Karia (ed.), *Yayoi Kusama: A Retrospective*, exh. cat., Center for International Contemporary Arts, New York, 1989. Available online at: http://www.alexandramunroe.com/obsession-fantasy-and-outrage-the-art-of-yayoi-kusama/ (visited 25 March 2018)

JOSEPH BEUYS, THE PACK
50 Quoted in Caroline Tisdall, *Joseph Beuys*, exh. cat., Solomon R. Guggenheim Museum, New York, 1979–80, p. 190.
51 Ibid., p. 190.
52 C. G. Jung, 'After the Catastrophe' (1945), in *Essays on Contemporary Events, 1936–1946*, Routledge, 2002, p. 62.

ROBERT SMITHSON,
SPIRAL JETTY
53 Robert Smithson, 'The Spiral Jetty' (1970), republished in Jack Flam (ed.), *Robert Smithson: Collected Writings*, University of California Press, 1996, p. 146.
54 Ibid., p. 165.
55 Ibid., p. 145.
56 Ibid., p. 343.
57 Ibid., p. 10.
58 Ibid., p. 42.

ANSELM KIEFER, OSIRIS AND ISIS
59 Quoted in Daniel A. Siedell, 'Where Do You Stand? Anselm Kiefer's Visual and Verbal Artifacts', *Image Journal*, issue 77, https://imagejournal.org/article/where-do-you-stand/ (visited 19 April 2018).
60 Mircea Eliade, *The Sacred and the Profane: The Nature of Religion*, trans. Willard R. Trask, Harcourt, Inc., 1987, p. 12.

BARBARA KRUGER, UNTITLED (I SHOP THEREFORE I AM)
61 Michel Foucault, *Discipline and Punish: The Birth of the Prison*, Penguin, 1991
62 Craig Owens, 'The Allegorical Impulse: Toward a Theory of Postmodernism', in *Beyond Recognition: Representation, Power, and Culture*, University of California Press, 1992, p. 54

63 Barbara Kruger interviewed by Christopher Bolen, *Interview Magazine*, 13 February 2013, https://www.interviewmagazine.com/art/barbara-kruger (visited 25 March 2018)
64 'Playing with Conditionals', an interview with Barbara Kruger by David Stromberg, *The Jerusalem Report*, 4 February 2016, p. 40
65 Barbara Kruger interviewed by Richard Prince, *Bomb Magazine*, 11 September 2009, http://magazine.art21.org/2009/09/11/barbara-kruger-interviewed-by-richard-prince/ (visited 25 March 2018)
66 Barbara Kruger interviewed by Christopher Bolen, *Interview Magazine*, 13 February 2013, https://www.interviewmagazine.com/art/barbara-kruger (visited 25 March 2018)

XU BING, A BOOK FROM THE SKY
67 Quoted in Britta Erickson, *The Art of Xu Bing: Words Without Meaning, Meaning Without Words*, exh. cat., Arthur M. Sackler Gallery, Smithsonian Institution, Washington DC, 2001–2, p. 33.
68 See https://chinese.yabla.com/chinese-english-pinyin-dictionary.php?define=%E5%A4%A9%E4%B9%A6 (visited 19 April 2018).
69 Hsingyuan Tsao and Roger T. Ames (eds), *Xu Bing and Contemporary Chinese Art: Cultural and Philosophical Reflections,* SUNY Press, 2011, p. xv.
70 Xu Bing, 'The Living Word' (2011), trans. Ann L. Huss, n.p., http://lib.hku.hk/friends/reading_club/livingword.pdf (visited 19 April 2018).
71 Xu Bing, 'The Living Word' (2011), trans. Ann L. Huss, n.p., http://lib.hku.hk/friends/reading_club/livingword.pdf (visited 19 April 2018).

72 Lao Tzu, *Tao Te Ching*, http://www.taoism.net/ttc/chapters/chap01.htm (visited 19 April 2018).

73 Xu Bing, 'The Living Word' (2011), trans. Ann L. Huss, n.p., http://lib.hku.hk/friends/reading_club/livingword.pdf (visited 19 April 2018).

BILL VIOLA, *STILL FROM THE MESSENGER*

74 Laura Cumming, *The Guardian*, 6 May 2001. Available online at: https://www.theguardian.com/education/2001/may/06/arts.highereducation (visited 19 April 2018).

75 See, for example, Ronald R. Bernier, *The Unspeakable Art of Bill Viola: A Visual Theology*, Pickwick Publications, 2014, Introduction.

76 *Bill Viola Interview: Cameras are Soul Keepers*, Louisiana Channel, http://channel.louisiana.dk/video/bill-viola-cameras-are-keepers-souls (visited 19 April 2018).

77 Ibid.

78 Quoted in Ronald R. Bernier, *The Unspeakable Art of Bill Viola: A Visual Theology*, Pickwick Publications, 2014, p. 8.

79 *Bill Viola Interview: Cameras are Soul Keepers*, Louisiana Channel, http://channel.louisiana.dk/video/bill-viola-cameras-are-keepers-souls (visited 19 April 2018).

80 Ibid.

81 St John of the Cross, *Ascent of Mount Carmel*, trans. David Lewis, Cosimo Classics, 2007, p. 69.

LOUISE BOURGEOIS, *MAMAN*

82 'Statements from an Interview with Donald Kuspit (extract) 1988', in Robert Storr et al., *Louise Bourgeois*, Phaidon Books, 2003, p. 125.

83 Quoted in Christopher Turner, 'Analysing Louise Bourgeois; Art, Therapy and Freud', *The Guardian*, 6 April 2012. Available online at: https://www.theguardian.com/artanddesign/2012/apr/06/louise-bourgeois-freud (visited 19 April 2018).

84 Quoted in Elizabeth Manchester, 'Louise Bourgeois, *Maman*, 1999', December 2009, Tate website, http://www.tate.org.uk/art/artworks/bourgeois-maman-t12625 (visited 19 April 2018).

85 Quoted in Kirstie Beaven, 'Work of the Week: Louise Bourgeois' *Maman*', 2 June 2010, Tate website, http://www.tate.org.uk/context-comment/blogs/work-week-louise-bourgeois-maman (visited 19 April 2018).

86 Excerpt from Louise Bourgeois, *Ode à Ma Mère*, Éditions du Solstice, 1995, quoted in 'Louise Bourgeois, *Ode à Ma Mère*, 1995', Museum of Modern Art, New York, website, https://www.moma.org/collection/works/10997 (visited 19 April 2018).

87 'Statements from Conversations with Robert Storr (extracts) 1980s–90s', in Robert Storr et al., *Louise Bourgeois*, Phaidon Books, 2003, p. 142.

88 The work, dating from 2000, is in the collection of the Museum of Modern Art, New York. See: https://www.moma.org/collection/works/139281 (visited 19 April 2018).

LEE UFAN, *CORRESPONDENCE*

89 Jean Fisher (ed.), *Selected Writings by Lee Ufan, 1970–96*, Lisson Gallery, London, 1996, p. 51.

90 Ibid., p. 51.

91 The title of Lee Ufan's retrospective exhibition at the Solomon R. Guggenheim Museum, New York, in 2011.

92 Lee Ufan, *The Art of Encounter*, trans. Stanley N. Anderson, Lisson Gallery, London, 2008, p. 179.

93 Jean Fisher (ed.), *Selected Writings by Lee Ufan, 1970–96*, Lisson Gallery, London, 1996, p. 120.

94 Lee Ufan, *The Art of Encounter*, trans. Stanley N. Anderson, Lisson Gallery, London, 2008, p. 20.

95 'Artist Lee U-fan's Forgery Scandal Continues', *Korea Herald*, 16 November 2016 http://www.koreaherald.com/view.php?ud=20161116000655&mod=skb (visited 19 April 2018).

DORIS SALCEDO, *UNTITLED*

96 'Doris Salcedo's Public Works', a recorded lecture given by Salcedo at the Museum of Contemporary Art Chicago, 2015, https://www.youtube.com/watch?v=xdt2vZ9YpwE (visited 19 April 2018).

97 Ibid.

98 Doris Salcedo and Charles Merewether, Interview (1998). Reprinted in Simon Morley (ed.), *The Sublime: Documents in Contemporary Art*, Whitechapel Art Gallery/MIT Press, 2010, p. 191.

99 Ibid., p. 192.

100 'Doris Salcedo's Public Works', a recorded lecture given by Salcedo at the Museum of Contemporary Art Chicago, 2015, https://www.youtube.com/watch?v=xdt2vZ9YpwE (visited 19 April 2018).

101 Ibid.

102 Ibid.

103 Ibid.

104 Ibid.

105 Doris Salcedo and Charles Merewether, Interview (1998). Reprinted in Simon Morley (ed.), *The Sublime: Documents in Contemporary Art*, Whitechapel Art Gallery/MIT Press, 2010, p. 189.

106 'Doris Salcedo's Public Works', a recorded lecture given by Salcedo at the Museum of Contemporary

Art Chicago, 2015, https://
www.youtube.com/
watch?v=xdt2vZ9YpwE
(visited 19 April 2018).
107 Doris Salcedo and Charles
Merewether, Interview
(1998). Reprinted in Simon
Morley (ed.), *The Sublime:
Documents in Contemporary*

Art, Whitechapel Art
Gallery/MIT Press, 2010,
p. 189.
108 The name of an important
book by the French
Situationist Guy Debord,
originally published in 1967.
109 Jason Farago, 'Doris
Salcedo Review –

an Artist in Mourning
for the Disappeared', *The
Guardian*, 10 July 2015.
Available online at: https://
www.theguardian.com/
artanddesign/2015/jul/10/
doris-salcedo-review-
artist-in-mourning
(visited 19 April 2018).

PICTURE CREDITS

21 Photo 2019 The Museum of
Modern Art, New York/Scala,
Florence. © Succession H.
Matisse/DACS 2019
29 Photo 2019 The Pierre Matisse
Gallery Archives, The Morgan
Library & Museum/Art
Resource, NY/Scala, Florence.
© Succession H. Matisse/DACS
2019
33 Tate, London. © Succession
Picasso/DACS, London 2019
34 Photo Private Collection/
Archives Charmet/Bridgeman
Images
45 State Tretyakov Gallery,
Moscow
51 Photo Private Collection/
Bridgeman Images
57 Philadelphia Museum of Art. ©
Association Marcel Duchamp/
ADAGP, Paris and DACS,
London 2019
61 Yale University Art Gallery,
New Haven, CT. © Man Ray
Trust/ADAGP, Paris and DACS,
London 2019
69 Kunstsammlung Nordrhein-
Westfalen, Düsseldorf. ©
ADAGP, Paris and DACS,
London 2019
73 Photo 2019 ADAGP Images,
Paris/SCALA, Florence
79 Photo 2019 The Museum of
Modern Art, New York/Scala,
Florence
84 Photo Bettmann/Getty Images
89 Photo 2019 The Museum of
Modern Art, New York/Scala,
Florence. © Banco de México
Diego Rivera Frida Kahlo
Museums Trust, Mexico,
D.F./DACS 2019
93 Photo Bettmann/Getty Images

99 Photo Prudence Cuming
Associates Ltd. © The Estate
of Francis Bacon. All rights
reserved, DACS/Artimage 2019
102 Photo Paul Popper/
Popperfoto/Getty Images
111 Tate, London. © 1998 Kate
Rothko Prizel & Christopher
Rothko ARS, NY and DACS,
London
117 Photo 2019 Albright Knox
Art Gallery/Art Resource,
NY/Scala, Florence. Photo
Rudy Burckhardt © ARS, NY
and DACS, London 2019. ©
1998 Kate Rothko Prizel &
Christopher Rothko ARS, NY
and DACS, London
121 Centre Pompidou, Paris.
© 2019 The Andy Warhol
Foundation for the Visual
Arts, Inc./Licensed by DACS,
London
123 © Eve Arnold/Magnum Photos
133 Museum Boijmans Van
Beuningen, Rotterdam.
Purchase with support of
Stichting Fonds Willem van
Rede, Mondriaan Fonds en
BankGiro Loterij. © Yayoi
Kusama
136 © Yayoi Kusama
145 Museumslandschaft Hessen
Kassel. Photo 2019 Scala,
Florence/bpk, Bildagentur für
Kunst, Kultur und Geschichte,
Berlin. © DACS 2019
148 Photo Alfred Eisenstaedt/The
LIFE Picture Collection/Getty
Images
157 Dia Art Foundation, New York.
Photo George Steinmetz/
Corbis Documentary/Getty
Images. © Holt-Smithson

Foundation/VAGA at ARS,
NY and DACS, London
165 Photo Jack Robinson/Hulton
Archive/Getty Images
169 San Francisco Museum
of Modern Art, Purchase
through a gift of Jean Stein
by exchange, the Mrs Paul L.
Wattis Fund, and the Doris
and Donald Fisher Fund. Photo
Ben Blackwell/San Francisco
Museum of Modern Art.
Courtesy of White Cube
© Anselm Kiefer
171 Photo Kelm/ullstein bild/
Getty Images
181 Modern Art Museum of Fort
Worth, Texas. Courtesy Mary
Boone Gallery, New York ©
Barbara Kruger
193 Photo Hong Kong Museum
of Art
197 Photo Michael L. Abramson/
Getty Images
205 Solomon R. Guggenheim
Museum, New York. Photo Kira
Perov. Courtesy of Bill Viola
Studio
211 Courtesy of Bill Viola Studio
217 Photo o2 Photography/Alamy
Stock Photo. © The Easton
Foundation/VAGA at ARS, NY
and DACS, London
218 © Inge Morath/Magnum
Photos
227 Photo Leeum, Samsung
Museum of Art, Seoul. ©
ADAGP, Paris and DACS,
London 2019
239 Photo Sergio Clavijo. Courtesy
of Alexander and Bonin, New
Yotk
241 Courtesy of Alexander
and Bonin, New York

INDEX

Numbers in *italics* refer to
 illustrations

abstract art 80, 83, 87, 112,140,
 183
Abstract Expressionism 112,
 125, 127, 161, 221, 222
abstract sublime 113
Adorno, Theodor 240
advertising 188, 189, 190
Age of Anxiety 101
Albright-Knox Art Gallery,
 Buffalo 214
alchemy 176
Alien 222
Andy Warhol Authentication
 Board 129
angst 245–6
aniconism 116
anima and *animus* 96
anomie 83–5
anthropology 176
anthropomorphism 221, 244
anthroposophy 151–2
archetypes 176
Arensberg, Walter C. 65
Armory Show (International
 Exhibition of Modern Art),
 New York 30, 41
Art Institute of Chicago 30
Arts Council of Great Britain 108
Auschwitz-Birkenau 101, 240
axis mundi 176–7
Aztecs 91, 93

Bacon, Francis *102*, 127
 Head VI 98–109
 Popes series 100, 108
 Study from Innocent X 108
 *Three Studies of Lucian
 Freud* 108
Barcelona 35
Baroque art 206, 208
Baselitz, Georg 172
Battleship Potemkin 100
Bauhaus 188
Beauvoir, Simone de 183
Beckett, Samuel 106–7
Beethoven, Ludwig van 101
Bei Dao 195
Bei Shan Tang Foundation 201
Beijing
 Tiananmen Square
 protests 196
 University 196
 Berlin 103
 Wall 147
Bernheim-Jaune, Galerie, 28

Beuys, Joseph *149*, 170, 176, 240
 The Pack 144–55, *145*
 *'La Rivoluzione siamo
 Noi'* 152
Bignou Gallery, New York 22
The Blind Man 58
Bogotá 240, 246
Bohen Foundation 214
Bolshevik Revolution 52
Bourgeois, Louise *218*
 Maman 214–25, *217*
 Spider 221, 224
Braque, Georges 37, 41
Brazil 246
Breton, André 91
British Museum, London 201
Buddhism 198, 212–13, 233
 Zen 140, 200, 209, 212, 233

calligraphy 196, 198
Camus, Albert 106
Cape Cod 85
capitalism 13, 129, 153, 182,
 186–7, 194, 241
Capra, Frank 80
Catholic Church 93, 124, 147,
 212, 242
cave paintings 221
Le Centaure, Galerie, Brussels
 72
Centre Georges Pompidou,
 Paris 129
Céret, Pyrenees 36
'Challenge and Defy'
 (exhibition) 65
Chernobyl disaster 172
ch'i 233
Chia, Sandro 172
China 194–202, 228, 230, 246
 Cultural Revolution 194, 195,
 196
 New Wave of Fine Arts
 movement 194
 Chinese (language) 195
Christianity 176, 212
Christie's
 London 77
 New York 23, 87, 97, 108,
 129, 141
Clemente, Francesco 172
climate change 160, 167
cognitive strain 232
Cold War 100, 147, 170
collage technique 36, 37, 40–1,
 48
Colombia 240–2, 246, 248
 La Violencia 240
colour 23–8, 47, 48, 48–9, 52,

 74, 81, 94, 101, 105, 112, 119,
 126–7, 127, 140, 160, 175, 208
 field of 23, 30, 113, 114,
 115, 125, 128
commodification of art 164
commodity fetishism 186
Communism 93, 194, 195, 196
Conceptual art 87, 173
Confucianism 233
Constructivism 188
consumerism 122, 147, 186–7
Crimea 147
criticality 190
Crow, Thomas 124
Cubism 35, 37–8, 39, 48, 52, 59,
 60, 87
 Analytical and Synthetic 37
Cubo-Futurism 49

Dada 58, 139
Dansaekhwa 230, 235
de Hooch, Pieter 81
de Kooning, Willem 112
Dead Sea 158
deafferentation 213
death (as theme) 128
deconstruction 200
Delacroix, Eugène 30, 100
Deleuze, Gilles 105
Derain, André 23
Derrida, Jacques,
 Of Grammatology 200
Descartes, René 186
Dia Art Foundation 164, 188
diagram 40
Disney, Walt 221
'documenta' (exhibition series)
 154
Donatello 23
doubles 96
dreams 70, 75, 80, 90, 93, 176
Duchamp, Marcel 17, 37, *61*,
 150, 183
 Fountain 56–67, *57*, 248
 *From or by Marcel Duchamp
 or Rrose Sélavy (Box
 in a Valise)* 65
 *Nude Descending a
 Staircase, No. 2* 60
Duchamp-Crotti, Suzanne 59
Duchamp-Villon, Raymond 59
Durham Cathedral 209
Durkheim, Emile 83

earthworks 162, 164
easel paintings 86
East Asia 25, 198, 228–33
Edwards, John 108

Egypt, mythology 173
Einstein, Albert 37
Eisenstein, Sergei 101
El Greco 208
electric chair 124–5
Eliade, Mircea 176
encounter 234
entropy 163, 166
Existentialism 106
Expressionism 87
 German 174

The Factory 122
Fauvism 23
feminism 137–8, 182–3,
 222, 224
Le Figaro 36
First World War 30, 58
Fluxus 146
Foucault, Michel 74, 185
Free International University
 for Creativity and
 Interdisciplinary
 Research 149
Freud, Sigmund 13, 70–1, 76,
 96, 118, 222, 223
Frida (film) 96
Friedrich, Caspar David 113
Futura (font) 188
Futurism 48, 59, 139

Gargoyle Club, London 22
Gauguin, Paul 23
Gaut, Pierre 41–2
German Democratic Republic
 147
German Student Party 149
Germany 28, 146–51, 170, 188
Gesamtkunstwerk 139
Globe movie theatre, New
 York 80
Goldwater, Robert 219
Gottlieb, Adolph 112
grammatology, applied 200
Grand Guignol 107
Great Depression 80–1
Great Salt Lake 158–60
Green Party, West Germany
 149
The Guardian 142
Guggenheim Museum Bilbao
 220, 223
Guggenheim, Solomon R.,
 Museum, New York 214

hallucinations 135
Hanover Gallery, London 108
Happenings 139
Harvard University 201
Hayek, Salma 96
Heidegger, Martin 233, 245–6
Heron, Patrick 22
Herrera, Hayden, *Frida: A
 Biography of Frida Kahlo* 96

Hiroshige 100
Hiroshima 101, 135
Hirshhorn Museum and
 Sculpture Garden,
 Washington DC 141
Hitler Youth 147
Hofmann, Hans 112
Hollywood 80–1
Holocaust 116
Holt, Nancy 163
Holzer, Jenny 185
Hong Kong Museum of Art 201
Hopper, Edward *84*
 *East Wind Over Wee-
 bawken* 87
 Hotel Window 87
 New York Movie 78–87, *79*
Hopper, Jo 80, 85

icon (painting) 23, 25, 47, 208
icon (sign) 40
iconoclasm 72
identity politics 190
illusion 85
image 40
Impressionism 23, 63, 81, 85
India 246
Indra's net 138–9, 142
Inkombank 54
Instagram 16, 142
Interros company 54
Ireland 101
Issy-les-Moulineaux, avenue
 du Général de Gaulle 30
Istanbul 233, 244, 246, 247
Italy 28

Japan 135–7, 140, 228–30
Jesus Christ 151, 209, 242
John of the Cross, St 212
Judaism 113, 116
Julien Levy Gallery,
 New York 91
Jung, Carl 13, 96, 147, 176

Kahlo, Frida *92*, 222
 *Self-Portrait with Cropped
 Hair* 88–97, *89*
Kahnweiler, Daniel-Henry 41
Kandinsky, Wassily 47
Kaprow, Allan 139
Kassel 154
Kaufmann, Edgar, Jr 96
Keller, Georges 22
Kelly, Ellsworth 125
Kiefer, Anselm *171*
 *Let a Thousand Flowers
 Bloom* 178
 Osiris and Isis 168–79, *169*
Kiev 50–2
kinaesthesia 174
Kline, Franz 112
Korea, North and South
 228–30, 235

Korean War 228
Kruger, Barbara 17, *184*
 *Untitled (I shop therefore
 I am)* 180–91, *181*
 *Untitled (When I Hear the
 Word Culture I Take Out
 My Checkbook)* 190
Kunstsammlung Nordrhein-
 Westfalen, Düsseldorf 77
Kusama, Yayoi 17, *136*, 224
 *Infinity Mirror Room -
 Phalli's Field* 132–43, *133*
 Infinity Net 137, 141
 White No. 28 141
Kyoto School 233

Land Art 162, 163, 164
language 72–4, 76
'Last Exhibition of Futurist
 Painting 0.10' (Petrograd/
 St Petersburg) 46, 47
Le Cateau-Cambrésis 28
Lee Ufan *229*
 Correspondence 226–35,
 227
 From Point 235
Leningrad 48
Leonardo da Vinci,
 Salvator Mundi 77
Lessines, Belgium 72
Levinas, Emmanuel 245
Levine, Sherrie 185
libido 70
liminal space 206–7
logocentrism 200
Los Angeles 182
Lost Horizon (film) 80
Louvre, Paris 96
Luftwaffe 147

MacArthur Foundation
 Fellowship 196
Madonna 97
Magritte, René *73*, 222
 La Corde sensible 77
 Le Domaine d'Arnheim 77
 The Empty Mask 68–77, 69
Malaga 35
male gaze 137
Malevich, Kazimir 37, *51*, 64,
 94, 230
 Black Square 44–55, *45*
 Suprematist Composition 54
Manet, Édouard 63
 A Bar at the Folies-Bergère
 81
Mannerism 208
Mao Zedong 194, 195, 196
Marlborough Fine Art,
 London 108
Marx, Karl 186
mass culture 122, 124, 127,
 161, 190
Matisse, Henri *29*, 64, 81, 94, 126

Dance 30
Luxe 24
Music 30
'Notes of a Painter' 28
L'Odalisque, harmonie bleue 23
Red Room 52, 58
The Red Studio 20–31, *21*, 113
Maya culture 93, 172
mechanical reproduction 130
Menil, Dominique and John de 129
Menil Foundation 129
Merleau-Ponty, Maurice 233
metaphor 40
Mexico 90, 93, 97, 172
Mexico City 90
Millet, Jean-François 100
Ming Dynasty 198
miniatures, Persian 25
Minimalism 137, 140, 161, 221
mirror installations 134
Modernism 48, 63–4, 72, 76, 86, 126, 129, 161, 170, 174, 177, 188, 194, 198
 European 66
 Russian 188
Mondrian, Piet 47
Monet, Claude 30, 104
Mono-ha movement 228
Montparnasse, boulevard Raspail, Paris 36
Moore, Henry 223
Moreau, Gustave 28
Moscow 52
Motherwell, Robert 112
Mott, J. L., Iron Works, New York 58
movie theatres 80–1
Munich 23, 41
Museum Boijmans Van Beuningen, Rotterdam 141
Museum of Contemporary Art, Chicago 96
Museum of Modern Art, New York 22, 86, 96, 113
 Industrial Design Department 96
mysticism 176, 209, 212, 214

Nagano Prefecture, Japan 135
Nagasaki 101, 135
Nancy, Jean-Luc 245
narcissism 138, 142
National Forensic Service (South Korea) 235
National Gallery of Canada, Ottawa 224
National Museum Wales 72
Nazism 101, 147, 149, 151, 172
negative theology 212
Neo-Expressionism 170, 172

Netherlands 141
New York 58–9, 122, 137, 140, 182, 219
New Yorker 189
Newark, New Jersey 182
Newman, Barnett 112
Nietzsche, Friedrich 116
Noland, Kenneth 125
Normandy 59
North Africa 28
'Nul' art group 139
Nyack, New York 85

objectification (of women) 138
objectless art 46–7
'oceanic feeling' 118
Odessa steps 100
Orientalism 235
Owens, Craig 185

Palace movie theatre, New York 80
Paris 59, 65, 72–4, 85, 101
 School of 113
Passaic, New Jersey 163
Peirce, C. S. 40
Perov, Kira 209
perspective, fixed-point 74
phenomenology 233
Philadelphia Museum of Art 65
Phillips de Pury & Company, London 214
Phillips de Pury & Luxembourg, New York 66
photography 81, 130, 159, 166, 214
Picasso, Pablo *34*, 64, 100, 101
 Blue Period 52
 Rose Period 52
 Bottle of Vieux Marc, a Glass and a Newspaper 32–43, *33*
 Women of Algiers 41
Pittsburgh, Pennsylvania 122
Plato 85, 116
Poland 50
politics 182
polka dots 134–5, 137
Polke, Sigmar 172
Pollock, Jackson 112
Pop art 87, *123*, 161
Portland, Oregon 116
Post-Impressionism 23, 64, 76
post-industrial society 186
Post-Minimalism 221
Post-Modernism 150, 170, 185, 194
post-Romanticism 149
post-structuralism 199–200, 201
Potanin, Vladimir 54
power 185–7
psychoanalysis 76, 222, 223–4
 theory of 138

psychosis 135, 137
pyramids 162, 172–3, 177

Queensland Art Gallery, Brisbane 201

readymades 37, 58, 59, 62–6, 150
Redfern Gallery, London 22
Redon, Odilon 71, 221
Renaissance 198
Renner, Paul 188
reproduction 16, 86, 100, 126, 128, 130, 166
Republic movie theatre, New York 80
Rilke, Rainer Maria 101
Rivera, Diego 90, 93, 95
Rodchenko, Alexandr 188
Rodin, Auguste 223
Romanticism 113, 129, 174
Rosenberg, Julius and Ethel 124
Rothko, Mark 16, 101, *117*, 126, 127, 138, 161, 230
 Black on Maroon 110–19, *111*
 Seagram Murals 112, 118
Rozel Point, Utah 158–60
Russia 46, 47, 52, 115
Russian Federation, Ministry of Culture 54
Rybolovlev, Dmitry 77

Salcedo, Doris 17, *241*
 Untitled 238–48, *239*
Salon d'Automne exhibition, Paris 28
Salon des Indépendants, Paris 60
Salt Lake City 158
San Francisco Museum of Modern Art 178
Sarah Norton Goodyear Fund 214
Sartre, Jean-Paul 106
Saussure, Ferdinand de 39–40
Schnabel, Julian 172
Schubert, Franz 101
Schwarz, Arturo 65
Schwarz, Galleria, Milan 65
Seagram Building, New York, Four Seasons Restaurant 112
Seattle 137
Second World War 41, 52, 101, 103, 147, 170, 240
Selfridges 189
semiotic theory 39–40, 126
Seoul Auction 235
Seven Keys, defined and discussed 10–15
Seville 23
Shchukin, Sergei 28, 30, 52

Sherman, Cindy 185
'shock of the new' 64, 194
'shock of the old' 194
Sidney Janis Gallery, New York
 65, 76
signifier and signified 39–40,
 126
signs 128
 iconic 40
 indexical 40, 46, 128
silk-screen process 126–7
Sing Sing State Penitentiary
 125
Smithson, Robert 17, *165*
 Amarillo Ramp 163
 'A Sedimentation of the
 Mind: Earth Projects' 162
 Sites and *Non-Sites* projects
 161–2
 Spiral Jetty 156–67, *157*
social sculpture 153
Socialist Realism 52
Society of Independent Artists
 58, 65
Song Dynasty 198
Sotheby's 97
 Hong Kong 201
 New York 54, 66, 108, 129
Southern Pacific Railroad 160
Southwest American Indian
 rock art 162
Soviet Union 124
Spain 28, 35
Staatliche Museen Kassel,
 Neue Galerie 153–4
Stalin, Joseph 52
State Hermitage Museum,
 St Petersburg 54
State of Utah Division
 of Forestry, Fire and
 State Lands 164
Steiner, George 101
Steiner, Rudolf 151–2
Stepanova, Varvara 47
Stieglitz, Alfred 65
Still, Clyfford 112
Stonehenge 162
Strand movie theatre,
 New York 80
sublime (as concept) 113, 174,
 208
Sufism 212
Suprematism 48, 49
Surrealism 70, 72–4, 80, 87, 90,
 91, 93, 221, 222
symbol 10, 13, 15, 24, 28, 40,
 46, 50, 62, 83, 91, 94–5, 112,
 125–6, 135, 138, 146, 147,
 150, 153, 161, 170, 173–4,
 176–7, 190, 199, 207, 219, 224
symbolic systems 182–3, 185
Symbolism 28, 71, 161, 174, 221
Syracuse University 209

Tao Te Ching 200
Taoism 15, 200, 231, 233
Tate Gallery, London 41–2, 87,
 101, 118
Tate Modern, London 115, 223
technology 81, 85, 86, 126, 128,
 134, 141, 145, 151, 176, 188,
 190, 198, 206–8, 207–8,
 210, 213–14, 222
 communication 122
 energy 172
 imaging 209, 210, 214
 printing 198
Tehuana clothing 90, 91
Tennant, David 22
Thannhauser Moderne Galerie,
 Munich 41
Tisdall, Caroline 146
Titian 30
Tokyo 137
tragedy (as concept) 116
Tretyakov Gallery, Moscow 48
Turner, J. M. W. 113
typography 188

Ukraine 50–2
uncanny (as concept) 71, 90,
 94, 96, 207, 220
unconscious 70–1, 176
 collective 176
United States of America 30,
 80–1, 87, 112, 140, 147, 164,
 196, 201
Utah, University of, Utah
 Museum of Fine Arts 164

Van Gogh, Vincent 23, 100
vanitas painting 125
Vauxcelles, Louis 23
Velázquez, Diego, *Portrait
 of Pope Innocent X* 100–1
Vermeer, Johannes 81
Victory over the Sun 48
video as medium 208–9,
 210, 214
Vietnam 147
Vietnam War 164
Villon, Jacques 59
Viola, Bill 17, *211*
 Eternal Return 214
 The Messenger 204–15, *205*
violence (as theme) 242,
 243–6, 247
visual field 24, 26, 39,
 115, 134, 207
Vlaminck, Maurice de 23
Volkswagen 146
Vollard, Ambroise 28

Wagner, Richard 139
Waldorf Schools 152
Warhol, Andy *123*, 182
 Big Electric Chair 120–31, *121*

Campbell's Soup Cans 122
Death and Disaster series
 124–5
Little Electric Chair 129
*Silver Car Crash (Double
 Disaster)* 129
water 207, 209, 210
Wells, H. G., *War of the Worlds*
 222
Westminster College, Utah,
 Great Salt Lake Institute
 164
Whitney Biennial 182
Wonder, Stevie, *Songs in the
 Key of Life* 15
'Word as Image' (exhibition) 76

Xu Bing *197*
 A Book from the Sky
 192–203, *193*
 Square Word Calligraphy
 196

Yale University 116
'Yayoi Kusama: Infinity
 Mirrors' (exhibition) 141
yin/yang 15

'Zero' art group 139
zero point 47, 50
Zurich 58